German Settlers
OF SOUTH BEND

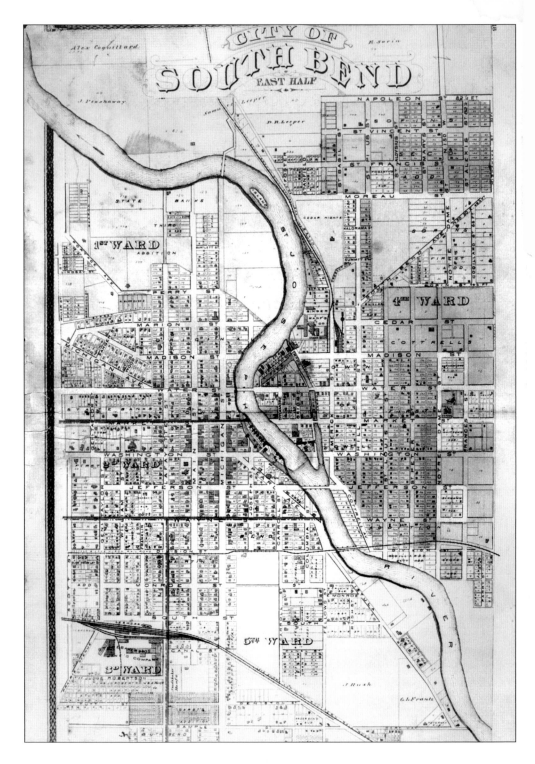

This c. 1875 map of South Bend shows the business center at Michigan and Washington Streets, "Little Arzberg" at Lafayette and Marion Streets, and the east side across the river, formerly the town of Lowell.

VOICES OF AMERICA

German Settlers

OF SOUTH BEND

Gabrielle Robinson

ARCADIA

Published by Arcadia Publishing,
an imprint of Tempus Publishing, Inc.
3047 N. Lincoln Ave., Suite 410
Chicago, IL 60657

Printed in Great Britain.

Library of Congress Catalog Card Number: 2003103949

For all general information contact Arcadia Publishing at:
Telephone 843-853-2070
Fax 843-853-0044
E-Mail sales@arcadiapublishing.com

For customer service and orders:
Toll-Free 1-888-313-2665

Visit us on the internet at http://www.arcadiapublishing.com

To Mike

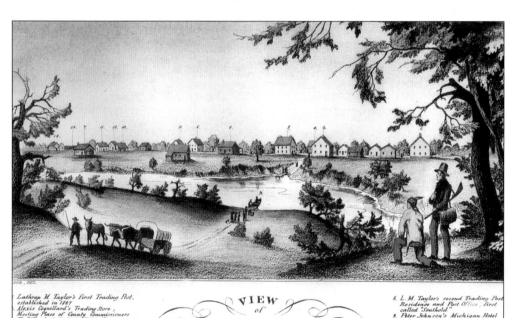

A View of South Bend in 1831 is seen here in the romantic tradition, but it also shows the sites of the time, including the first ferry at the bottom of Water Street.

Contents

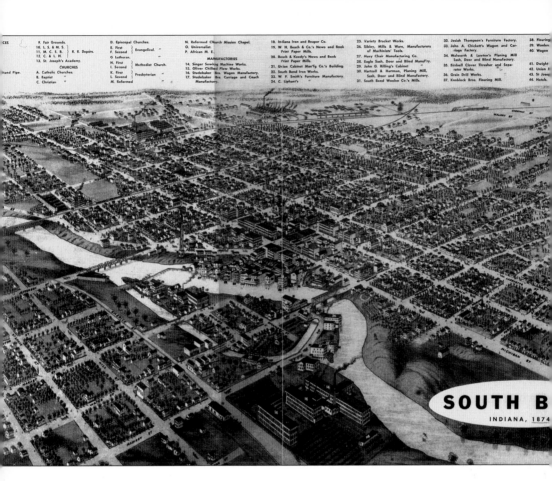

South Bend 1874. (Courtesy Northern Indiana Historical Society.)

Acknowledgments

In many ways this book is a collaboration, since it could not have been written without the genealogies, stories, and pictures provided by a large number of people all across the United States and on both sides of the Atlantic. My chief collaborator has been Erwin Scherer of the Lutheran Church in Arzberg, Germany, who was tireless in his efforts to find information for the book. His knowledge of the Arzberg area and its history has been a never-ending resource which has helped me understand the people and the times. Scherer also came to South Bend to transcribe, from the old German, the over 200 letters written to and by German immigrant Christian Sack in the mid-nineteenth century.

In South Bend, Harry Koehler, archivist at Zion Church and third generation German, has been another enthusiastic collaborator, making available church records and the German newsletter, and telling me about the South Bend German community. It is thanks to his contacts that we could rescue the *Maennerchor* records and preserve them at the Northern Indiana Center for History. Sarah Coffman, archivist at Temple Beth-El, has spent hours with me among the stacks of neatly labeled acid free boxes in which she has organized temple records. David Bainbridge, senior curator at the Northern Indiana Center for History, has given me the benefit of his vast knowledge and opened the resources of the museum. It was Bainbridge who found the Sack letters in the attic of a house about to be torn down and at the last moment stuffed as many as he could into a box, which was stored at the museum. Jackie Dougherty at the Indiana Province Archives, Notre Dame, Sister Campion Kuhn, CSC, archivist at St. Mary's College, and Brother John H. Kuhn, CSC, archivist at the Midwest Province Archives, Holy Cross College, have been most helpful in providing information on German Catholics. Everyone at the local history room of the St. Joseph County Public Library has been most helpful. Mary Jane Lepird, archivist at the Ligonier museum, has made special trips, even on her birthday, to show me around the museum and the town. Professor Don Heinrich Tolzman of the University of Cincinnati made the extensive bibliographical material at his Institute for German-American Studies available to me.

I am also grateful for the cooperation of Mayor Steve Luecke of South Bend, and Mayor Robert Beutter of Mishawaka, both of German heritage, as well as to Mikki Dobski, Director of Community Affairs in South Bend.

Private genealogists have added immeasurably to this book, and this listing in no way does justice to the tremendous amount of original material they have provided, nor to their energy and enthusiasm. It was one of the greatest pleasures of this project to get to know them. Henry Zeitler McCrary has spent years putting together vast genealogies of the Zeitler family and all the other interrelated German families in South Bend. John Gardner traced all the land transactions of the Bellmans and Ritchies, and I am grateful to Dolores

C. Hinton for the amazing story of the Betcher family, and the Dudley, Texas, land scam. John H. Schelleng has been most helpful in giving me access to pictures and the family history his father has written. Allan Soellner and his mother Lorraine have contributed wonderful stories on the Soellner family. Frederick C. Elbel helped with the Elbel history and provided pictures from his collection. A very special thanks also to Dieter Reiss in Arzberg for doing all the photo work for the pictures and documents there.

But the list is much longer than that and I have fond memories of sitting in many different living rooms learning about the German immigrants. Contributors were Charles Beutter, Merle Blue, Floyd Catterlin, Eileen Copsey, Oscar Dobereiner, Ingrid Eisenkolb, Denise Fiedler, Cindy Fodness, William Fuerbringer, Jane and Peter Huester, Beth Kamm Reising, Natalie Kamm Danielson, Lois Kamm, Harriet Kamm Nye, Elfrieda Kuespert, Walter Jaeger, Tom and Phyllis Lang, Robert Lang, John Lederer, Ann Leonard, Judy McCollough–Historical Archive Manager in the Marshall County Museum, Frederic M. Messik, Carol Muessel McFarland, Richard A. Muessel, Bernard Neitzel, Adele Paskin, Martha M. Pickrell, Colleen Poehlman, Ruth and Eberhard Reichman at the Max Kade German-American Center in Indianapolis, Mary Renshaw, Professor Joachim Reppman, Marjorie Roessler Kinney, John F. Rockstroh, J. Richard Rockstroh, Elfriede Schuell, Carol Schuell McKirgan, Margaret Strebinger who made available to me *Turnverein* records long believed lost, Christopher Walz, and Professor Erwin Weiss who let me see his family biography.

My family also has accompanied me on this journey. My mother, Dr. Margit Schoenfeld, has transcribed some of the letters, and my son Professor Benedict Robinson has helped with ideas and related literature. But the one person who has been with me at every step in this project is my husband Professor Mike Keen. From the very beginning when we visited every little cemetery in the area in search of German graves, and made several trips to Germany, to the final manuscript, which he has read and edited line by line, I have been sustained by his constant and patient support as well as by his creative ideas, although it must have seemed to him at times that there was no other topic than "the Germans."

Needless to say, the mistakes are all my own, and I appreciate any corrections. As anyone engaged in genealogical work knows only too well, inconsistencies abound in this area, from the spelling of names, to dates, and even details of life stories. I am grateful for any help the descendants of German immigrants are able to give.

Preface

Although the first Germans arrived in Jamestown, Virginia, as early as 1608, the major tide of German immigration occurred in the nineteenth century. At least one and a half million Germans emigrated to the United States between 1840 and 1860. The 1850s was the peak decade when, according to census statistics, 976,072 or 34.7% of all immigrants were German.

This book concentrates on the tidal wave of those who arrived in the South Bend area between the 1830s and 1870s and began their lives there just at the moment that South Bend began its own. It deals only with the immigrants who came directly from Germany, or who spent at most a short time in, typically, New York, Pennsylvania, or Ohio before reaching South Bend. This excludes the large group of Pennsylvania Dutch who already had settled in the eastern United States before coming to Indiana, as most notably did the Studebakers. William Ruckman was another second generation German who played a major role in building South Bend. He was instrumental in grading its streets, laying sewers, and erecting public buildings like the jail.

The material for this investigation has been collected from a large number of sources on both sides of the Atlantic, many of which have never been published before. This includes church and temple records in South Bend as well as Germany, newspapers, city directories, and the collection at the Northern Indiana Center for History. The minutes of German organizations also were a fruitful resource. Although most of these had been thought lost, I was able to locate the records of the South Bend Turners and the *Maennerchor*. Personal documents, and the amazing work of private genealogists has been an always surprising and abundant mine of information. As the project grew, descendants of immigrants from all over the United States and Germany have come forward with genealogies, recollections, and pictures, which has helped not only to flesh out a fuller picture of the times, but to bring together the two parts of the immigration stories.

The research also brought to light more than 200 German letters from the 1840s to the 1870s. Most of them are addressed to Dr. Christian Sack, who emigrated in 1855, with some of them written to him during the upheavals of 1848 before he left Germany. The letters provide further glimpses into the day to day lives of these pioneer immigrants, including their activities during the Civil War, and they also help to explain conditions back in Germany.

Whenever possible, the book introduces the personal stories of these early German immigrants since they illuminate the larger historical and social context in which they lived. They also show to what extent the case of South Bend fits into the larger pattern of German immigration in the 19th century, and how it differs from other Midwestern cities. For example, unlike in larger communities such as Milwaukee and Columbus, South Bend

never had the ethnic enclave of a Germantown. Although a number of the early German settlers lived near each other—one area even was called "Little Arzberg"—the Germans never made up more than about 30% of any city ward.

Two sets of key issues in studying any group of immigrants are social mobility, and rate of assimilation or the politics of identity. It is interesting to note that, although this wave of German immigrants bettered their standard of living and their wealth considerably, most of them maintained their relative social position in their move across the Atlantic. Upward mobility, then, was a matter of improving one's financial security rather than moving up in class.

The question of ethnic identity is one with which the Germans had to struggle over the centuries and in different political environments more, perhaps, than any other ethnic group. The first immigrants clung to their culture, traditions, and their language, which they maintained in organizations such as the *Turnverein*, their churches, and their schools as well as in singing and dramatic societies, and bands and orchestras. But through these activities they also tried to introduce their culture to the new world, and this effort functioned as a bridge to the native-born society. They were proud of their German heritage, but at the same time talked and acted as loyal Americans, taking pride in their hyphenated German-Americanism. However, when anti-German sentiment ran high during World War I, this changed rather abruptly. The Second World War further attenuated German-American sentiment and identity. It is only recently that the descendants of German immigrants are able once again to celebrate their heritage.

The story of the German immigration to Northern Indiana not only brings with it the romance of the past, but also illuminates a defining era in the creation of a Midwestern city like South Bend and its surrounding farmland. It reaffirms the powerful connection between Germany and the United States, the "Germany in US," and Indiana in particular, where according to the 1990 census one out of three Hoosiers can claim at least one German ancestor. It shows the continuing interconnectedness between these two worlds. And as the South Bend area is experiencing another massive immigration, this account may help to bring the perspective of the past to bear upon the future.

I.

City Builders

GERMAN IMMIGRANTS IN EARLY SOUTH BEND

*A*ugust 15, 1847 was another sunny summer's day in South Bend, Indiana. In fact, there had been a drought that made the sandbars on the St. Joseph River tricky to navigate. But Captain John Day brought his steamboat "Michigan" safely to the wharf at the foot of Washington Street in the center of the town. On board were 22 German immigrants from Arzberg in eastern Bavaria, whose arrival created quite a sensation. With barely 15,000 inhabitants at the time, South Bend was hardly more than a village, and most of the town had gathered at the wharf to watch the newcomers arrive and give them welcome.

The Germans had made the entire trip by water. Sailing from Bremen, Germany on May 22, they arrived in New York in late July. On July 31, they left New York taking the swift Hudson steamboat, traveling about 100 miles a day, to Albany. From there they got passage on the Erie Canal. The trip was cheap—about 1 cent per mile—but they had heard that it could be difficult and also dangerous. The 350-mile canal had 84 locks and there were reports of a number of explosions on the boats. Fortunately the Arzberg group arrived in Buffalo without incident. From there they sailed the Great Lakes to St. Joseph, Michigan, and then finally took Captain Day's steamboat along the St. Joseph River to South Bend.

The immigrants, who had seen only unknown faces and heard a language they could not understand, were glad to find Johann Wolfgang Schreyer among the townspeople who greeted them. He had come from Arzberg to South Bend in 1843, when he bought 40 acres of land 8 miles south of South Bend. By 1846, when he felt securely established and acclimatized, he had written a detailed and enthusiastic letter back home, informing his friends and relatives of the opportunities in the new world and lauding the freedom and equality he had found there.[1] The people of Arzberg were so excited by his letter, which was passed from hand to hand and copied over and over, that many planned to follow him as soon as possible. Now, just a year after that letter, Schreyer took the tired travelers to his farm where they were able to see for themselves the abundance of land and that, as he had written, they had more meat to eat than they had potatoes in Germany.

For more than 50 years after their arrival, the 1847 group celebrated their arrival in South Bend on August 15 with a picnic, which was attended by an ever-growing number of families. And they had much to celebrate since most of them did very well in their new home. Among them was the wealthy widower Johann Melchior Meyer with his five daughters and the widow Elizabeth Katharina Zeitler who came with two sons and three daughters. As soon as they were in South Bend, Meyer and Zeitler got married, and purchased one of the finest farms in St. Joseph County. Eventually each of Meyer's daughters married into an important German-American family. Soon there was a closely interrelated network of German families who played an important role in the development of South Bend.

The story of the first German immigrants to Northern Indiana also is the story of the beginnings of South Bend. Although they did not quite equal the power and influence of the native-born elite, the Germans were the predominant immigrant group during this

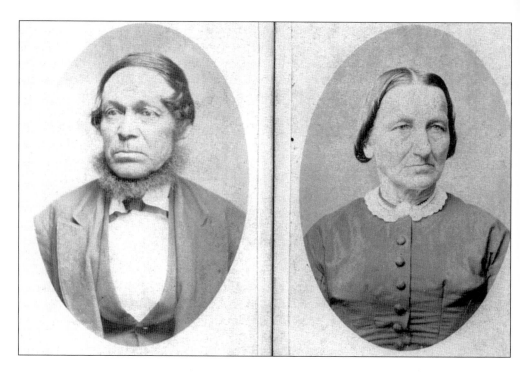

Johann Christoph Keisler and Anna Barbara Kunstman Keisler from Arzberg, Bavaria, who emigrated in 1848, are pictured here in Mishawaka c. 1870. (Courtesy John H. Schelleng.)

period of growth. They came early enough, between the 1840s and 1880s, to help build South Bend from an isolated trading post into a thriving city, and to transform the wilderness of dense forests, prairie, and swamps around it into rich and fertile farmland. In South Bend, the immigrants established the many businesses that make up a center of commerce. They owned hardware stores, and groceries; they were cabinet-makers, tinsmiths, tanners, weavers, butchers, tailors, shoemakers, coopers, blacksmiths, and harness-makers. A smaller group of professionals opened doctor's offices, pharmacies, and architectural firms. In South Bend as elsewhere in the Midwest, most of the clothing and dry goods stores were owned by German immigrants, many of the Jewish faith. Brewing and baking were fields dominated by the Germans, who owned flour mills, bakeries, and pastry shops. In 1871, eight out of twelve saloons in South Bend were German-owned. All three major breweries, the Kamm and Schellinger and the Muessel Brewing Companies, and the later Hoosier Brewery, were German.

The German immigrants literally helped to build the city. The first brick house was built in 1831 by Frederick Bainter, who was of German origin. It stood near the southeast corner of Main and Water Streets and was so much admired that people called its owner "Frederick the Great." German craftsmen contributed their skills to beautify and enrich South Bend. August Beyer from Pomerania frescoed the Masonic Hall, the old courthouse, and helped to decorate Notre Dame. The architect and contractor Robert Braunsdorf from Danzig built for the Studebaker Corporation and St. Mary's College. The firm of Meyer and Poehlman did the roofing and elaborate cornice work for all major buildings and churches in South Bend.

By 1880, German immigrants Meyer Livingston, Caspar Rockstroh, Andrew Russwurm,

George Muessel, and John Lederer all had major brick buildings in the business center. For example, John Lederer, who had arrived in 1853, owned a "business block" on Washington Street, known as the Blue Front, and in 1880 had under construction "one of the finest business blocks in the city, to be known as Union Block."[2] In 1872, George Muessel built the three-story Muessel building on Main Street for his fancy grocery, and the impressive Rockstroh Buildings were erected in 1880. To put this into perspective, in 1873 there were altogether only 16 brick buildings in South Bend, and by 1875 the number had gone up to 27.

Early city directories indicate an already considerable German presence in downtown South Bend. By 1867, virtually every other house on Michigan and Washington Streets, the cross streets at the center of South Bend, had a German business or resident. Main and Market, the next streets over, which were less developed, also had a large number of Germans. There are two remarkable aspects of this. The first is the concentrated German presence in the very heart of South Bend, and the other is the fact that the Germans were not isolated into an ethnic ghetto but lived and worked side by side with the native-born. German immigrants thus had daily contact with, and conducted their businesses right alongside, those of the English-speaking community.

Nevertheless the Germans, especially if they came from the same area or were related, also liked to live near each other. This is true especially of the area around Lafayette and Marion Streets, just north of the business center, which was dubbed either "Little Arzberg" after the many immigrants from that Bavarian town, or "Goose Pasture" because many Germans kept geese. At the corner of Marion and Michigan Streets stood Turner Hall, built in 1869, the center of German social activities. Another concentration of Germans, particularly later

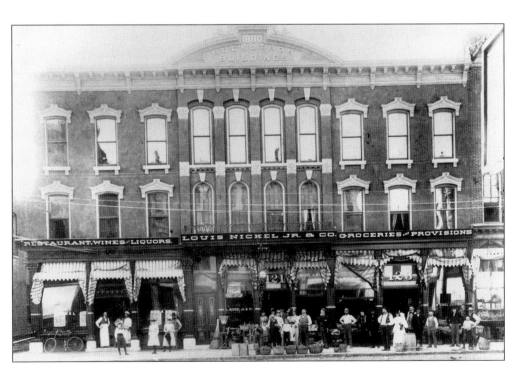

The Rockstroh Building was erected 1880 and housed the well-known Nickel's restaurant and delicatessen. (Courtesy Northern Indiana Historical Society.)

working-class arrivals, was located on the east side across the St. Joseph River in the fourth ward. Even given these concentrations, there developed, however, no lasting ethnic enclaves, such as the Germantown in Milwaukee or in Columbus. For example, in 1870 the first ward, north of Market Street, was 32 percent German, but by 1880 the percentage had fallen to 28 percent. In 1880, the Germans were evenly distributed between the first ward, and the second and fourth wards, which had 23 percent each.[3] The second ward, just west of the business center, increasingly became the preferred location of the wealthy elite.

The Germans were leaders in introducing culture and a social life of balls, parades, and celebrations to South Bend. But perhaps more than anything, they brought their love of music to their new home. The very first organizations they formed were a band in 1852, and a choral society in 1855. Out of these grew many more musical clubs, singing groups, bands, and orchestras. Chief among them was the Elbel cornet band and orchestra, which were credited with upgrading American taste in music and introducing audiences to the great operatic literature. Timothy Howard's history of St. Joseph County states: "What the Olivers and Studebakers have been to the industrial life of South Bend, the Elbels have been to the musical life."[4]

As early as July 1860, the Elbel band won a prize, against great odds, at a tournament just north of the border in Niles, Michigan, garnering the coveted Silver Cornet Award. They had arrived late, weary, and covered with dust from the trip on sandy roads by horse and wagon. While all other competitors sported fancy uniforms, the Elbel band just had their travel-stained suits. The crowd nicknamed them the "backwoods band."[5] At first their music could hardly be heard above the din of hooting. "When the South Bend group started to play the crowd jeered and booed but it was not long before jeers turned to cheers."[6] Professor Christian Elbel, as he was always called, was the leader of the orchestra, and for many years, his father's house at 300 West Marion Street was a center of musical activity. Christian's brother Lorenz Elbel carried on the family musical tradition as director of the Elbel cornet band and orchestra, and one of his sons, Louis, composed the now famous Victor's march for the University of Michigan. Louis was one of the few Americans at that time to appear in Germany as a soloist. The last public appearance of the Elbel band was on the night of the Armistice in 1918.

Music distinguished the Germans and united them as a group, but it also helped to integrate them into native-born society. The Elbel Band played at major functions in South Bend and worked closely with the best of the native-born musicians, accompanying their singers and arranging music for them. In the 1880s, for example, the famous "Annual Serenaders" were made up of the quartet from the St. James Episcopal Church and the Elbel orchestra, with the best singers and musicians of South Bend, both native-born and German, joining in. The Serenaders performed vocal and instrumental pieces for one long summer's night early in July, using two large wagons lit by torches to transport the orchestra and a grand piano. Afterwards there was a feast, put on by Louis Nickel Jr., owner of the foremost German delicatessen in South Bend. The menu included "paté de ris de veau, à la Financière" and "escalopes d'huitres au gratin." Even one of the desserts which was, no doubt angel food cake, sounded distinguished in its French guise as "Gateau des Anges."[7] The guest list included Germans as well as prominent members of native-born South Bend society.

The immigrants loved feasts, performances, and celebrations of all kinds as relaxation from their hard daily work. They celebrated the anniversaries of German writers, and performed five to six plays each season. The Turner Society introduced public celebrations and festivals on days like May Day, Mardi Gras, and, of course, Christmas. It was said that the first Christmas tree in South Bend appeared in the home of Lorenz and Johanna

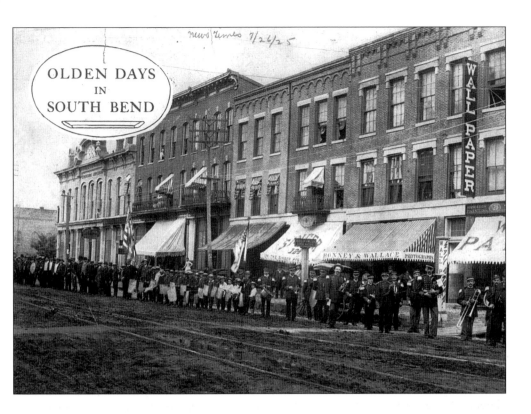

*The Turner parade on the east side of Michigan Street, July 4, 1885 is featured above. (*South Bend News Times, *July 26, 1925.)*

Mainer Elbel in 1869, and that many came to marvel at its lighted splendor. But the society also honored the Fourth of July with parades and pageantry. In his study of South Bend ethnic communities, Dean Esslinger found that "the ethnic group that contributed the most to the social activities of the community was the Germans."[8]

However, these achievements also could attract negative attention, especially when the social and cultural patterns of the Germans clashed with those of American Puritanism. The Germans tended to feel that they were bringing culture to a wilderness and introducing higher ideals to people interested only in making money. Needless to say, such sense of cultural superiority grated on the English-speaking residents, even as they appreciated the newcomers' contributions.

German sociability also could antagonize the puritan Yankees who disapproved of this propensity for partying, drinking, and singing. Perhaps still trying to defend German ways, Thekla Sack, daughter of German immigrant Dr. Christian Sack, wrote in 1904 that the theatrical performances of the German theater group were not just for pleasure, but "left a deep impression on receptive minds and hearts, sweetened the hard hours of daily toil and beautified both the inner and the outer life and made its burden less difficult to bear."[9]

Germans and Yankees particularly disagreed on the use of the Sabbath. For the Germans, Sunday was a time to socialize, enjoy outings, dances, picnics, theatricals, singing, and card playing. The granddaughters of brewery owner Adolphus Kamm still remember fondly the regular Sunday family gatherings at the Kamm house, which always included a keg of beer in

the kitchen and card games in every room, including bridge, romme, euchre, canasta, and a game called "schmier."[10] Such activities were in sharp contrast to the Puritan Yankees' idea of honoring the Sabbath through prayer and rest. After five years in the United States, a German immigrant wrote: "On no other day…does the German feel more deeply that he is a stranger in a strange land, and always will remain a foreigner."[11]

Drinking was another major point of contention between the ways of German Continentalism and American Puritanism, particularly as the Temperance Movement gained momentum throughout the century. The Germans were known for their fondness for their "liquid bread." Beer, or more rarely wine, was an integral part of their cultural and social life. The pub functioned as a social club or a "third place,"[12] both public and private, where one discussed affairs, exchanged news, and shared each other's joys and sorrows. Unlike the American saloon, generally frequented only by whiskey-drinking men, the entire German family went to the pub or beer garden.

More evident, however, than these frictions was the fact that the Germans' success in business and their active social life helped them become involved in South Bend's civic life. Nearly half the foreign-born leaders of South Bend between 1850 and 1880 were German.[13] John C. Knoblock, a Republican, was one of three town trustees in 1861 and 1862, before South Bend was incorporated, and from 1866 to 1870, he was a member of the Board of County Commissioners. The Germans became politically active in city government in significant numbers in the years of growth and prosperity after the Civil War when a number were elected councilmen of their wards, in particular in the first and fourth wards.

John Klingel was one of the prominent public servants in these early days of the city who, as his obituary said, was "a man who was actively identified with the growth and development of South Bend."[14] Klingel was born in Walhallen, in the Rhine country, on

John Klingel was a businessman and public servant. (Courtesy Northern Indiana Historical Society.)

August 31, 1835. In 1839, he migrated to Rome, New York, with his parents, two brothers, and a sister, and in 1856, they came to South Bend. His father Philip, who had served under Napoleon Bonaparte, opened a shoe store, Philip Klingel and Sons, located at 80 Michigan Street. John followed his father into the business and was a shoe merchant for 20 years. Although his formal schooling ended when he left Germany at the age of 15, John loved learning, especially Shakespeare and the German classics, and he devoted 15 years of service to reforming the South Bend school system and creating a public library.

He began his public career in the Masonic *Germania* Lodge, but soon became politically involved in the larger community. He was elected in 1865 by the first ward to the first city council, established after South Bend was incorporated. Two years later, he was re-elected but resigned to join the Board of Education for the city, serving from 1867 until 1883. In the 1860s, students of all ages were taught by one teacher in one classroom. Under Klingel's leadership, classes were separated into different grades, a high school was established, and a superintendent appointed. Klingel was secretary for the board from 1867 to 1979, when he became treasurer. The presidents of the organization, however, were major industrialists such as Almond Bugbee, Elliott Tutt, and John M. Studebaker.

In 1872, after he sold his shoe store, John Klingel, always an avid reader, worked closely with William G. George and Louis Humphreys, South Bend's first and second mayors, both native-born, to establish the first public library. It was initially located in the rear of a store on Michigan Street, but soon thereafter moved to the second floor above one of his brother's shoe stores at 123 West Washington Street. The store already was popular for its pet raccoon who loved to search customers' pockets as they entered.

Once the library was established in a place of its own, Klingel volunteered two days a week as librarian and helped to make the city library one of the most popular institutions of South Bend with a collection of 2,500 volumes. It is perhaps fitting that Klingel, who loved to quote Shakespeare, died on April 23, Shakespeare's birthday, in 1900. Symbolizing his affiliations with both the German and the native-born society, the pallbearers at his funeral were D.R. Leeper, John Gallagher, Samuel T. Applegate, and John W. Harbou, as well as Germans Louis Nickel and Meyer Livingston.

The Germans did not only settle in town, but many immigrants, hungry for land, developed the countryside of northern Indiana, clearing away the dense hardwood forests to make room for their farms. Nineteenth century country cemeteries are filled with German headstones. A number of them were, of course, Pennsylvania Dutch, but many came directly from Germany, since the prospect of cheap and plentiful land had driven them to America. More than any other nationality, the Germans have been responsible for creating farms out of virgin forests and running them successfully.[15]

One reason for the success of German immigrants clearly was the timing. The Germans prospered along with South Bend, which, between the 1850s and 1880s, exploded from a trading post into a city. In the 1870s, when South Bend became a major industrial center with companies such as the Studebaker, Oliver, Singer, and Birdsell manufacturing companies, the Germans were already established in businesses of their own. This may be why the South Bend Germans on the whole fared better than did the German immigrants in other Midwestern cities like Milwaukee.[16]

Another reason for their strong impact was sheer numbers. Between the 1840s and the 1870s, they were the predominant ethnic group in the city. In 1850, 40 percent of the total of 274 immigrants to South Bend were German, and in 1860, it was 50 percent. Although this was less than for the state as a whole where it was 54 percent in 1850, and 57 percent in 1860, it was a critical mass that enabled the Germans in South Bend to create a network

of support, both economically and socially.

A third reason was their social status. These first Germans tended to start out at a relatively high economic and occupational level. By and large, they were educated master craftsmen and farmers who had come with some money. They were well positioned to reap the utmost benefit from the rapid growth of the city. In general, the early German immigrants were more successful in entering middle-class occupations than any other ethnic group except the English. In 1850, one in four held non-manual jobs, most of them as businessmen, and a few were lawyers, physicians, and pharmacists.[17]

Although the Germans, as is all too often the case with ethnic groups, are often treated as a unit, they were by no means a homogeneous group. They came from different classes and different states, and did not even bring with them a sense of national identity until after the unification of Germany in 1871. They were split along many different interests as well, especially in terms of religion. The Roman Catholics were at odds with the Lutherans, and both were separated from the German immigrants of the Jewish faith. The church-oriented Germans wanted little to do with the club-oriented Germans. The earlier immigrants, who came in the 1830s and 1840s, had little sympathy with those who arrived in the 1850s after the failed 1848 revolution. The so-called "Forty-Eighters" were critical of the earlier immigrants, especially of their conservatism and religion, and the earlier immigrants in turn disapproved strongly of the "infidel" Forty-Eighters' radicalism and arrogance.

Outside forces could bring these disparate elements together, as did the Know-Nothings in the 1840s and 1850s who attacked all foreign-born. The Temperance Movement likewise helped unite the Germans in fervent opposition. The diversity of the German immigrants, however, also helped them to establish themselves and make a strong impact on the developing town and country. It was just because the Germans were a diverse group of people with different skills and interests that they could form a well-functioning community.[18]

II.

Why They Left Germany

*A*ndreas Soellner was born on March 10, 1844, in Seussen near Arzberg. His family was proud to trace their ancestry back to the crusades with a family crest to prove it; at least there was an old cracked painting of a coat of arms hanging on their parlor wall. Andreas' father was a farmer who had instilled in his son a longing for freedom and equality along with a thorough Protestant ethic. Andreas had learnt to be a builder and carpenter, but in the 1860s times were so bad that there was no work for him in his trade. He had to do hard labor in the fields in order to support himself. Andreas was in love with Susannah Troeger, who lived just down the hill from him near the village pond. But neither had enough money to get married. So he waited, saved whenever he could, and looked for a way out.

One evening in 1869, after he had finished his dinner of black bread and stew, Andreas was sitting in front of his house with a friend smoking a pipe, when his neighbors, the Sommers, excitedly ran over with a letter sent to him from America. Soon many other neighbors gathered around, since a letter from America was a great and rare occurrence. Andreas read carefully so that everyone could hear: "My Friend Andreas: I am in America and working in the great city of Chicago in the state of Illinois. I work in a shop making cigars and always have plenty of money for food, clothes, and rent. Maud has given birth to a baby whom we call John. We are all well and worry about the appearance of growing problems at home with you and the old home country. If you feel unsafe, come here to America and Maud and I will put you up until you have a job and can get on your feet. Here is a clipping we cut out of a newspaper as we left Germany. It was printed by one of the big railroads here in the Midwest of the United States of America. 'Open land, work for all who are willing to work; a higher standard of living for all, religious freedom, political democracy, social equality, and a second chance for the young.' Your friend Karl."

Andreas could not sleep that night. "America" rang in his head all night, and he began to work out an idea that would give him and Susannah the opportunity they had longed for. The next morning he did not go to work in the fields, but instead ran down the hill to Susannah's house to tell her about the letter and his idea. They would become engaged right away and then Andreas would take a ship for America, and get a job there. As soon as he had earned enough, he would send money so that she could follow him. Neither of them was overjoyed at the idea of leaving their home and everything they knew for an unknown country, but they saw no other choice.

Once the decision was made, Andreas began to plan his journey. He "went through his house, his father's house, from room to room, looking at the things from the past that he would not be able to take with him, the things he had grown up with and enjoyed all his life. Things he would never see again. The giant clock on the wall and the massive chest in the corner that had been made from the wood of the black forest; the old sword that his father had kept wrapped carefully from the times of the Teutonic knights, the old family Bible…the family coat of arms with a heart on it…an old cane and a pair of hunting boots."

Andreas could take only very little since he had to carry everything on his back across Germany from east to northwest. He decided to take the small mattress that was used for visitors to sleep on and roll up his belongings inside of it; with the addition of a stout leather strap, he would have a neat and convenient

In front of his home in Seussen, Bavaria, in 1869, Andreas Soellner read the letter that motivated him to emigrate.

traveling bag. Among the few items he took, he included a pocket knife, a razor, his scissors made of Solingen steel, and a few of his tools. He chose his hobnailed boots for the journey since they would take longer to wear out.

The next morning Andreas saw soldiers all over the village looking to draft able bodied young men into a war nobody wanted, imposed by foreign rulers. With a heavy heart, he slipped out through the back door of his father's house, the pack on his back.

"It was a long journey to Nürnberg and he took advantage of every offer when a cart came by and gave him a ride. The countryside was full of fugitives and refugees. It was said that the enemy was advancing. Many times, to eat, Andreas had to dig up vegetables for himself, for most of the towns kept their shutters closed during the day, the people peering suspiciously from behind them at every stranger."

That evening he passed the point furthest from home he had ever gone before. It was at the foot of a crumbling castle where his father once had taken him, telling him that his ancestors had lived there a long time ago. "Nearing Nürnberg, he decided to shave; looking into a pool of water that was a convenient mirror he shaved his chin and stopped, razor in air. A few more days, and the beginnings of his moustache would be a good cover in case he might see someone who knew him. Besides, it made him look older, he thought.

Andreas dusted off his overcoat as best he could, hoping no one would recognize that it was a retailored military coat. With his only white shirt on and his shoes, if not shiny, at least wiped clean, he entered the teaming metropolis of Nürnberg. Soldiers were everywhere, always in a hurry from one place to the next.

The only person who did not seem in a hurry was an old man, leaning on his cane and watching the birds in the city square pecking at crumbs and bits of refuse. Hoping that he could give directions to the train station, he asked the old man. The old man's name was Karl Stadt; he not only gave directions, but, realizing the condition of Andreas, invited him to his home for dinner and the night. With a full stomach and a real bed underneath him, Andreas was asleep before his head touched the pillow."[19]

Until 1870, Germany did not exist as a unified nation. Instead there were a number of entirely separate estates, duchies, grand duchies, and even kingdoms in the various regions, each with its own ruler and subject to its own laws and regulations, even separate currencies, with little common ground between them. The myriad tariffs and taxes—including window and animal taxes—imposed by an intricate network of local rulers, municipalities, the church, and the estates made it difficult for the majority from both the middle and the working class to make a living. The entire society was dominated by a rigid and very precise social hierarchy. This went down into the most ordinary details of everyday life, such as doffing one's cap. If a man met someone with only a little more land than he had, it was imperative that he doff his cap to him. In addition, the Napoleonic Wars and subsequent feuds between the states created an atmosphere of permanent political instability. Each state had different requirements for military service, but all were demanding, generally requiring young men to do military duty of up to 5 years.

Mired in this feudal condition, the country was backward in its industrial development, and could not compete economically with already established nation states, in particular England. With the gradual introduction of new machines and technology, the German cottage industries as well as the once significant group of master craftsmen were put out of work. As a result of pressures, from both the industrializing future and the feudal past, the survival of independent master craftsmen was becoming increasingly threatened.

Farmers also found it difficult to survive. In southwestern Germany, a tax canvass in 1844 showed that three-fifths of the rural population were propertiless and living in poverty.[20] In addition, taxes took a good part of the farmers' hard won earnings. Finally, bad harvests and the infamous potato blight, which spread across Europe in 1845, threatened their livelihood.

These problems were compounded by the rapid growth in population. In the first half of the 19th century the total German population grew by more than half. This population explosion contributed to the impoverishment of both rural areas and towns. Joblessness was widespread. As families were less and less able to support their numbers, homelessness and destitution increased dramatically.

These economic, social, and political crises led to an atmosphere of violence and fear. In the 1840s, hunger riots, attacks on factories, raids on harvests and merchants were common and kept everyone in a state of anxiety. Writing from Arzberg in 1846, Johann M. Meyer, who was to emigrate to South Bend one year later, described the conditions for his brother-in-law Johann Wolfgang Schreyer, who already had left for Indiana three years earlier: "Everybody entertains great fears for the future, for no one is sure of his possessions. Much theft is committed even now, and the lower classes threaten that before they will die of hunger, they will resort to robbery and murder; many thousands would like to emigrate if they could only find the necessary funds; but even the rich are emigrating."[21]

If these social and economic factors were not enough to make the Germans flee their homeland in large numbers, German romanticism also helped to propel them away from what was seen as a tired and confining civilization and toward the United States, which was imagined as a new world of untold bounty and open spaces where one could find freedom and land in abundance. As South Bend German-American Otto Knoblock put it: people like his family had been "leaving old world oppression to seek new homes in the wilds of free America."[22] By 1830, Fennimore Cooper's *Leatherstocking Tales* had been translated into German, and travelogues such as Gottfried Duden's somewhat embellished account of life on a Missouri farm in the 1820s were widely read. In 1838, Ernst Willkomm published a tract disguised as a novel with the title *Die Europamüden*, "Those Tired of

Europe." Later, Karl May's "westerns," full of "noble savages" and adventures in the wilderness, became hugely popular.

Letters were another major impetus for emigration. An estimated one hundred million letters were sent from the United States to Germany between 1820 and 1914. "Emigrant letters—not agents, not advertisements, not books or periodicals—were the major factor that made people decide in favor of emigration."[23] The letter Johann Wolfgang Schreyer wrote from South Bend to Arzberg in 1846 stressed the equality and independence everyone enjoyed, which were in stark contrast to the oppressive semi-feudal social system under which his readers suffered in Germany. "All men are equal here and no one thinks that he should have greater respect shown him or that he should enjoy some higher title than his neighbor." No one had to cheer public officials as one had to do in Germany, since they all are "sovereign citizens who recognize no superior but God." He concluded that "everyone is filled with enthusiasm, especially a German who hears all this for the first time. It seems impossible to him that there is really a country on earth where the worth of the individual is so recognized, and it is to him a delight to hear people say, 'Thank God, I, too, am an American.'"

In the earlier period from the 1840s to the 1850s, only the better-placed families could consider the journey to America since it was both difficult and costly to leave Germany. There were countless procedures potential immigrants had to undergo before receiving the "*Auswanderungspatent*" or emigration visa, which allowed them to depart. Although these regulations differed from area to area, they were equally oppressive everywhere. One had to apply to the local community for permission to emigrate and make a declaration of abandonment of citizenship. Immigrants were forbidden to return in poverty as many had done at the end of the previous century. All taxes and community payments had to have been met. One had to provide a birth certificate and testimony from the church, together with proof of having sufficient funds for emigration. All this was sent on to the county, which then publicized the intent to leave, giving anyone who was owed money a chance to respond. Men had to have fulfilled their military duties or pay a hefty fee to be excused from them. Only after weeks of waiting would the county office finally issue the emigration visa.

Another major problem was the sale of property. Once the permission to leave the country was granted, one had to depart within six weeks. In Arzberg, for example, so many people were leaving that it was difficult to sell one's house and goods. Thus Johann Melchior Meyer wrote back to Johann Wolfgang Schreyer that "On account of your letter, many desire to leave Arzberg...but it is difficult to sell property because so many are anxious to leave."[24]

The emigrants may have been anxious to leave, but abandoning one's known and loved environment was still a traumatic experience. A farewell letter of Johann Christoph Keissler, who emigrated in 1848 at the age of 27, eloquently expressed the pain and anxiety caused by this separation from all he knew and loved. "I cannot express how hard it is to say goodbye forever to my dear parents and good friends... It is hard to leave my dear fatherland and seek a new home... Farewell, you mountains where we left our childhood dreams; farewell you spaces and valleys in our dear fatherland; farewell you good and dear comrades, do not forget us..."[25] Not surprisingly, the letters the German immigrants sent home expressed their homesickness. They were anxious for news from home and several requested seeds of favorite trees, such as the spruce, and flowers such as the cowslip, which in German bears the more poetic name of "heaven's little key" (*Himmelschlüsselchen*).

The sea journey in itself was an adventure, if not an ordeal. It lasted six to eight weeks,

Certificate of Good Conduct: "Troeger, Susanna, unmarried farmer's daughter, born Nov. 15, 1847, has quite a good reputation, as is attested for the purpose of her emigration to America. Municipal Administration Seussen, May 11, 1869: Dötsch, Lang, Lederer, Fickentscher. (Courtesy Lorraine Soellner.)

longer in bad weather, in crowded conditions and with inadequate provisions. According to family history, 16 year-old Sophia Mainer's journey across the Atlantic lasted nine weeks during which they were lost in a storm and drifted towards Greenland. Their provisions had been scheduled for only a five-week passage. A long letter of 1846 recommended potential seafarers to take with them "dry bread, black (smoked) meat, but not too fat, one

pound of pepper, vinegar [to make the water taste bearable], and a small barrel of wine."[26]

The journey, however, was not over once the immigrants reached land in America. In fact, the most difficult part was just beginning. New York itself was an overwhelming experience for the new arrivals. What struck most at first was the commercialism of the teeming city. German immigrant Isaac Mayer Wise, who was to become the spiritual leader of the Jewish community, said in 1846: "The whole city appeared to me like a large shop where everyone buys or sells, cheats or is cheated. I had never before seen a city so bare of all art and of every trace of good taste; likewise I had never witnessed anywhere such rushing, hurrying, chasing, running.[27]

In the 1850s, New York offered hardly better opportunities for survival than the immigrants had experienced back home. Industrialization and the creation of a class of industrial laborers in the cities made life as difficult in the new world as it had been in the old. The problem was further aggravated by mass immigration, which threatened the new arrivals with permanent unemployment. And even for those lucky ones who did find a job, long hours and low wages allowed for nothing but a minimal existence. Immigrants found themselves huddled together in dark tenements or the basements of houses.[28] Trying to survive in New York in 1850, a German tailor wondered: "We have come to this country because our own country had oppressed us. But what have we gained by the exchange? … We have found here nothing but misery and hunger and oppression."[29] At the height of the immigration of the 1850s, New York, like many cities in the United States, suffered a major economic crisis. *Harper's Weekly* spoke of "universal prostration and panic." Even if families had managed to put away a little money, they lost their small savings in the many bank crashes.

Not only one's livelihood, but one's very life was threatened in the cities through diseases, especially cholera epidemics. This is not only true of New York, but also of Chicago, which suffered a major such epidemic in the 1880s. Even as early as the late 1840s, however, cholera was rampant in Chicago. Shortly after John Keisler's arrival in South Bend in 1848, he and his friend Mayer went to Chicago in search of land. They did see desirable property, but were kept awake at night by the constant rumblings of wagons. When they found out in the morning that these were the cholera victims being carted to their graves, Mayer decided to leave instantly. Although Keisler would like to have pursued the land opportunities, he did not have enough English to complete the business by himself. They returned to South Bend where there was no cholera, but they lost a huge opportunity since the property in question became the center of Chicago where major buildings were soon to be erected. In his letter of 1855 to Christian Sack in Arzberg, Johann Friedrich Elbel also stressed the relative safety of South Bend when he assured Sack that, unlike in the cities there was no cholera in South Bend.[30]

For many reasons South Bend and northern Indiana were good places to settle. The town was poised at the brink of tremendous growth and major industrial development, and the surrounding country still had relatively cheap public land available for immigrants not afraid of the labor involved in carving farms out of the wilderness. The immigrants found that the dangers and personal agonies of the journey were well worth the risk. They wrote home urging their friends and relatives not to put off emigration out of fear, since the rewards, especially in terms of personal freedom and economic opportunities, far outweighed the risks and even the pain of leaving one's home and family.

III.

Early South Bend

*O*n an exceptionally balmy Christmas Day in the year 1873, a group of South Bend's honoraries, including Schuyler Colfax, Caleb Kimball, Edwin Nicar, and German-American John C. Knoblock, stood high on the belfry of the Studebaker factory as guests of John M. Studebaker. Below them, a crowd of onlookers filled the streets. The reason for the excitement was a bet between Leighton Pine and John M. Studebaker. The bet concerned South Bend's most controversial new landmark, a water tower, referred to as the stand pipe, which was located on the north side of Pearl Street, on what is now Lincoln Way East. It was designed to provide sufficient water power for the fire protection of the growing population. The Great Chicago Fire of 1871, followed by an equally ferocious conflagration, which destroyed much of Mishawaka in the following year, had made everyone so afraid that fire protection became the foremost political issue.

In a long battle, Leighton Pine, superintendent at the Singer Sewing Machine factory, had been the spokesman for the stand pipe. The opposition, including John Studebaker, had wanted to create the Holly Water Works Company which would pump water directly from the river into the mains. This controversy was the main issue in the mayoral campaign of 1872. When William Miller won the election, he had the majority of the common council behind him in favor of the stand pipe.

Alexander Staples, a member of the common council and an engineer whose father had helped to build the first Washington Block in 1837, was charged with the erection of the structure. "The stupendous task of raising the stand pipe was undertaken on Friday, Nov. 14, 1873. The tube was elevated 22 feet the first day and it was not until 2:30 on the following Monday that the structure was perpendicular to its base, rising 200 feet in the air." As tribute, people dedicated an adapted version of the Star Spangled Banner to Staples. The long poem included the following lines:

And the lamp-light's bright glare, the dark tube in the air
Gave proof through the night that our pipe was still there.[31]

Once the tower was standing, many still doubted whether the water pressure would be sufficient. This was why Pine bet Studebaker that he could soak the honorable party on the belfry with a one-inch stream from the water hydrant near the works, while at the same time five other one-inch streams would be opened at five other hydrants in the vicinity. The wager was a cow, and Nicar, Kimball, and Knoblock served as judges.

The crowd watched expectantly as the hydrants were turned on and the water gushed forth. The Studebaker party was drenched to their skins, though luckily for them the temperature that Christmas day was 85 degrees. Staples was declared a hero and Leighton Pine donated the cow, decorated with ribbons, to charity. The famous animal was resold several times for the benefit of the poor.[32]

After a formal inspection in October 1874, the stand pipe, towering many feet above the highest building in South Bend, was opened for visitors who could enjoy the magnificent view of the city and the surrounding country from its top. The stand pipe now had become a source of civic pride. "Our citizens can, with pride, point to this tower as a work reflecting credit on the builders, as well as an honor to the city."[33]

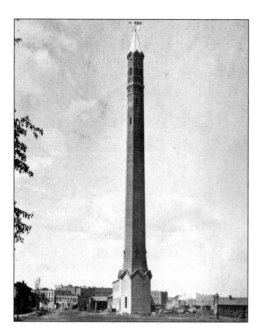

The "standpipe" was erected in 1873 to provide water for the fire protection of South Bend. At first, it was the city's most controversial structure, but it soon turned into a source of civic pride. (Courtesy Northern Indiana Historical Society.)

The early history of South Bend between the 1830s and 1880s is nothing but a long series of "firsts." In 1830-1831, St. Joseph County was first divided into townships, and South Bend, located on the west and south banks of the "Big St. Josef River," was platted by two fur traders, Alexis Coquillard and Lathrop Taylor, on March 28, 1831.

Early on transportation on land and by water was a priority. The first road in Indiana, built by the state government, known as the Michigan Road, was begun in 1830, in Madison, Indiana. Laboriously cut out of the wilderness, it reached South Bend in 1832, and then went northwest, on what is now Lincoln Way West, to Michigan City. The road was 40 feet wide, with an additional 30 feet on either side where the mountains of oak logs from the trees that had to be cleared were stacked. Gradually local homesteaders took the logs to build their houses, barns, and fences, and later the Studebaker Company used them to make their wagons.[34] Many of the leftover logs were burnt, and Arzberg immigrant George Beck used the ash from the burnt logs to make potash, which he exported to Europe. In 1831, the state legislature established the first road from Fort Wayne to South Bend, commonly known as the State Road. The early 1830s also saw the opening of the Territorial Road from Detroit to Chicago, and the Vistula Road from Toledo to Chicago, both of which passed through South Bend.

South Bend's real growth began in the 1850s, which coincided with the first major tide of German immigration. It was fueled by the growth in population and the building of the railroads. At the time of the first official count, recorded in 1831, South Bend had a population of 128 settlers, and they were outnumbered by the Potawatomi Indians. Between September 4 and November 4, 1838, however, the Indians were forcefully relocated to Kansas in a march later known as the Trail of Death. By 1840, the population of South Bend had increased to 728. After that it more than doubled every ten years, reaching 13,392 in 1880. Nevertheless, Northern Indiana was still largely a rural environment. In 1860, the census statistics recorded South Bend with a population of 3,832 and St. Joseph County with 18,455 inhabitants.

The construction of railroads was crucial for South Bend's development. The Michigan Southern and Northern Indiana Railroad Company reached South Bend in 1851. The first

train was greeted by a jubilant crowd and celebrated with a town holiday. In 1852, the line connecting New York to Chicago was finished. From then on, the railroads developed with amazing speed. By 1859, as many as 48 freight trains a day passed through South Bend, and by 1907, South Bend was served by 8 railroads. An interurban began operation in 1882, and eventually connected all the surrounding towns, from Elkhart to Michigan City and La Porte.

The St. Joseph River was a most important factor for the town's development. The first ferry started operation in 1831, at the foot of Water Street (now LaSalle). In 1835, digging began on the race and locks of what became the South Bend Hydraulic Company. After the East Race was completed in 1842, and the West Race in 1844, flour and grist mills, furniture factories, and paper mills sprung up along them. By 1855, South Bend had 3 saw mills, 2 flour mills, 2 cabinet maker manufactures, 1 wagon maker, 2 tanneries, and 1 wool carding factory. The first bridge, leading from Washington Street on the west to Market Street on the east, was erected in 1847. The second was the covered bridge at Water Street. When its roof was blown off by a tornado in 1865, the bridge was rebuilt without it. Later, two plain wooden bridges were constructed on Jefferson and Leeper Streets. By 1849, South Bend even had a telegraph office, located at the corner of Washington and Main Streets. Although the area experienced another depression in 1857, it was neither as severe nor as lasting as the one of the 1830s, and South Bend continued to add more and more municipal facilities. In 1854, an Italianate Court House was built on the site of the original one. The first jail was erected in 1860, and the post office on the southwest corner of Main and Market Streets in 1865.

In 1831, South Bend's first newspaper, called the *Pioneer,* appeared even before there was a paper in Chicago. After its demise, the *Register* started publication in 1836. In 1845, it was bought out by Schuyler Colfax and became the *St. Joseph Valley Register.* The *South*

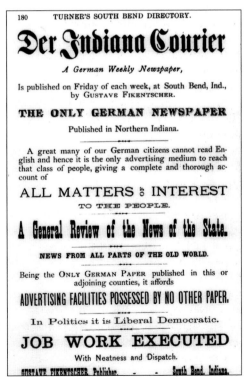

This was an advertisement for Der Indiana Courier in Turner's South Bend City directories of the 1870s. (Courtesy Northern Indiana Historical Society.)

Bend Weekly Tribune began in 1872, and ceased publication in 1909. The *Daily Tribune* first appeared in 1873. The *Times*, started in 1853, was the first Democratic paper in St. Joseph County. It was renamed the *South Bend Times* in 1881.

The only German language newspaper of the area, *Der Indiana Courier*, began in October 1873. The famous German newspaperman John B. Stoll edited the paper at first. In October 1878, Gustave Fickentscher bought the paper and renamed it *Der South Bend Courier*. Later Andrew Troeger, also from Arzberg, joined Fickentscher as editor. The *South Bend Courier* carried national and international news. It had a large section on news from the German states. As is typical of German newspapers even today, it also featured a "feuilleton" section in each issue, containing essays on culture and society as well as a serial story. The paper appeared every Friday until September 1901.

In 1865, when South Bend was incorporated, the streets in the city area were first graded. Over the years, streets and sidewalks were improved, but until the 1880s traffic on both streets and sidewalks was arduous. In the 1860s and 1870s, the streets of the inner city were a mixture of dirt, gravel, and cobblestones. It was not until 1888 that the much smoother cedar blocking was laid on the main streets, starting, as always, with the center of town at Michigan and Washington Streets. The first brick pavement, only two blocks long, appeared in 1889, but as late as 1898 Washington Street was paved in brick only to Michigan Street. Until 1868, the business district was lit by only four coal oil lamps at Main and Washington Streets, shedding the dimmest light. In the 1870s, the brighter-burning gas light helped to light up the city at night.

Sidewalks were particularly treacherous, especially at night or in wet weather. Pedestrians had to cope with sudden gaps and holes in the walk, and negotiate wooden planks and mud. For example, the *South Bend Daily Tribune* reported on June 6, 1879, that "There is an apparent unfriendliness, a want of unanimity, as it were, existing between the sidewalks and crosswalks of the city. Upon some of our principal streets, these walks appear to be at outs and not on good terms with one another and do not meet upon a common level. There is a chasm between them, which in the rainy season has been both broad and deep with mud and mire, so that a pedestrian has to go-as-he-pleases, either take a running jump and chance landing on the other side of the gulf, or wade through it."[35]

South Bend's first major industries were makers of farm implements, which were followed by, or developed into wagon works. With the introduction of steam power factories could move away from the river, as did the Studebaker Manufacturing Company. Begun in 1852 on the southwest corner of Michigan and Jefferson Streets, with a capital of $68, it was producing twenty thousand wagons a year by 1879. The Oliver Chilled Plow Company began in 1855, the Birdsell Manufacturing Company in 1864, and the Singer Manufacturing Company in 1868. The actual sewing machines were made in the east, but the wooden cabinets were produced in South Bend with its rich supply of hardwood.

The 1870s saw another depression, more severe than the one of the 1850s, and sometimes called the "Long Depression." The "panic" of 1873, during which banks closed and people lost their money, put an extra burden also on the immigrants. It made even the wealthy German brewery owner Adolphus Kamm hide enough money in a secret room, accessible only through the floor boards of his basement dining room, to pay his employees for at least two pay periods. The hidden treasure was removed only in the 1930s, at which time the large and by then moldy bills were divided among the family.

The earliest big building, erected in 1837, was the three-story frame Washington Block, which stood at the north side of Washington Street. After a fire in 1865, a three-story business building took its place. It was called the St. Joseph Block, and housed the St. Joseph Hotel as

well as the Good's Opera House. In 1878 it, too, fell victim to fire, and in 1879 the first Oliver Hotel was built on the same site for the then enormous sum of $600,000, which in today's money would be about ten million dollars.[36] It was connected, under one roof, to the restored Good's Opera House. Opposite the St. Joseph Building, on the southwest corner of Washington and Main Streets, stood the courthouse and the jail. Across from them was another large structure, the Odd Fellow's Building.

Because of this concentration of important buildings, the block on Washington between Michigan and Main Streets was a choice business location, and there were a large number of German establishments mixed in with those of the native-born. One of the prominent native-owned businesses was Josiah Thompson's general store in the Odd Fellow's Building, where one could buy anything from ammunition and cutlery to bellows and blinds. Thompson's clearly catered to the two main constituencies of the growing South Bend, pioneer farmers and townsfolk. Across the street, another native-born business was Daniel Holland's cigar and tobacco store, located in the St. Joseph Building. Others on this block were Lotan Hitchcock's grocery; Milton Stokes' clothier and tailor shop; John Treanor, druggist; Wheeler and Orivs, hats, caps, and furs; J.B. Lott's barbershop; and the law firm of Almond and Bugbee. The Reed and Conley drugstore ended the block on the southeast corner of Washington and Michigan Streets.

German-owned businesses were just as prominent in this central location. In the two blocks of Washington Street going west from the river, first to Michigan and then to Main Street, almost every building contained a German-owned business, five of which were saloons or a combination of saloon and billiard hall. Starting from the St. Joseph Building on Washington and Main Streets and going east toward the river, there also was the Muessel Brothers grocery and Myer Friedberger's dry goods store. Continuing east along Washington Street was a series of German-owned businesses one next to another, Adam Klingel's boots and shoe store, Carl Lederer's carpentry shop, George Rockstroh's butcher shop, the well-known Knoblock grocery and bakery at 62 Washington Street, Edwin Frederickson's billiard hall, the Jacob Wagner restaurant and saloon—which in 1871 was one of the first to offer fresh oysters—the Benz and Wagner wine and liquor store, Isaac Kahn's hats and fur store, John Lederer's butcher shop, and Siegfried Lenz's boots and shoe store. The next block between Michigan Street and the river was less densely populated with businesses, but there, too, were a number of Germans, such as Andrew Russwurm's harness shop and the Elbel Brothers' shoe store.

On Michigan Street, between Washington and Market, there was a similar mixture of native-owned and German businesses, along with some residences. On the northeast corner was the native-owned Nicar and Deming hardware business, not far from the German Neuperth and Benz hardware store. Across the street was Meyer and Poehlman's tinshop. Moses Livingston's clothing store could be found at 98 Michigan Street, not far from Lantz Brothers clothiers at 105 Michigan. Livingston also lived on Michigan Street. The Liphart furniture manufacture was on Michigan between Washington and Jefferson Streets.

On the west side of the next block north on Michigan Street, between Jefferson and Market Streets, were the native-owned Glassman's butcher shop, the German boarding house called Union House, George Knoblock's saloon and, at the corner of Market Street, the First National Bank. On the east side of the street were German-owned Philip Klingel's saloon and shoe store, the native-born Darwin Baker's shoe store, and Alexis Coquillard's livery stable. Continuing further north on Michigan, approaching Marion Street, one entered "Little Arzberg," with the Kunstman boarding house at 125 Michigan Street, and Lorenz Elbel's residence at 127 Michigan. In that area were also several more German saloons, such as the two owned by George Hagen and George Goeschel.

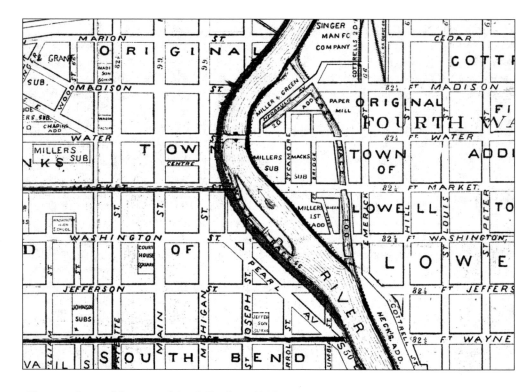

Close-up of map of the center of South Bend, c. 1875.

Pearl Street, which ran from the lower part of Washington Street, across St. Joseph and Jefferson Streets to the river, was another area of mixed businesses and residences where many Germans were located. The Sack family lived there near the corner of Jefferson, and Christopher Muessel also lived on Pearl Street and had his first brewery there. Meyer Livingston also resided on Pearl between Jefferson and Wayne Streets.

The most densely populated residential area for the early German immigrants were Marion and Lafayette Streets. Market Street was also largely residential. Judge Thomas Stanfield lived on Market as did Germans William C. Lantz and Henry Ginz. Schuyler Colfax's home was at 83 Market. The large mansions further west on Market Street were built in the 1880s, and the wealthiest Germans, such as John C. Knoblock, also could be found there, living among the native-born elite.

In order to feel more at home, the Germans put their mark on the city by creating a number of social organizations for themselves, whose business was conducted in German. The *Turnverein* was founded in 1861, and the Masonic *Germania* Lodge No. 301 in 1865. The Odd Fellows Robert Blum Lodge No. 278 began in 1867, and the South Bend *Maennerchor* in 1875. In the 1860s, the Germans also had a baseball team, called the Head Cheeses, and a volunteer fire company, Hose Company No. 1, which sponsored dances and parades.

The minutes of the *Maennerchor* show the establishment and activities of a German club. On July 9, 1875, a group of 18 men met at the restaurant of the German Union House in order to start a men's singing club. Within two weeks of this initial meeting, their numbers had grown to 37 founding members, and they chose the roll of singers and the conductor, Christian Elbel, who received $150 a year for his services. The *Maennerchor*, first located

above Philip Klinger's shoe store, moved to its present location on the corner of Water and Sycamore Streets in 1879. It soon established a sequence of performances and events which it maintained through the years. The entertainment committee was particularly busy, organizing balls, picnics, dances, and parties. One of the highlights of the year was a masked ball in February. Christmas and New Year's saw a number of special celebrations, many of which included women and children. In the summer, garden parties and concerts were popular, often held in Singer Westphal's adjacent beer garden, where afterwards everyone would be treated to sausage and beer. Since card playing was an important diversion for the Germans, the *Maennerchor* organized *Schafskopf* card parties with prizes for the winners. Since there was no network of social services at that time, one committee was dedicated to provide financial support for their sick members, and to disburse funds to them by the week.[37]

The immigrants also established German churches, often with parochial schools attached. The German Evangelical Church was founded in 1855. Later renamed St. Peter's Church, it included a parochial school with instruction in German. Its first pastor was the Rev. Philip Wagner, a pioneer missionary of the German Evangelical Synod, who had held services in the area before.

In 1877, seven families left the church and a year later established the German M.E. Church, also with a parochial school, on the southeast corner of Jefferson and General Taylor Streets. The first pastor was the Rev. Henry Siek, followed by the Rev. Paul Heid. The Rev. Johann Traugott Thieme was pastor there from 1889 to his death in 1912. After another split, which ended with the dismissal of Reverend Wagner, a part of this congregation established Zion Church in 1888, which maintained its German hymnal until the 1920s. In 1927-1928 a new St. Peter's church was built on the northwest corner of William and La Salle Streets. The building still stands and today houses the Emanuel Church of Deliverance congregation. The first German Catholic church and school were not built until 1884.

Just as they were pioneers in coming to South Bend and establishing themselves in the city, the Germans also pioneered inventions, and were fascinated with trying new ideas. John C. Knoblock, for example, was famous for his many innovations. "In 1865, he started the first delivery wagon in this city and employed the first cash girl in South Bend. He had the first gas pipes in his residence…. He was the pioneer in building his store without shutters and the first to excavate under the sidewalk and utilize this valuable space. He put down the first drive well in South Bend, and laid the first stone gutter in front of his store."[38] The brewer Christopher Muessel had a patent for a bottle decanting and cleaning device that later was used all over the U.S. His daughter, Anna Katharina Muessel, owned two patents for a device that made it easier to do the laundry.

Martin V. Beiger, son of German immigrants to Mishawaka, invented the All-Knit Boot, which later developed into a tennis shoe with a black band around the top and a red ball at the back. It became a nationally known trademark and the tennis shoe every youngster needed to have. In a local saying, Beiger had created "the boot that made Mishawaka famous." In 1889, the Ball Band company, later called Uniroyal, had sales of $65,000 and in the 1930s it employed 5,000 workers and sales amounted to $20,000,000. Beiger's partner Adolphus Eberhart, also a German immigrant, held the patent for the machine that produced the boot.

Adolphus Kamm from Württemberg constructed a dam that led from his personal property to the Kamm and Schellinger Brewery, allowing him to harness the power of the St. Joseph River. In 1914, Kamm bought the Mishawaka car company American Simplex, later Amplex, which was started in 1904. Its philosophy—before Ford—was to make a good and cheap car that everyone could afford. Two of its cars raced in the first Indianapolis 500; one crashed and its driver became the first Indianapolis fatality and the other finished eighth.

31

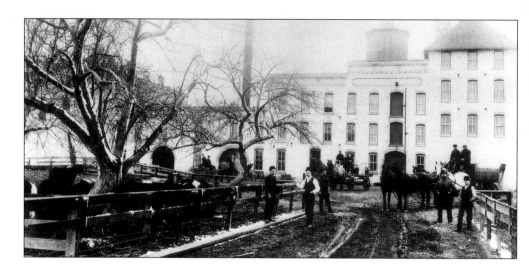

In 1882, the Kamm and Schellinger Brewery not only kept the beautiful draught horses but also cows, as can be seen to the left of the picture. (Courtesy Beth Kamm Reising.)

Despite the depressions that hit with regularity every 20 years—in the 1830s, 1850s, and the 1870s—South Bend was a thriving community. Its period of most vigorous growth began with the end of the Civil War. Before that, South Bend, not yet incorporated, was little more than a village. Otto Knoblock, the son John C. Knoblock, fondly remembered how as children in the 1860s, they used to play in the village streets. South Bend had only one police officer, Constable Bill Crews, and a bucket brigade for fire protection. Farmers would bring their produce to town in ox carts, and stagecoaches connected South Bend to other villages like Plymouth and St. Joseph.[39] And even as late as the 1880s, Adelaide, the granddaughter of early immigrant Johann Wolfgang Schreyer, remembered the wilderness encroaching quite near to where they lived. Between her home at 611 Navarre Street and the river rose what at least seemed to her large sand dunes. She was forbidden to play there because gypsies were said to camp in that wild and isolated spot. But, of course, these warnings made the place even more attractive to the adventurous child, and Adelaide would sneak out to watch the gypsies and when she was lucky would be able to spy on a medicine show.

Looking back from the perspective of 1907, Caleb A. Kimball, who first owned a lumber mill and later became president of the First National Bank, reflected on the growth of the city since 1850. "Where now there is the most densely populated portion of the city, there was nothing but a cleared space which was used for the storage of logs. It was a long hill, at the foot of which stood two sawmills. The logs would be rolled down the hill into the race and up the race into the various mills that lined the bank." The foot of Washington Street where the lock and gate for the boats were located was a very busy place since all water traffic had to pass through there. Along the city side of the west race, where the South Bend Century Center now stands, were two tanneries, Bugbee's, and Elliott Tutt's. The east side of the river was nothing but dense forest and a few log cabins. "Where now wide streets, handsome homes and parks are common, there was nothing but darkness of dense forest and the clinking of log chains." It inspired Kimball with awe to see how, by 1907, the trading village of 1850 had become the metropolis of northern Indiana, and that he had a part in it all. Kimball concluded that "the growth of the city is a wonderful thing."[40]

IV.

How They Fared

REPRESENTATIVE STORIES

A *ndreas Soellner came to South Bend in 1869. Just as he had planned in the anxious days before his departure from Arzberg, he sent for his fiancée Susannah Troeger to join him as soon as he had saved enough money, and they got married in South Bend. The Soellners lived at 412 South Francis Street in the small Arzberg enclave called the "Hoyt," named after a farm area outside Arzberg. Soellner became a typical solid working class resident of South Bend. He was employed as a cabinet maker for the Singer Sewing Machine Company, a few minutes' walk from his home. It was located on Emrick Street, just across the river from downtown.*

For more than 50 years, Soellner worked long exhausting hours to produce the wooden cabinets for the sewing machines, work that made his shoulders and arms grow big and strong. In conversation he liked to gesture rather vehemently, often nearly slapping those who stood next to him. His English had a heavy German accent, and with friends he fell back into German. Soellner was the model of a "strong headed German," who did not speak much or reach conclusions quickly; but when he made a decision, he stuck to it and others believed him. Soellner always wore steel rimmed glasses perched low on his nose, which made it appear as if he looked critically at the world. His piercing blue eyes seemed to penetrate into one's innermost thoughts.

On weekdays, he wore gray tweed pants, a spotless white shirt without the stiff collars he hated, suspenders, and a wide-brimmed felt hat. Soellner's soft felt hat marked him as a German, for the American fashion at that time was for men to wear high and stiff top hats. Another indication of his German origin was his thick beard. A short, fat, black cigar was stuck in the corner of his mouth, but it remained unlit since Susannah disapproved of smoking. On Sundays he wore an expensive black woolen suit with a waistcoat and high-buttoned shoes. A gold watch was one of his most prized possessions; it was fastened to the seventh hole of his waistcoat and had an iron cross—probably an heirloom from the Napoleonic Wars—attached to it. He was a religious man and loved his small black German bible, which he proudly carried to church every Sunday.[41]

Andreas and Susannah both died in 1927, within months of each other.

German immigrants on the whole did very well in the rapidly growing city. Success, however, did not come to them instantaneously. It was a gradual progress toward economic security, built on years of thrift, hard work, and endurance. The majority first worked in their trades or began as store clerks or factory workers. Upon arrival, they moved in with relatives whenever possible, or boarded in one of the German-owned boarding houses—Union House, South Bend House, or the Kunstman House. Some also lived with their employers. Over a span of 10 to 20 years, they were finally able to purchase their own homes or even businesses of their own. Only those few who already came over with considerable money could set themselves up in their own enterprises right away.

If they found that the streets were not paved with gold in South Bend, neither did most of them step out of the class into which they were born. Whether they ventured into businesses

Left: *Andreas Soellner is pictured as an older "Hoyt" resident on the east side of South Bend. (Courtesy Lorraine Soellner.)*
Right: *Andreas' wife was Susannah Troeger Soellner. (Courtesy Lorraine Soellner.)*

of their own, which gave them the opportunity for much larger success and influence, depended as much on their original class background, family backing, and education, as on their entrepreneurial skills or love of risk. They often started out not by themselves but in partnerships with other Germans, most often relatives. Or the immigrants helped each other to get started, not only within families but as friends. Philip Klingel, for example, repeatedly loaned money to August Beyer to buy land for his truck farm, and many Germans purchased land or businesses from each other. Those who ended up being most successful were eventually engaged in affiliations with the native-born elite.

Not surprisingly, the available records and stories, or lack thereof, are themselves a reflection of the immigrants' class standing. Those who became most prominent through their businesses, their families, and their civic activities were much written about in the press, or even did some writing themselves. Thus their lives were more clearly defined and visible than those of the working and lower classes. There is far less information on working-class men like Andreas Soellner since they did not engage in business transactions, apart from buying their own homes, and rarely appeared in the social register of the papers. And there is even less known of those who did not succeed at all or moved frequently from place to place. They briefly slip in and out of city directories or the census and then are not heard from anymore.

Until 1870, there were no residential divisions based on class or ethnic origin. But after 1870, the factors of urbanization, industrialization, and immigration made South Bend a community divided into separate areas according to class and ethnic background.[42] Describing the social structure of South Bend before 1870, Chauncey N. Fassett said, "The

leaders of society were then the people who had grown up with the city from small beginnings. They had acquired social leadership so gradually that differences were almost imperceptible and distinctions were not made. Invitations to social functions were quite general. The community was smaller, the individuals were brought into more frequent contact and mutual interest, socially considered, was more prevalent."[43]

After 1870, the majority of new German immigrants was working class. Although most of them did make successful lives for themselves in South Bend, in general they did not move up to the local elite. They tended to become workers in the four major industries of that time—Studebaker, Birdsell, Singer, and Oliver. These new arrivals often settled on the east side of South Bend, much of which originally was the town of Lowell; because of its tremendous growth it was incorporated into South Bend in 1866.

The east side equivalent to Little Arzberg, although much smaller, was the "Hoyt." It was located near the river on South Francis, St. Peter's, and Parry Streets. The German immigrants from Arzberg named it the "Haid," which in Bavarian is pronounced to sound like "Hoyt." Haid means heath and also refers to a place in the hills of Arzberg, made up of a scattered group of farms and lots of empty space. Since their new home in South Bend was at the edge of town, with nothing but trees beyond, the "Hoyt" was a suitable description that stuck and is still used by old timers today.

However, the Germans were not ethnically segregated, but distributed rather evenly across the 1st, 2nd, and 4th wards. Within their group, they maintained the class divisions they had brought with them, although these were somewhat softened by the common experience of living in a foreign country and sharing a common culture and a common language. The Germans interacted across class lines in their many social clubs, while yet also maintaining class distinctions in their business and family associations. By and large, they replicated the social standing that they had held in Germany when they came to the new world. Those who became major entrepreneurs usually had the benefit of at least a middle class background. For example, the Schellingers, who had been successful millers in Baden Württemberg, living in a mill that rightfully was called the "Schlössle" or "little castle," in South Bend became part owners of the Kamm and Schellinger Brewery, one of the major companies in Northern Indiana. Conrad Liphart, who owned a large furniture manufacturing company in South Bend, was born on a farm in Hessia that had been in the family for 300 years. Adolphus Eberhart, who became a partner in the Mishawaka Woolen Company, later Uniroyal, can trace his lineage back to Johann Adam Eberhart, Duke of Alsace.

The trajectory of Johann Friedrich Weiss was fairly typical of a first generation immigrant of the tradesmen class. He came to South Bend as a young man and eventually established his own business. Weiss was born in the tiny mill valley of Flittermühle near Arzberg on December 31, 1835. His father was a miller who had fallen on hard times, and his mother had died in 1851. In 1855, father and son left their home to come to the United States. They must have chosen South Bend because so many others from their area already had settled there.

In 1869, Weiss worked as a clerk in the grocery store and bakery of another German immigrant, Henry Ginz, and also boarded with him in Little Arzberg. In Ginz's grocery Weiss could both speak German and learn the trade. In 1871, he was himself a grocer, but still boarded with Ginz. In 1873, he moved into his own place. It was only in 1875, when Weiss was 40 years old, that he owned his own establishment, a combination grocery store and saloon. It was located on East Water Street, between Emerick and Bridge Streets, in an area on the east side of the St. Joseph River, where fellow German immigrants Franz Vahlert and Robert Westphal also owned saloons. Weiss lived on the premises until 1879.

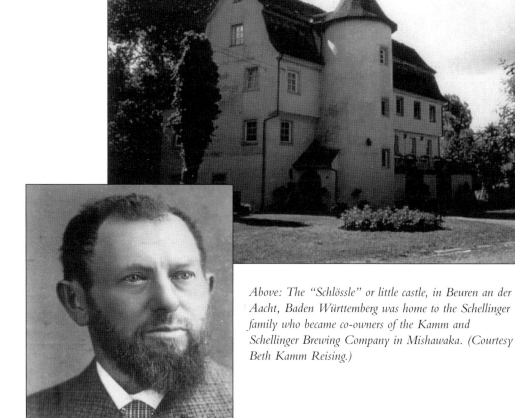

Above: The "Schlössle" or little castle, in Beuren an der Aacht, Baden Württemberg was home to the Schellinger family who became co-owners of the Kamm and Schellinger Brewing Company in Mishawaka. (Courtesy Beth Kamm Reising.)

Left: Johann Friedrich Weiss came to South Bend in 1855 and owned his own grocery store and saloon on the east side by 1875. (Courtesy Erwin Scherer.)

Once he had set himself up in a business of his own, he could get married. His wife Elisabetha Schaefer was the daughter of German immigrants, now living in Ohio. His first daughter Katharina was born on December 8, 1877. In 1880, the Weiss family finally was able to move out of the building where their store was located and into a house of their own. It was near their business, on the corner of East Washington and St. Louis Streets.

As with many of the German immigrants, Weiss' progress was steady though slow. It took him 20 years to establish his own business and 26 to have his own home. After he owned his saloon, he became involved in the civic life of South Bend, and from 1889 to 1891 served as a member of the Common Council for the 4th ward. He also donated the land on which the German Zion church was built. Weiss died on December 5, 1893, and two of his daughters eventually married two Weiss brothers back in Arzberg and returned to live in the birthplace of their father. The older daughter, Katharina, got married in Zion Church in South Bend in 1899, and to make her feel at home in Arzberg, her husband Friedrich built her a house modeled on the one she most admired in South Bend. In 1905, Louisa,

the younger sister, married Friedrich's brother in Arzberg. He owned the public house "zum Weissen Ross." Their mother eventually completed the return immigration of the Weiss family when she joined her daughters in Arzberg.

The success of men such as Weiss had a cumulative impact on South Bend's economy. By 1869, the Germans were among the largest property holders. While the majority of houses built in South Bend in 1869 ranged in value between $500 and $1,500, in the following year the median value of real estate owned by German immigrants was $2,213.[44]

The tax records also show the financial success of the Germans. The total value of taxables for German immigrants in 1871 ranged between $300 and $16,231. The John C. Knoblock Company claimed the latter, which was among the highest values that year altogether. Native-born major business men such as Horatio Chapin and Elliott Tutt were listed at $10,900 and $13,430 respectively. The German-owned hardware store and tin shop of Meyer and Poehlman had $5,600, German businessman John Lederer $4,430, financier Theodore Seixas $5,045, and furniture manufacturer Conrad Liphart $9,875. Most people who did not own a business were clustered in the $300 to $1,000 range.

In contrast to these successful businessmen, much less is known about the working class German immigrants who did not become businessmen on their own. John Kuespert came to America at age 20 in 1871, and for 64 years was employed as a tinsmith and sheet metal worker at the German-owned G.E. Meyer & Son's hardware store. He lived as a boarder for ten years, changing residences frequently but apparently always staying with other Germans. From 1875 to 1878, for example, he boarded at 85 Main Street with the Rockstrohs, who like Kuespert were from Arzberg, and in 1880, while still a boarder, he lived at 7 William Street in Little Arzberg. It was not until 1881 that he moved into his own home at 318 North Cushing Street. The same year, he married Emma S. Heinzman, whose parents also had emigrated to South Bend from the Arzberg region. Raising five children, they stayed at 318 North Cushing until 1900, when they moved to 812 Grand Avenue.

In 1935, when Kuespert was 84 years old, an article appeared about him saying that in 64 years as a tinsmith he had missed only one day because of illness, and one week during the panic of 1873.[45]

The most dramatic success stories go beyond the gradual accumulation of money and property, and these people were able to ally themselves closely with the financial powers of South Bend. They tended to start out at a higher class, with more money and a better education. But their stories also show the enterprise, flexibility, and stamina necessary to succeed in business ventures and adventures during this pioneer period. Johann Nicol Lederer was an example of this. He became a major entrepreneur in South Bend, forming business alliances with other Germans as well as with the native-born elite. On the occasion of Lederer's 76th birthday the paper featured his success and called him "one of the prominent men in the commercial life of the community."[46]

Lederer was born in Arzberg on November 16, 1833, the son of blacksmith and wagon maker Frederick and Barbara Kunstman Lederer. His mother's father was Johann Nicol Kunstman, who came to South Bend at the same time as John. Lederer was educated away from home, first at the Latin school in Wunsiedel and then at the gymnasium in Hof. He came to South Bend at age 19, on June 18, 1853, and found work at a flour and gristmill for $8 a month. In 1854, he changed to work on the Air Line Railroad from Toledo to Elkhart, but after only two weeks the contractor ran away, leaving Lederer without pay. He then found work in the gravel pit at Hudson Lake. After four months of hard labor he left the pit to return to South Bend, where he landed a much better job as clerk in the John C. Knoblock grocery store.

He must have had some money of his own or had the help of his mother's family, for already in 1859, he opened his own market on Washington Street, selling meats and packing pork. On June 27, 1860, he married Antoinette Bauer. They had two children, Anna and Hugo; Hugo, however, died of diphtheria in 1864. The grocery business was profitable for it allowed Lederer to become involved in land speculation on a grand scale. In 1868, in partnership with A.T. Cocquillard and W.H. Longley, he purchased large tracts of land in Boone County, Nebraska, and platted the village of St. Edwards. In 1876, the group formed the St. Edwards Land and Emigration stock company.

In 1870, the Board of County Commissioners had appointed Lederer Commissioner for South Bend with an office at 86 Michigan. His wife Antoinette died in 1871. At this point, to recover no doubt from the personal trauma of losing both his son and his wife, Lederer left for a visit to Arzberg and a tour of Europe.

Upon his return in 1872, he went into partnership with his former employer John C. Knoblock in the Knoblock and Lederer grocery store at 62 Washington Street. Five years later, he sold out his interest in the store and set up as an agent for real estate, insurance, and steamship lines. In 1879, in partnership with German and American businessmen, namely Cocquillard, Daughtery, Howard, Lomont, Longley, Russwurm, and Poehlman, he entered into a contract with the Northwestern Railroad Company for the purchase of 25,000 acres in Oconto County, Wisconsin. By the 1880s, John Lederer owned two business buildings on Washington Street and a large residence at 316 North Lafayette Street. In 1880, he married again. His second wife was Margarethe Kunstman, daughter of Christopher Kunstman, another Arzberger who had become wealthy in South Bend. John and Margarethe had four children, Herbert, Adam, Irina, and Agnes; Agnes died young. In 1892, Lederer won election as County Commissioner in the 2nd district. He was a life-long Democrat. John Lederer died on May 14, 1914.

John Lederer's case was not unusual. Many immigrants moved from one business to another and from one association or stock company to another, usually increasing their wealth with each change. Typically, the earlier the immigrants came, the greater was their chance and rate of success. Esslinger notes that "Fifty per cent of the 1850 group and thirty-eight per cent of the 1860 group had improved their occupational and financial standing after ten years."[47] Esslinger's study provides thorough statistical information on the mobility of all ethnic groups in South Bend between 1850 and 1880. However, when one follows the German immigrants back to their origins, it becomes clear that, more often than not, they replicated their relative social status from the old world to the new, even as they increased their wealth thanks to the favorable conditions in these founding years.

John B. Stoll was another of these highly successful and energetic German immigrants. He was known well beyond the borders of South Bend, becoming the Honorable John B. Stoll for his services to journalism and politics. His story comes closest to fitting the rags to fame myth, and yet even here class standing and background no doubt helped him to advance. Although Stoll arrived in America desperately poor, he came from a wealthy landowning family. He was born in Württemberg on March 13, 1843. His father, a large landowner, died before he was born and his mother lost most of their considerable property in her second marriage.

In 1853, now quite poor, mother and son emigrated to Harrisburg, Pennsylvania, where his mother died two years later when John was only twelve. Although he spoke only German, he managed to support himself by working as pin boy in a bowling alley and peddler of peppermints, pins and needles. Then one hot summer's day he was asked to deliver a message to the country house of General Simon Cameron. While he waited in the pleasantly cool hall of the mansion, standing barefoot and in awe of its grandeur, Mrs.

John N. Lederer was a businessman and owner of the "Blue Front" and "Union Block" in downtown South Bend. Lederer also was elected as Democratic County Commissioner for the 2nd district. (From Goldenes Jubiläum des South Bend Turnvereins, *1911.)*

Cameron came up to talk to him. She told him that every boy should learn a trade and suggested the printer's trade to young Stoll. Her kindness and earnestness impressed him and he resolved to follow her advice. For the rest of his life, Stoll was grateful to Mrs. Cameron, who continued to support him. When she died many years later, he wrote a eulogy that became a family treasure.

With his savings and the support of Mrs. Cameron, Stoll bought his first paper, the *Independent Observer* of Johnstown, when he was not yet 18. However, increasing costs during the Civil War forced him to close, and Stoll, disappointed but not defeated, returned to his printer's job in Snyder County. There he married Mary F. Snyder, a descendant of an early governor of Pennsylvania.

Always an avid reader, he developed a great ability as public speaker, which was to become invaluable in his career as a Democratic political activist. Stoll organized a "Buck and Breck" campaign for the candidacy of Buchanan and Breckenridge, and in 1860, was chosen as the Democratic delegate of Cambria County, Pennsylvania, to the Douglas State Convention where he reportedly delivered a masterful speech.

In 1865, his wife's parents moved to Noble County, Indiana, and asked the young couple to follow them. Since there was no Democratic paper in the county, John Stoll, together with Thomas J. Smith, an attorney friend from Pennsylvania, established the *Ligonier Banner,* whose first issue appeared in May 1866. It was a time of bitter political fights between Democrats and Republicans, and soon Stoll's partner became discouraged and returned home. Stoll continued the struggle alone. But he needed money to support himself. Since President Johnson had once promised his support, Stoll turned to him for help. As a result, he was appointed assistant revenue assessor. The position gave him the steady salary that allowed him to continue his work.

Stoll started the Press Association of Northern Indiana in 1881 and served as its president for six years. On March 2, 1882, he founded the Times Printing Company in South Bend, which took over daily publication of the *South Bend Times* in 1883. As in any

The Hon. John B. Stoll, renowned newspaperman and politician. (From Timothy Howard's History of St. Joseph County, Indiana, *1907.)*

of his previous papers, the *Times* reflected the personality of its publisher, and his editorials became well known throughout the Midwest.

As one of South Bend's most prominent citizens, Stoll served eight years as president of the school board. He gave speeches in every county of Indiana, was editor of the Laporte *Argus*, and contributed to the German *Indiana Courier* of South Bend, and the Elkhart *Daily and Weekly Democrat*, which eventually became the *Elkhart Truth*. He also wrote several books, including a history of Indiana democracy and a history of St. Joseph County.

In South Bend the Stolls moved frequently, in 1885 living at 229 South William, at 131 South Taylor in 1891, and at 319 West Wayne in 1892, their final and major residence. When Stoll retired in 1911, the *South Bend Times* passed to the control of the News Times Printing Company. At the end of his life the fervent Democrat wrote a regular Sunday column in the Republican *South Bend Tribune*, entitled "Observed and Noted." Despite their different views, he had become a close friend of the publisher, who allowed him free expression of his opinions and even an unheard of second proof for his editorials. John Stoll died on April 2, 1926, at the age of 83, still doing public service. Against medical advice, he had traveled to Michigan City where he served on the prison board. Only three of his eight children survived him.

The obituaries in papers across the state mentioned Stoll's many achievements, but one also stressed his German origins; "Mr. Stoll exemplified also the success in the world which can be attained by those born in a foreign land. Although he was a native of Germany he was so much an American that many, reading his obituary, will be surprised by the information that he was not born in the United States."[48]

Class background and age at immigration were important predictors of success. As shown by Stoll, however, the immigrants also needed to be resilient in the face of defeats, and adapt themselves creatively to changing circumstances. Perhaps few showed these strengths to the same degree as did August F. Beyer. Born in Pomerania on November 1, 1842, he became recognized as one of the greatest fresco painters of Berlin. He even worked in the palace of Emperor Wilhelm, where it is said he played with Prince Wilhelm. When he came to America in 1870, with his wife Louisa Hagedorn and their son Paul, he

continued his career, decorating churches, courthouses, and other public buildings first in Chicago, then in La Porte, Indiana. In both locations, fire destroyed his paints and his home, but he never gave up. In 1875, he moved to South Bend where he frescoed the Masonic Hall, the courthouse, and several churches, including St. Mary's and Notre Dame.

However, the paint fumes destroyed his health as surely as the fires had destroyed his work, and he had to relinquish the vocation at which he excelled. So he bought land and started to grow vegetables. Inexperienced at first, he bought land that was unfit for gardening. In the effort of making it pay after all, he lost his money and his health. At this low point, a German friend helped Beyer to purchase one acre of good land. With the profits he then managed to pay $500 as down payment on a 10-acre tract near Sample Street Bridge. It was owned by a German immigrant, and another German, Philip Klingel, loaned him the remaining $2,000. As soon as Beyer had paid off this debt, Klingel offered him more money so that he could purchase the adjoining 10 acres. Eventually, through persistence, hard work, and Klingel's help, he accumulated about 40 acres. He won a great number of prizes for his excellent produce. One year, he garnered 17 out of 26 awards from the Indianapolis State Fair Association. For 17 years, Beyer continued successful in this work. He never rested on his achievements, but always tried something new. Next he started a flower shop with a greenhouse and rose garden. South Bend was not ready for this and the business failed. At this point his doctors seriously advised him to leave the area to recuperate his health. Beyer went to Seattle and after only a two months stay he was made president of the Washington Produce and Fruit Growers Union. Although he clearly did not rest in the way the doctors had hoped, his health improved and he returned to South Bend. With renewed energy, he started raising flowers again, and ended up building one of the most successful and up-to-date flower shops in the state of Indiana. His oldest son Paul continued the florist business with a store in the center of South Bend at Michigan and Washington Streets. August Beyer was a member of the German Lutheran Church and the *Turnverein*, where he was president. Beyer Street near the Farmer's Market in South Bend was probably named after this creative and resourceful German immigrant.

Needless to say, they were not all success stories. The obituaries record suicides as well as pioneer triumphs. If difficulties in business, personal relations, or health were added to the tremendous pressures of immigration and adjustment, some immigrants broke down and saw no other way out than committing suicide. This was the fate of George A. Goeschel, who in 1876 drowned himself in the St. Joseph River. A witness saw Goeschel jump into the water and wade in up to his waist when he stopped. "He held up his hands as though praying." Then he went in further and was swept away.[49]

Goeschel was born in Bavaria in 1824, and came to South Bend when he was 30 years old. He owned a profitable saloon at 86 Michigan Street. In 1861, he married Margaretha Miller, a daughter of Katharina Klughart Zeitler. Margaretha had been married before and brought a daughter and a son into the marriage. Goeschel's stepson occasionally helped out in the saloon, but the two could not get along. The general financial crisis of the 1870s added to Goeschel's personal pressures. On top of all this, he suffered from consumption. Money, however, cannot have been the main reason for his suicide. Although during the depression of the 1870s his total value of taxables had gone down from $7,985 in 1871, to $5,490 in 1876, he still had considerable assets for that time. Goeschel's saloon was bought by John Lederer's brother Carl.

In 1906, Adam Gross killed himself at the age of 55 because he had lost his job at the South Bend Woolen Company. He was found drunk and poisoned with carbolic acid on the steps of the company where another job had been promised him should a loom become

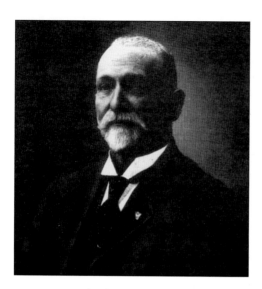

August F. Beyer was a man of many skills: fresco painter, truck gardener, and florist. (From Timothy E. Howard's History of St. Joseph County Indiana, *1907.)*

available. Gross, who was known for his drinking and for his abusiveness toward his wife, left a suicide note in the wood shed. He had written it in German on a 3-foot piece of siding. "Good night. I forgive you all. May the Lord Almighty send you blessing."[50]

The immigrants about whom least is known were those who moved from place to place in search of fortune or just for adventure. They were almost exclusively single young women and men. The city directories listed many people only for a year or two, after which time they may have left, fallen victim to the many diseases that were rampant, or were just missed in the counting. Georg Dobereiner was such a migrant. He arrived in New York in 1853, together with many other Arzbergers, and gave Indiana as his final destination. He did spend two years in South Bend, but then was not heard from again.

Andreas Sack was another young man who appeared briefly in South Bend, and did not settle down for a long time. Thanks to personal correspondence, however, his itinerary can be traced, providing some insight into the fate of such migrant young immigrants. Andreas was the son of Christian Sack's older brother Johann Christoph, who had died in 1848. Andreas' mother died four years later, leaving four orphaned young boys, ranging in age from 4 to 18 years old. After their mother's death in 1852, the two oldest sons, Georg and Andreas, went to America. The entire extended family in Arzberg, and especially Christian Sack, worried about their welfare. But the family also cherished high hopes for them in the new world, as their uncle never tired of reminding them. "So many beautiful hopes," he wrote, "have been founded on you, dear Andreas, since we were so sure that you could make your fortune in that country."[51]

The brothers first went to Cincinnati. Soon after their arrival, Andreas became seriously ill and was hospitalized for a while. The family back home was distraught with worry. In 1855, Christian Sack himself emigrated, taking with him Andreas' brother Christian, then only 14 years old. The youngest brother, Friedrich, also eventually came to America. In South Bend, Christian Sack continued to watch over Andreas with concern and advice.

After Andreas recovered from his illness, he went to Monroe, Michigan, because other Arzbergers were already there. It was from Monroe that his employer C.F. Grob wrote to Sack complaining about Andreas' "careless ways" and his drinking, which, he believed he learnt in Cincinnati from his older brother, who made Andreas play at drinking bouts and

introduced him to bad company. Grob would not allow Andreas anything heavier than beer to drink, and then only one or two glasses a day, and the young man seemed to improve under this regime. Andreas for his part complained to Sack that Grob did not pay him, while Grob insisted that he gave him $3 a month despite the young man's shortcomings.[52]

At the end of 1855, both Andreas, who came from Monroe, and his brother George from Cincinnati, were with Sack in South Bend, and were mentioned as two of the original members of the Choral Society. Sack repeatedly urged his nephews, who had inherited the considerable sum of 900 Guilders, to settle down and set themselves up in business. As early as 1855, he had offered to buy materials from Germany, which he could get advantageously from a friend. But Andreas was not ready for the regular life of a businessman. He loved to play his violin and "cultivate his heart," but seemed less interested in steady work.

In 1862, Andreas enlisted in the Civil War. By January 1, 1863, he had left the army and gone to Chicago. From there he wrote to ask Sack's forgiveness for "having shown so little gratitude for all the benefits I received from your family... But I also thought that after these weeks I should have a better idea about how I like it here in Chicago. Tailoring was always middling, only this week I had no work, but my boss believes that after New Year's things will pick up. Nevertheless I will look for another workplace."[53] The rest of the letter dealt at much greater length with his violin playing.

Eventually, however, Andreas, George, and Christian all settled in Ligonier, Indiana, which was becoming a wealthy little town largely because of the many German Jews who did business there. In the winter of 1872, Andreas wrote Sack from Ligonier, excited about their first experience hunting turkeys. On the first outing George and Christian had come home empty handed. "Yesterday, however, Brother Christian and I went out to try for the same big birds and to find out whether one really can't get any. Luckily we shot three, terrible guys. One weighed 19 pounds. This got George so excited that he left early next morning together with some others from town. Next Sunday Brother Christian and I want to try to send one to you, that is if there is good snow."[54] This ended Andreas' correspondence with his uncle. He had

The Sack house in downtown Ligonier was where the young Sack brothers eventually settled down.

suffered from unspecified illnesses all along, and died some time in the 1870s.

The other Sack brothers, however, finally established themselves, just as their uncle had hoped all along that they would. Ligonier has a Sack house on its main street, next to the Mier Bank Building, and old residents still miss the Sack grocery and bakery there. The Sacks also started an orchestra in Ligonier and still are remembered for their beautiful music.

The gold rush attracted some of the adventurous immigrants. In 1853, George Geltz went with J.M. Studebaker to the gold fields of California for three years. They returned in 1856, and Geltz resumed his work for Studebaker. In 1860, Godfrey Poehlman joined a group of young men from South Bend on an expedition to Pike's Peak, Colorado, making the journey across the plains with a team of horses. The party, however, met with little success, and Poehlman soon started on his way back to South Bend. He stopped over in Denver where he worked on the roof of the first mint. Safely back in South Bend, Poehlman proceeded to make his fortune slowly but surely in his hardware business.

The immigrants who came with families could not afford to roam about like the young and single men. And, as Poehlman found out, it was to their advantage to stay in a place like South Bend and participate in its growth. Overall, most of them coped amazingly well with the challenges and hardships of their early years and managed to prosper while at the same time helping South Bend grow into the major city of northern Indiana. The headline of an article in the *South Bend Tribune* on William Knoblock, brother of John C. Knoblock, was typical for many of these successful early German immigrants; "William Knoblock Grew Up With Town. Helped Clear Forest. Engaged in Many Manufacturing and Mercantile Enterprises."[55]

The immigrants succeeded not only because they worked hard and saved, but because they came from a background that had provided them with skills and often some money. And, although they maintained a certain class-oriented cohesion among themselves, they did not segregate themselves from the larger society, but found many ways of interacting and contributing to their new community. They eased their way into local society as German-Americans, who adapted themselves to American ways while still maintaining the cultural and social advantages of their German heritage.

<div align="right">

V.

</div>

The Second Generation

*J*ohn C. Schreyer, son of farmer Johann Wolfgang Schreyer, had met Katherina Barbara Meyer at a number of German functions. Katie, as her friends called her, was the daughter of German immigrants Johann Meyer and Margaret Zahn Meyer, who had come from the same area as John's parents. In June 1875, John decided to ask Katie for a first date. Katie was 18 and John 22 years old.

Sitting down to write, he chose a sheet of the stationary from the prestigious Knoblock and Lederer grocery, where he had just been made bookkeeper. John wrote in English since, as was the case with most second-generation Germans, that was the first language for both of them. Nevertheless, he capitalized some nouns in a manner familiar from German. After a moment's hesitation, he began simply with "Friend."

"I have the pleasure to address you for the first time. The object of which I will at once explain. To Morrow Night will be the Annual Festival of the St. Peter's Church at the Good Opera House. And I most Respectfully solicit the Honor of your Company on that occasion. The young folks are all going as far as I have heard from, and a general good time will be the result. Should this meet with a favorable reply, I will call on you about half past eight to Morrow Evening. With hopes I remain Yours Very Respectfully, J.C. Schreyer."[56]

As he had hoped, Katie responded favorably, and they were married in 1876.

On the whole, the second generation born of German immigrants had an easier time than their parents. Conditions were favorable, and sons were able to follow fathers into already established businesses, as did all the Klingel and the Beitner sons who owned shoe stores in South Bend. Similarly Andrew Russwurm's son Christian took over and enlarged his father's harness-making business. Even if the parents did not own businesses, the sons were able to make a faster transition into their own establishments, often owning their own stores when they were only in their 20s. Many had received a useful post-secondary education, and did not have to struggle for financial backing to the same degree. All of this helped them to build on and enlarge the foundations that their parents had laid.

Andrew Kunstman, son of Johann Nicol Kunstman, started out in the family trade as a cooper, but became owner of boarding houses and saloons. He was born in Arzberg on March 22, 1838, and came to South Bend as a young boy with his family in 1847. Kunstman married Arzberg-native Barbara Bauer on December 6, 1860. In 1869, at the age of 31, he was part owner with his father-in-law Franz Bauer of Union House, located at 83 Michigan Street. It was the first home for many a German workman arriving in South Bend. In 1871, he opened Kunstman House at 125 Michigan as sole owner, while his brother-in-law Frank Bauer Jr. took over Union House. In 1875, Kunstman sold his boarding house to another German, Conrad Oltsch, and invested the money in a saloon opposite the courthouse. His brother-in-law apparently followed his example, since in 1883 Franz Bauer and Son had a saloon at 127 North Michigan Street. The Kunstmans, including the children Andrew Jr.

and his sister, all lived next to each other at 228, 230, and 233 Lafayette Street in Little Arzberg. Andrew Kunstman's son, Andrew Jr., added to his father's real estate holdings by building the Kunstman Flats on Washington Street.

George Christopher, son of the first Muessels to arrive in South Bend, also came to America as a child. His father Johann Balthasar Muessel, a farmer and butcher, his mother Eva Katharina Riess, and his three siblings came in 1848, when George was six years old. The family first settled two miles east of Mishawaka, in the Dutch Island area. In 1852, they bought the Bresset farm on the Michigan Road in South Bend. From there they moved into the city and four more children were born in South Bend.

At age 13, George started as clerk in the J.G. Bartlett grocery on Washington Street, where he worked for six years. In 1865, when he was only 23 years old, he went into partnership with Christopher Kunstman in the Kunstman and Muessel grocery store, located on Main between Washington and Market Streets. One year later, he bought his partner out, and in 1867, formed a partnership with his brother Johann Michael. The Muessel Brothers grocery store became known citywide for its fancy groceries. The same year it was established, George married Caroline Elbel, who was 26 years old. She, too, was born in Arzberg. Her father Johann Friedrich Elbel had emigrated in 1853. Five years later, in 1872, George built the three-story Muessel block on North Main Street where the family also lived.

By the time George died suddenly on December 4, 1907, he had become a well-known grocer and respected businessman in South Bend. One obituary suggested that "his name had become synonymous with the entire trade. He was publicly acknowledged as a man of great worth and unshakable honesty—his word could always be depended on. His manly characteristics became the hallmarks of business life in this city...He brought with him to this country the steadfastness for which the Bavarian mountain people are known, and which contributed to the population growth in South Bend starting in the early 50s....The passing of this man is an absolute loss to the community. It is the passing of an era with all of the old landmarks disappearing, one after the other."[57]

Muessel was part of a larger group of second-generation immigrants who moved from the country into the city. Others like John V. Zeitler, owner of a very prosperous farm, kept his land but also engaged in business ventures in the city. John C. Schreyer, Godfrey Meyer, and Frederick Mueller left family farms to make their success in business. Frederick's family belonged to the large group of Arzberg immigrants who had sailed together in 1853. After a six-months stay in South Bend, the Muellers settled in Jefferson County, Wisconsin, where his parents became well-to-do farmers, and later also owned a hotel in Jefferson. Frederick came to South Bend in 1872. He started out as harness maker, but two years later became a clerk in Louis Nickel's famous grocery. By 1880, he opened his own grocery at the corner of Jefferson and Michigan Streets, and that same year married Anna Sack, daughter of Christian Sack.

By far the majority of second-generation Germans married the sons and daughters of other German immigrants. They also maintained membership in German organizations. John Schreyer was active in the *Turnverein*, helping to organize their famous masked balls. George Muessel also was a member in the *Turnverein*, and Frederick Mueller participated both in the *Germania* Lodge and the *Robert Blum* Lodge. In this way, although fully Americanized, at the same time they preserved some contact with their German heritage.

The 1878 wedding of Emma Muessel, daughter of Wilhelm Muessel, who came to South Bend with his parents at age six, and George Rockstroh, son of Arzberg-immigrants Caspar Rockstroh and Elizabeth Zeitler, not only was another example of the intermarriage and socializing of the German immigrants, but also showed the luxury the immigrants had achieved in just a few years' time. The paper described it in admiring detail as "one of the most brilliant

This c. 1890 window display was located at Frederick Mueller's grocery store, at 139 South Michigan Street. Mueller was married to Anna, daughter of Christian Sack, and it was at their house that the Sack letters were found. (Courtesy Northern Indiana Historical Society.)

weddings that has marked the social history of this city for many a day… At 8:30 the majestic strains of the wedding march began to flow from the instruments of Lorenz Elbel's orchestra, and a few minutes later the bridal party descended the stairs and took up a position in the large reception room facing the clergyman, Rev. Philip Wagner, pastor of St. Peter's Evangelical Church. The music then ceased and the solemn words of the marriage ceremony, spoken in German, fell upon the ears of the assembly."[58]

As with the first-generation immigrants, there were a number of spectacularly successful men among the second generation. The outstanding example doubtless was John C. Knoblock. As early as 1869, when he was not yet 40, the South Bend city directory singled him out as a most successful young man who had come to South Bend without a cent and now had "the leading grocery establishment in this city….He has gradually and steadily worked himself up until he is one of the 'millionaires' of the city, and is held in high estimation by all who know him, for his uprightness and integrity; such men should prosper." And prosper he did, going on to even more successful ventures after 1869. However, John Knoblock did not start out quite as poor and alone as the city directory might have led one to believe. His father was a prosperous farmer, and young Knoblock had the advantage of a relatively affluent upbringing and a network of well-connected people with whom he could partner and collaborate.

John was born on November 3, 1830 in Canton, Ohio, the son of Frederick and Salome Knoblock, who had come to the United States from Strasburg, Germany, in 1829. His father was a weaver who, for 15 years, had produced blankets in Canton. In 1843, his family migrated to Indiana, making the arduous journey overland in an oxcart. They bought government land in Marshal County, which they cleared for farming, and over the years kept adding to their property. By 1880, Frederick Knoblock had accumulated 430 acres. In his letter, Johann Wolfgang Schreyer called Frederick "the best friend that I have ever known," and said that Knoblock liked it better in Indiana than in Canton.[59]

John Knoblock worked on the family farm for five years. But like others, he too left the farm for the city. He was first hired out as a teamster for A.R. and J.H. Harper at $10 a month. The

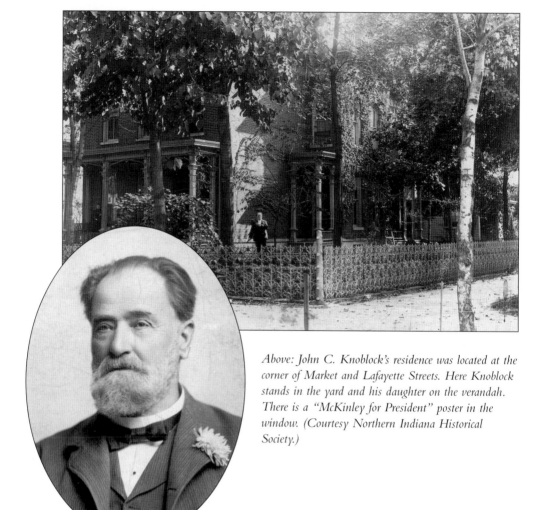

Above: John C. Knoblock's residence was located at the corner of Market and Lafayette Streets. Here Knoblock stands in the yard and his daughter on the verandah. There is a "McKinley for President" poster in the window. (Courtesy Northern Indiana Historical Society.)

Left: John C. Knoblock was "one of the 'millionaires' of the city." (Courtesy Northern Indiana Historical Society.)

firm liked his attitude and hard work and soon offered him a position in their flour mill, the Phoenix. While at the mill, Knoblock made friends with millwright Michael De Camp, who was about to open his own grocery store. When De Camp left the Phoenix Mill, he offered Knoblock a position as clerk.

On March 3, 1853, Knoblock teamed up with German immigrant Caspar Rockstroh to start a grocery business, which flourished over the years. Knoblock left that business in 1871. Two years later, he began a partnership with John Lederer and opened Knoblock and Lederer, which became the largest grocery in the area. Their ads in 1874 claimed that "They sell more groceries than any other house in Northern Indiana." Knoblock also put to good use what he had learnt at the Phoenix. In 1865, he started his own flour mill, which produced the then-famous "White Rose" flour. In 1872, he took German immigrant Henry Ginz into the company as part owner. In 1867, Knoblock joined in partnership with John V. Zeitler and Zeitler's step-father John M. Meyer in the large St. Joseph Custom Mills, which was situated on the East

Race. His business ventures did not end there, however. In 1870, Knoblock also was one of the charter members of the St. Joseph County Savings Bank, whose other trustees were Almond Bugbee, John M. Studebaker, J.B. Birdsell, and B.F. Dunn. By 1871, his estate was worth $75,000, which corresponds to over one million dollars today.

After his considerable success in the flour mill and grocery business, Knoblock entered into furniture manufacturing in 1871, together with his brothers William and Theodore. In 1876, this factory was remodeled into the St. Joseph Reaper and Machine Company that produced chilled plows. Its owners were again his brothers William and Theodore as well as Colonel Adam S. Baker, George W. Baker, and Darby Baker. They sold 650 plows in the first year and 4,672 in the second. On July 1, 1878, the company was reorganized under the name of the South Bend Chilled Plow Company, with Adam S. Baker as president and Knoblock as treasurer. It was located on Washington Street, one mile west of the court-house, in the buildings of the Northern Indiana College, which had to close after only 10 years of operation. In 1880, the factory produced over 50,000 plows and employed 150 men. In 1890, Knoblock sold out his interest in the company, and then became president of the Miller Knoblock Electric Priming Manufacturing Company, which later became the Knoblock-Heidman Company, where Knoblock's son Otto was an officer.

Knoblock had married Lissetta Meyer, a native of Bavaria, in 1853. Their first home was situated on the St. Joseph River, at the foot of Madison Street in "Little Arzberg." As his busi-nesses grew and multiplied, the family moved into the center of town. Their large two-story brick home, located on the southeast corner of Market and Lafayette Streets, became well-known for its social gatherings, as well as its beautiful gardens where storks could be seen spearing fish out of the fountains.

The Knoblocks had three children, although the oldest, Clara, died at age 9. Otto, born June 19, 1859, became a local historian and author of books and articles on South Bend. In 1895, Otto helped to organize the Northern Indiana Historical Society. He also was one of the founders of the South Bend Rotary Club. One of Otto's earliest memories was when his father's pet antelope, scared by dogs, bounded into the dining room while the family was sitting at dinner, jumped clear across the table and over their heads before rushing out the opposite door. Otto also remembered that his father had provided bread for the troops encamped on the fair grounds on Portage Avenue during the Civil War. One morning, as Otto accompanied his father to visit the troops, a wheel of their buggy broke. Both climbed down to find out what happened, and his father burst out laughing when he saw what had caused the accident—he had driven over one of his own loaves of bread.[60]

John Knoblock maintained close ties to the German community, since all his early business associations had been with recent German immigrants. Both his wives—he married Rebecca Baer in 1905, just a year before his death—were German. He was a member of the South Bend *Turnverein* until 1877, when his son Otto joined. Knoblock's brother Theodore, a club member from the beginning, remained a leader in the *Turnverein*, helping to make the gymnastic equipment and designing the wooden horses for the parades. But as John Knoblock prospered, he also became part of the wealthy elite of the city, working and socializing with John Studebaker, Almond Bugbee, and others, and actively supporting the Republican Party.

Just as in the previous generation, a number of the sons and daughters of German immi-grants could not cope with personal problems and the tough conditions of the growing city, and ended up taking their own lives. Some fell victims to scams; others could not bear the stress of running a business, or were driven to despair by ill health. A number of these suicides occurred among the members of the affluent middle class.

Charles J. Rockstroh came from a prominent German-immigrant family. His father was Caspar's brother George Rockstroh, who owned a meat market, and his mother Margaretha was born an Elbel. Charles, born in South Bend on July 31, 1856, for many years had been in partnership with his brothers John and the former sheriff George Rockstroh in a butcher shop on West Washington Street. Eventually however, Charles went into business by himself and opened his own meat market on North Main Street. The business appeared to prosper, but suddenly in 1899, Rockstroh sold everything to George Beyler for $14,000, which was much below the actual value of the business. Immediately afterwards he tried to kill himself twice with an overdose of laudanum, but was revived each time. Then on the morning of July 4, 1899, Rockstroh went out as usual to feed the chickens. He disappeared into the outhouse behind his home at 119 East Marion Street, and when he did not return nor respond to his wife Lena's question whether he wanted a fried egg, she went looking for him. She found her husband seated on the closet, vomiting so violently that his false teeth had fallen to the floor. She ran for help to his brother John next door, and they carried the by-then unconscious man into the house. He died 45 minutes later of carbonic acid poisoning. He was not yet 43.

The *South Bend Daily Tribune* attributed the cause to "the levying of blackmail by unscrupulous leeches of human form, but depraved senses, involving financial drains which finally induced mental desperation."[61] The paper also made the remark that "It is hinted that all were not women who played the vampire with the unfortunate man."

His wife was left alone with their 12 year-old daughter. Just a few months earlier, she had had to mourn the death of their only son. Lena Rockstroh was born a Sommers. She was most likely related to that family in Seussen who, in the 1860s, had delivered the letter from America that had led young Andreas Soellner to emigrate.

The son of successful and well-to-do Christopher Kunstman committed suicide at age 29, just a little more than a year after his father's death. He did so in a rather dramatic manner, reminiscent of the hero Konstantin in Chekhov's play *The Seagull*. George was suffering from consumption. Shortly before killing himself, he had told his sister Margaretha, who was married to John Lederer, that he did not have long to live. As soon as the words were out of his mouth, however, he wanted to retract them, but the family watched him closely from then on. Since both his parents were dead, George lived with the Lederers in their large home on Lafayette Street, as did his sisters Lena and Hattie.

At a family dinner during Christmas 1885, George seemed more cheerful than usual. This mood continued after dinner when they all sat together in the living room engaged in pleasant conversation. After some time, George got up and went out. A minute later, the family heard a pistol shot. John Lederer rushed out to find George lying on the floor, having shot himself in the head. The *South Bend Weekly Tribune* suggested "The charitable conclusion reached is that his mind had become unsettled by his long-continued and evidently incurable illness....The report that he had attempted suicide a year ago by taking poison, is denied by the family."[62]

These cases of suicide were, however, isolated incidents. Most second-generation Germans settled successfully into their lives as German-Americans in South Bend. They continued to be active in the German clubs and German churches their parents had established, where they gained familiarity with German culture. They liked the German food their mothers had prepared, participated in German celebrations, and sang German songs at their German meetings. Overwhelmingly, they married other second-generation Germans. Unlike their parents, however, they were not just familiar with American ways, but had adapted to them almost completely. Their first language was English, and many were no longer fluent in German. America had become their home.

VI.

The Arzberg Connection

South Bend, April 8, 1855
Mr. Christian Sack
Doctor in Arzberg

Dear Friend:

From the letter of Johanna Mainer, which she received from her cousin, I found out that he should tell you whether you would like to find a place in this town as doctor or country doctor. Since young people take little care with such matters, I took over this task and talked with some men who even wanted to write to you personally. They thought that you would not earn nearly as much in big cities as you would in this town. Although we are 2,500 here, you would function mainly as country doctor since there is no person here who can properly bloodlet or mend a broken arm or leg. It seems that you would find the best place here.

The main diseases here are cold fever which is cured with quinine, from which however most people get swellings; the second disease is a hot fever from which many die since they also try to cure it with quinine. The third main disease is a kind of dysentery, which may be contracted because the English eat everything unripe. The doctor, however, has the medicine with him each time as soon as someone asks for it; it would be good therefore if you would bring some of the German medicine with you. There are also many people who suffer from attacks of gout, but cholera as it is known in big cities does not exist here.

I have another commission: Mainer sends his greetings; you should bring him two pails of Kulmbach beer; he has long had an appetite for it....

I finally want to ask you not to come because I said so for I didn't want my brother to come to America; there are few who like it here to begin with, therefore every one has to follow his own free will. I myself live happily in this country.

Many greetings to yourself and all friends. Please give me an answer as soon as possible. In a hurry, Fare well, Your friend J.F. Elbel[63]

The single largest group of German immigrants to South Bend between 1830 and 1870 came from the area in upper Bavaria centered around the town of Arzberg, near the border of Czechoslovakia, then Bohemia, and the surrounding villages of Schlottenhof, Seussen, Bergnersreuth, Wunsiedel, and the town of Redwitz (now Marktredwitz). Arzberg is situated in the hills of the *Fichtelgebirge* (literally "spruce mountains"), a border area that still today is fairly remote. Arzberg is first mentioned in 1286 and became a city in 1408. Because of the regional politics of the German provinces, Arzberg lived under many rulers. Until the late 18th century it belonged to the duchy of Ansbach/Bayreuth. On December 2, 1791, the duke sold his realm to the King of Prussia, where it remained until 1806. After Napoleon's victory in the battle of the three emperors at Austerlitz in 1805, the dukedom of Bayreuth went to the French. In 1810, Arzberg became part of the state of Bavaria, as it still is today.

Christian Sack's lithograph of Arzberg in the 1840s shows his artistic talent. In his presentation, the hills appear larger than they are in reality. (Courtesy Erwin Scherer.)

The story of Johann Adam Mainer, grandfather of South Bend immigrants Johanna and Sophia Mainer, shows how this complicated history intervened in people's lives. In 1805, when King Friedrich Wilhelm III of Prussia and his wife Queen Louise visited Arzberg, 11-year old Johann Adam played for them on a piccolo he had received as a gift from an Austrian deserter during the Napoleonic Wars. The queen was much pleased with the blond boy, fitted out in a small uniform and even a saber, and gave him a violin as a present, which became a family treasure. The king promised to pay for his musical studies and added that if he did well, he might even become the royal *Kapellmeister*, the leader of the royal band. However, by the time Johann was old enough to take advantage of the king's offer, Prussia was defeated by the French and had to give up the dukedom of Bayreuth. Johann Adam lost his royal support and his fairy tale came to an end. He studied in Arzberg instead of Berlin, but became a good musician nevertheless, making his hometown of Hohenberg a well-known local musical center.

In the 19th century, Arzberg had a population of about 2,000. Although much of Bavaria was Catholic, Arzberg was predominantly Protestant because the local rulers, starting in the 16th century with George the Pious, Duke of Ansbach/Bayreuth, were Protestant. The town is dominated by the Protestant "castle-church," which served both as a place of worship and a refuge in times of attack. Surrounded by thick walls, the castle-church can be reached only by a number of steep passageways. Through the centuries, when Arzberg was threatened, the townspeople used these passages to seek the safety of the church.

Between 1838 and 1868, 10 percent of the residents left Arzberg, most coming to South Bend.[64] In the years 1852 to 1855 alone, 211 persons emigrated from Arzberg. The baptism records of the Lutheran church in Arzberg repeat over and over, *Ausgewandert nach*

In times of danger the citizens fled to the Lutheran Castle Church in Arzberg for protection.

Nordamerika (emigrated to North America) at the bottom of a person's entry. Some entries, like the one of Johann Pöhlmann of March 27, 1862, conclude with the note that the person died during the journey. But most records say nothing about the fate of these Arzbergers in the new world. As a result, even today there is great eagerness in the Arzberg community to find out more about what happened to its citizens in South Bend. The celebration of Arzberg's 550th anniversary, in 1958, included a float dedicated to South Bend. Most recently, Arzberg's city fest of 2002 was focused on South Bend with an exhibit and the unveiling of a memorial in front of city hall.

The reasons why so many people left Arzberg mirrored the conditions in the rest of Germany—industrialization, rural poverty, overpopulation, oppressive laws and taxation, and political repression and instability. Thirty-four percent of these immigrants were middle-class skilled master craftsmen, such as weavers, smiths, shoemakers, carpenters, masons, tanners, and coopers.

Ten percent were weavers who had fallen on hard times because the cottage industry of weaving was being displaced by the new mechanical looms, which were introduced into the Arzberg region around 1850.[65] As a result of this mechanization, in the 1850s, half of Germany's 18,000 hand operated looms had come to a standstill. The desperate situation of the weavers was movingly depicted in Gerhart Hauptmann's play *The Weavers*, in which the hero is not a single person but the whole group of oppressed workers.

Another profession that suffered from the advent of new technologies was the tanners. Arzberg had a large number of what were referred to as either white or red tanners, who used the bark from the spruce trees abundant in the woods surrounding the town. Nail smiths likewise were put out of business by new machinery. Many of them joined the

stream of people leaving for "Nord Amerika."

Ten per cent of the immigrants from Arzberg were the sons and daughters of single mothers. In the records of the Lutheran church, there are many baptism entries that list the mother as single. This high incidence of single mothers in part can be explained by the stringent state laws concerning marriage, which date back centuries. In the 17th century, for example, a couple could not get permission to marry if one of them or their families had what was considered an unworthy occupation, such as that of shepherd or executioner. In the 18th century, a man could marry only after having served in the army for four years. Decrees of 1721 and 1733 stipulated "people who cannot amass at least 50 guilders, cannot get married." In the middle of the 19th century, as the numbers of the poor increased alarmingly, many communities tried to prevent people from marrying who could not support a family, just as they did not allow a person without means to move into their community. Once Arzberg became part of Bavaria, these laws became even tougher, with the result that a significant part of the population simply could not afford to get married.[66]

Even if the participants belonged to the educated middle class, a couple had great difficulties in obtaining a marriage license. For example, when Anton Bauer, a teacher, wanted to marry Christian Sack's sister, Margaretha, their application was turned down. The two almost decided to join Sack in America, but tried one more time fearing, however, another denial. Their second application was submitted "with incontrovertible reasons and with the support of the best representatives of the local and district school inspection." Only by these extraordinary measures did Bauer get a hearing and eventually permission to marry.[67] The wedding took place on May 14, 1856.

The "Berg Muessel" brewery on the hill near the Arzberg church. (Courtesy Erwin Scherer.)

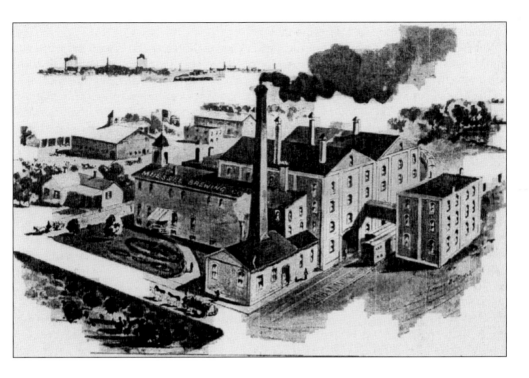

The Muessel Brewery in South Bend, near Portage Road. (Courtesy Northern Indiana Historical Society.)

Other reasons for emigration included the decline in the mining industry of Arzberg. Mining, from which the town derived its name—Arzberg meaning "ore mountain"—began as early as the 14th century. By the 19th century, however, the shafts were almost fully exploited. In addition, bad harvests and the potato blight made it difficult to earn a living. The founding of a porcelain factory, in 1839, was not enough to counteract all these negative trends, especially since by 1876, it employed no more than 56 people.

As in the rest of the country, overpopulation was a problem in Arzberg as well. In a report of 1837, Lutheran minister J.C.G. Scheretz noted that the region was so severely overpopulated that people could not survive. He observed that if no new factories came to town to alleviate this desperate situation, people would have only two options, either to steal or to emigrate.[68]

All these reasons propelled the people of Arzberg to emigrate in large numbers. And once the first families had ventured to the United States, they encouraged other members of their group to follow them. This pattern of chain migration is well-known in immigration history. The extent of intermarriage among Arzberg families meant that almost everyone had a close relative in the new world.

Thanks to surviving letters and other documents of Arzberg immigrants, it is possible to follow their social and economic progress from the old world to the new. Most of those who had fled the economic hardship of Germany improved their financial condition in South Bend. Yet they tended to maintain the same relative social and economic position they had held in Arzberg. That is to say, those who had been longest established and had the highest social status in Arzberg also became the leading citizens in South Bend. And even though they came to America, at least in part, to escape the rigid class lines of

Germany, they did not rid themselves altogether of their class consciousness. Moderated by their common experience of being strangers, they yet maintained distinctions of wealth and class in their new home. Even within extended families, the richer relations lived fairly separately from their poorer relatives.

The Muessels were a prime example of how the Arzbergers preserved and transplanted their class status. In Arzberg, they were a patrician family who in the 17th century owned three major buildings in town, two on the market square and another on the *Berg* or hill overlooking the town. The latter was the large Muessel brewery, and the owners were called the *"Berg Muessels."* In the 17th century, a Georg Muessel was mayor of Arzberg. At the end of the 18th century, the *Berg Muessels* hosted Alexander von Humboldt, the most illustrious visitor ever to come to Arzberg. From 1892 to 1897, the famous German scientist, explorer, and diplomat, stayed in the brewery on the hill while he was supervising mining in the area.

In South Bend, the Muessels again had a successful brewery. It was started by Johann Christoph Muessel, who was the son of George Adam Muessel, a master tanner and well-known beer brewer in Arzberg. In 1852, when he was 40 years old, Johann Christoph came to South Bend with his wife Christiana and their children Johann Ludwig, Wilhelm Lorenz, Johann Christian, and Margaretha Eleonora. Christopher, as he was called in South Bend, had sufficient capital immediately to open a brewery on Pearl Street, two houses south of the business center on Washington Street. At first the brewery distilled vinegar as well as beer. It survived the depression of the mid-1850s and prospered in the years of growth after the Civil War. The brewery produced beers labeled Arzberg Export and Bavarian.

In 1870, Christopher was able to build a much larger brewery just north of the city off Portage Avenue. He purchased 136 acres in that area because the artesian wells on the property provided excellent water for brewing. The new complex included malt houses, brewery buildings, bottling works, and stables.[69] Their ice machine was capable of producing 45 tons of ice daily. Unlike the other breweries around South Bend, it was steam powered. In 1893, the Muessel Brewing Company was incorporated with Christopher as President. When he died a year later on March 25, 1894, at the age of 82, the company was handed down to his children and grandchildren; William and Edward, and Anna Katharina Poehlman, Walter G., and Adolph J. Christopher's son Edward became president, since the oldest son Ludwig had died in 1884. Edward was born in South Bend on January 3, 1857, and was married to Mary Mueller, also of German descent.

For a short time at the beginning of prohibition, the company stayed open, manufacturing soft drinks. But unlike the Kamm and Schellinger Brewing Company of Mishawaka, Muessel's soon decided to shut down completely. This hindered its ability to resume production after the Volstead Act was repealed, and as a result, it was the last brewery in South Bend to reopen after prohibition. The increasing competition of the large national brewing companies eventually put the Muessel Brewery out of business, as it did most other smaller breweries. Muessel had to declare bankruptcy on May 25, 1936, and was taken over by Drewrys in October of that year.

The Elbels were another major Arzberg family that transplanted itself successfully to South Bend. The earliest reference to an Elbel in Arzberg was in 1495, in taxation records. Wolfgang Elbel, born in 1571, was a Protestant pastor, and over the years, the Elbels provided five mayors for Arzberg. After the 17th century, the Elbels were known in the entire region as smiths of all kinds, saw, kettle, and blacksmiths. Their successful business brought much money into the town. In addition, most of them were known for their music. They were the leaders who started bands and orchestras in Arzberg. To this day, a

The Elbel home in Arzberg. (Courtesy Frederick C. Elbel.)

Below: Lorenz Elbel's Orchestra, 1884. (Courtesy Frederick C. Elbel.)

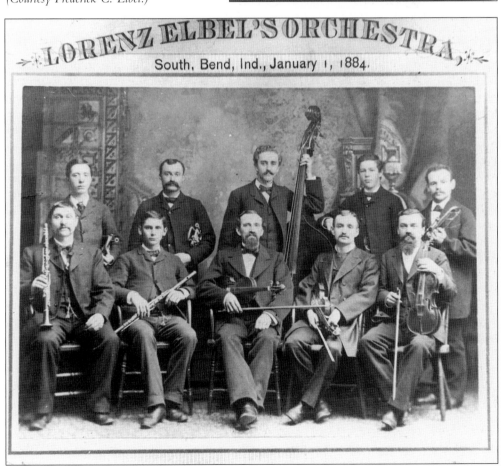

Willie Elbel is the leader of the Arzberg brass band.

The first of many Elbels to come to South Bend was Johann Friedrich Elbel, who arrived in 1848, with his wife Anna Susanna, daughter of the tailor Erhard Kunstman. Elbel was already 50 years old. The records of the Lutheran Church in Arzberg list him as a musician and tile maker. In the years after 1848, the Elbel children followed their parents. First came Wolfgang Adam, who arrived in 1850, at the age of 20. One year later came Johann Lorenz, who was three years younger than Wolfgang Adam. Then in 1853, a much larger group of Elbels reached South Bend, sailing on the same boat as over 80 other Arzbergers. By 1867, nine Elbel families were established in South Bend, most of them living right next to each other either on Lafayette or Marion Streets in Little Arzberg.

In 1854, Johann Friedrich Elbel built a house on 300 West Marion Street, which became the center of many of the family's musical activities. The Elbel Bros. Music Store was founded around 1880, and for 90 years, until it closed its doors in 1970, it provided South Bend with instruments and sheet music.

Like the Muessels, who had a park and a school named after them, there is an Elbel Golf Course in South Bend, named after Richard Elbel, a longstanding member of the Park Board.[70]

Business alliances among Arzbergers became part of the South Bend business scene, such as the Kunstman and Muessel grocery, and the Kunstman and Bauer boarding house. The Meyer and Poehlmann hardware store was founded by two men from Arzberg who both came to South Bend in 1853. In 1864, Poehlman married Anna Katharina, daughter of the brewer Christoph Muessel. This led to his becoming one of the directors of the Muessel Brewing Company. In 1879, he also became one of the partners with Arzberg-natives John Lederer and Andrew Russwurm, and native-born leaders Coquillard and

At the family home of Lorenz and Johanna Mainer Elbel the first decorated Christmas tree was on show for South Bend in 1886. (Courtesy Frederick C. Elbel.)

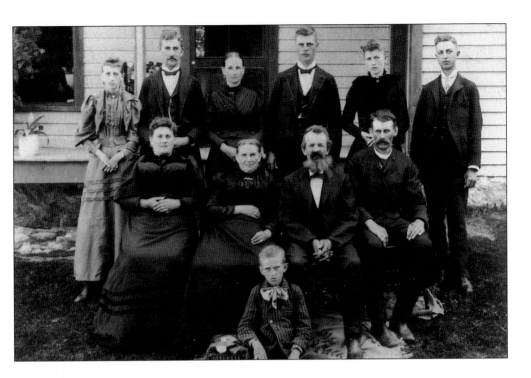

Three generations of the Walz family in 1894 are, standing from left: daughter Ida, son Christian, daughter Flora Walz Bunch, son George, daughter Amelia, son John; seated: daughter Anna Walz Ranstead, grandmother Sophia, aged 53, grandfather John, aged 58, son Charles; sitting in front: son Fred. (Courtesy Eileen Copsey.)

Longley in the purchase of 25,000 acres of land in Oconto County, Wisconsin.

The majority of Arzberg immigrants were farmers and craftsmen with less funds and education than families such as the Muessels or the Elbels. And they too established themselves solidly in South Bend, though as members of the working middle class to which they had belonged back home as well. They worked as cabinet makers and other skilled craftsmen in the city's major industries, and eventually could build or buy their own homes and raise their families in financial security. However, they remained workers all their lives and did not set up businesses of their own. And although they intermingled to a certain extent with the property- and business-owning Germans, for the most part they tended to live in separate spheres.

All these interrelated German families created many opportunities for social gatherings. The Meyer/Zeitler family held a celebration each year on August 15, the anniversary of their arrival. Otto Knoblock described the 1887 event; "The fortieth anniversary was therefore duly celebrated yesterday by this big family and a few invited guests, which formed a company of nearly 100, by a great dinner on the fair grounds. A table extending the entire length of Horticultural hall was loaded down with food of every conceivable kind prepared in the good old German way, and to this the entire company sat down at 1:30 o'clock and spent a full hour in filling up. Strange to say, after all this there seemed to be no diminution of the quantity, which the platters contained, and there seemed to be no limit to the supply. Some idea of the amount of provender prepared for the occasion may be gathered

when it is known that one branch of the family announced after dinner, that her basket had not yet been reached and it contained a dozen fat chickens, two hams, and any quantity of cakes, bread, preserves and the like. After dinner the people scattered out around the grounds, listened to some charming music upon the zither by the artistic player Will Hagen, to some excellent singing by Louis Nickel, John Wagner, Andy Russwurm and Godfrey Poehlman, and spent the remainder of the time in social intercourse. Not satisfied with the big dinner disposed of, the hearty Germans were prepared to eat again when supper was called at 6 o'clock, and the long table was again the scene of activity and lively German chatter."[71]

A glimpse into the day-to-day lives of an immigrant Arzberg family is provided by the 1872 diary of nine year-old Thekla. Her father was the doctor Christian Sack and her mother was Katharina Margaretha Koenig, who when only 16 years old, had followed her father to South Bend by herself, a year before her mother and siblings. The Sacks lived in a frame house at 127 Pearl Avenue in the triangle formed by Jefferson and Pearl Streets, the latter of which became Lincoln Way West. Their garden extended from the house to the point of the triangle. In the summer, people came to admire its riot of color and its beautiful fountain. The Sacks also kept chickens and geese, and even a cow and a horse in a barn behind the house. Following their German tradition, the geese were for festive occasions, particularly for the Christmas season. In December 1872, for example, the family had goose twice. On December 14, 1872, Mrs. Sack killed a goose and made lard. On December 26, Dr. Sack killed another goose for their Christmas table. But the family also seemed to have adopted some American ways of eating. New Year's Eve 1872, for example, they celebrated with punch, crackers, and oysters, which Dr. Sack had fetched from town that morning. Many friends visited throughout the day. In the evening there was a big dinner for family and friends and afterwards they sang songs around the fireplace, "and we had a happy New Year."[72]

Thekla Sack is seen here at about the time she wrote her diary in 1872. (Courtesy Erwin Scherer.)

Thekla was brought up with both love and discipline and taught the values of hard work and charity. She had to obey her parents unconditionally, help with household chores, and, above all, be good in her studies. Although Dr. Sack was a freethinker, Thekla went to the Catholic St. John's Academy because the Sisters of the Holy Cross provided an excellent grade school education. Thekla spent a good deal of time reading, playing the piano, or writing in her diary, but she always made sure that her lessons were well prepared. Thekla also helped her mother, carrying water, running errands, and sweeping the porch. Staying home from school, she looked after her father when he had injured his leg and could not move. She was eager to please her parents and felt mortified when they were angry. Thus she wrote on November 16, 1872; "I got a scolding because my shoes made a noise while I was walking, and I felt very bad." She was also taught to share with the needy. One day, for example, her father told her to give some of her toys to the children of one of his poor patients while Mrs. Sack prepared some clothes for the mother.

There was a good deal of socializing in the Sack household. Hardly a day went by without a visit of some Arzberg friend or relative. Mrs. Poehlman, Mrs. Rockstroh, and Mr. Beck visited often and their children played with the Sack daughters. In summer, they gathered on the porch, and in winter near the fire in the kitchen. For special occasions or when it was particularly cold, there was also a fire in the parlor. The Sacks were financially secure but lived, at least by our standards, parsimoniously. Thekla's birthday gifts were simple, such as a snowball geranium from her father, and a dress from her mother. For Christmas she received warm stockings. Thekla was content with their lives and often entered at the end of a day "and I was satisfied with the day."

The Arzberg family that became most prominent in the state of Indiana, although they did not live in South Bend, was the Schricker family. The original Schricker immigrant was Johann Christopher, who was born on April 2, 1843, in Thiersheim near Arzberg. He came to South Bend with his first wife Elisabeth Soellner. After Elizabeth's death in 1880, he married her cousin, who, together with her daughter, was still living in Germany at that time. The only son of this second marriage was George William Schricker. He was the father of Henry Frederick who became a two-term governor of Indiana, serving from 1941 to 1945 and then again from 1949 to 1953, the only governor in Indiana to be elected to two separate four-year terms.

The Arzberg immigrants formed a group within the group of German immigrants, and continued many of the traditions of their old home. They were active, and often founding, members of the various German organizations, especially the *Turnverein* and its singing section, and the *Germania* Lodge. When Zion Church was established on the east side of the St. Joseph River in 1888, a majority of its founding members were originally from Arzberg, and they introduced the traditions of the Arzberg Lutheran Church to their new church. Until today, and unbeknownst to current church members, the church maintains some of these traditions. For example, both in Arzberg and in South Bend, the church bells ring when the congregation prays the Our Father.

Arzbergers also maintained close ties to their hometown. In 1868, after a fire had destroyed much of Arzberg, the Elbel family gave benefit concerts and collected $400 (about 7,000 in today's dollars) for Arzberg. They sent the money together with a certificate of donation that specified that $290 should go to the victims of the fire. The remaining $110 was to be invested as a donation of the Elbel brothers and that every year on the anniversary of the fire the interest of that amount should be distributed to the poor.[72] According to these instructions, every year on the night of August 14, the night of the great fire of 1867, a bell was rung in the Arzberg market place to proclaim the distribution of the

funds to the poor.

A shared background and close family ties helped the immigrants from Arzberg to create cohesion also in South Bend. This was strengthened by their continued intermarriage, their many business connections, and their social and club activities. Of course, as with any small community, there also were plenty of rifts, aggravated by gossip and differences in wealth and class. But until this day, the immigrants from Arzberg have preserved some sense of their common origin. Most know that their families came from Arzberg and know the others with whom they share this background. And now that the two world wars, in which Germany was the enemy, are part of a past century, many feel eager to take up again the exploration of their Arzberg roots and reconnect with long-lost family there.

Zion Church in South Bend, 1888, was founded largely by immigrants from Arzberg.

VII.

Silent Partners

WOMEN IMMIGRANTS

Elizabeth Zeitler, born in Arzberg on April 21, 1833, was part of the group that arrived in August 1847, to the welcome of South Bend. She was just 14 years old and the middle child, traveling with her widowed mother, two sisters, and two brothers. At age 20, she married Caspar Rockstroh, also from Arzberg. They started a bakery on North Main Street, working long hours, day and night, to build their business.

Elizabeth gave birth to five children. In 1865, within one week, she lost three of her children to diphtheria. Two years later her husband died. Then their home and their bakery, situated in the St. Joseph Block, burned to the ground. But Elizabeth did not give up. She fought on by herself, developing the bakery and bringing up her two remaining children. In 1871, her daughter Katharina Sophia married the German Louis Nickel Jr. who had come to South Bend in 1870. Two years later in 1873, he purchased a half interest in the Rockstroh bakery and grocery, the other half belonging to Elizabeth's son George John. In 1880, the magnificent Rockstroh Building was erected, which housed Nickel's Delicatessen. The value of the Rockstroh estate doubled between 1871 and 1882.

All this growth and prosperity was at least in part thanks to Elizabeth's hard work and good business sense. But when she died in 1895, the obituary made no mention of her contribution. Instead of talking about her achievements, it said that her death took from her relatives "one whose life had been full of love and self sacrifice in their behalf."[74]

The voices of immigrant women were not much heard since "the immigrant experience was conceived as a male journey and challenge."[75] Women were merely men's appendages in that adventure. As a result there are far fewer details available about their lives than of the men's. Even at their deaths, the women's obituaries did not tell much about them, but instead dwelled on the achievements of their husbands or anyone else to whom they were related. As in the case of her sister-in-law Elizabeth, the death notice of Mrs. Lottie Zeitler talked almost exclusively about her husband John V. Zeitler's career as farmer, township assessor, and trustee.[76] Yet in the challenging task of settling into a new country, women played a most important part, and worked just as hard as the men. Moreover, it was the women who provided much of the culture and education for the settlers as well as their nursing care.

In the early struggle to provide food and shelter for their families, women worked right along side with the men. Especially if the immigrants were poor farmers, the women had to share in hard manual labor, burning wood, and hoeing Indian corn and potatoes. Writing in 1842, Matthew Hassfurther from Ferdinand in Dubois County, Indiana, described how a young woman's "clothes were torn in the process of burning the many branches and other man's work which she had to do."[77] Women also were responsible for maintaining

the household. Ordinary chores, such as washing clothes, were not only arduous but could become downright dangerous. Anna Barbara Keisler, wife of Mishawaka farmer Johann Christoph, for example, once suffered a seizure from the icy cold water of the creek in which she had to rinse the washing. Had not her lame mother-in-law, Anna Katharina Kunstman, rescued her, she would have drowned. As it was, Anna Barbara remained paralyzed for six weeks.[78]

Margaret Diehl and her husband, who came to South Bend in 1834, first lived in a log cabin from where they ran a bakery. Margaret gave birth to six children, but only three survived into adulthood. In 1838, the Diehls owned a hotel and tavern, the Franklin House, located east of Odd Fellows Hall. After her husband's death in 1845, Margaret ran the business by herself for many years. She moved the bakery to Washington Street, across the alley from the Knoblock grocery. Margaret continued to be a successful business woman until the infirmities of old age forced her to quit. She died in 1879, at the age of 77.

The first homes of the settlers offered only the most rudimentary comforts. A picture of the Schreyer family's first cabin shows it to be hardly taller than the men standing outside it and one can only imagine the heat and cold the family must have endured in it. Even though the Schreyers eventually built a larger place, it still was a small log house. The three children had to share a room where Mrs. Schreyer nursed them through diseases, and watched one of them die. No wonder she was ill much of the time in their first years.

An 1859 book of advice to German immigrants listed the many tasks women were expected to perform. "They keep their house clean and orderly, do the cooking, baking, washing, knitting, mending, sewing,...care for children, milk the cows, make butter, cheese and soap, dry the fruit, cook jams, prepare fruit and vegetables, tend the flower and kitchen gardens and the fowl. Indeed, many even weave the necessary fabrics for household use."[79] Its author Friedrich Muench, however, did not want to suggest any hardship here, but instead argued that this work kept women satisfied and out of boredom. Johann Wolfgang Schreyer and other male immigrant letter writers echoed these sentiments, feeling that women did not have to work as hard as the men. Schreyer claimed that women had the leisure to comport and dress themselves as did only upper class city-bred women in Germany. And he added, "women have nothing to do but to manage the house both in the city and in the country: they are not expected to work in the fields, and the husband builds the fire in the morning, even if he has a servant in the house."

Following their fathers or husbands into immigration, women had left their family networks behind and felt isolated in their new homes with little opportunity to create new networks beyond the immediate family and its neighbors. They tended to suffer from homesickness more acutely than the men, whose work took them into the world outside the home. One husband, writing in 1883, said; "My wife is homesick; she cries day and night and says if only we were back in Germany."[80]

In the South Bend area, immigrant women also suffered from homesickness. For example, Sophia Mainer Walz left Arzberg in 1857, at age 16, without money or education, to join her sister in South Bend. In 1860, she married German-immigrant John Walz, who had just saved enough money to buy 80 acres of undeveloped land south of town for $725. There they started to set up home and create a farm out of the wilderness. During the Civil War, John, who was afraid to leave his young wife alone there, had to come up with $300 for a substitute when he was drafted. Since he was drafted three times, he ended up having to pay out $900, more than his land had cost him.

Over the years, the Walzes cleared more and more of their land and Sophia gave birth to nine children. Life was hard and everyone in the family had to pitch in. Their daughter, who

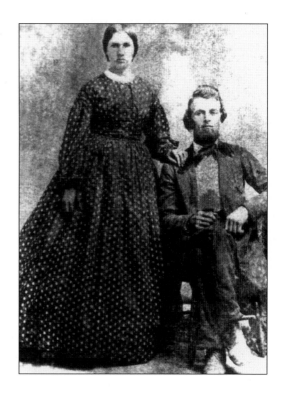

John and Sophia's wedding picture, 1860. He is 24 and she is 19 years old. (Courtesy Eileen Copsey.)

spoke only German until she went to school, was allowed to attend school for only four years because she was needed on the farm. Despite their gradual success and her growing family, Sophia's daughter would see her mother in tears whenever she wrote home to Germany. As a consolation, in 1876, her brother sent her a photo of Arzberg in which he designated the sites he wanted her to notice by perforating them with a needle and writing an explanation on the back. The photo clearly was treasured since it has survived in the family's possession. Sophia died at age 54 on July 16, 1895, of a heart ailment.

Sophia was homesick, but she also adjusted herself to her new life and supported her husband and children. Maggie Schelter was not so lucky. She arrived in South Bend in 1850, as a young girl of 20, in the company of her older sister Anna Maria and her brother Johannes. By 1880, she was mentioned as "the unfortunate Maggie Schelter, of county asylum notoriety."[81] In 1879 and 1880, Maggie had given birth to two baby boys in the asylum, both of whom died. That same year, John Schelter, a cousin of Maggie's father, committed suicide by stabbing himself with a butcher knife.

The language barrier was a major reason for the women's isolation. The men learned English on the job, but the women had less opportunity to learn the language. This inability to speak English cut them off not only from society but eventually even from their own family. John C. Schelleng said that he could not communicate with his German grandmother. "As far as I know she spoke very little English, even after a half century in this country." "Now," she would say, "That's a tree. If they'd call it a *Baum* you'd know what they meant!"[82]

Beyond work, the men also got together among themselves in their social clubs. It was only in 1904, over 40 years after its establishment, that the *Turnverein* added a Woman's Auxiliary or *Damen Verein*. It was a purely social auxiliary. The ladies gave card parties and organized refreshments. As was noted in 1911, the women "entertained their husbands

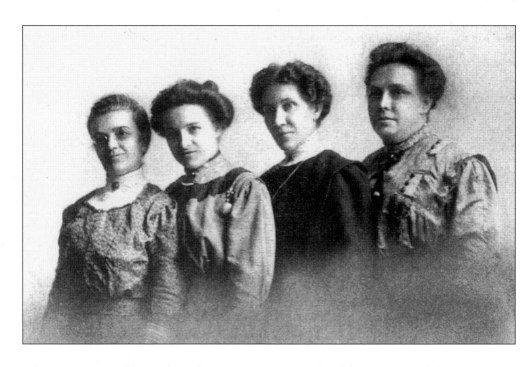

The Damenverein *of the South Bend* Turnverein, *1911 are, from left: Mrs. Otto Liebelt, treasurer; Mrs. Charles Engel, vice president; Mrs. William Sommerer, secretary; Mrs. Gus Goehner, president. (From* Goldenes Jubiläum des South Bend Turnvereins, *1911.)*

and friends in a most loyal manner. The *Damen Verein* has been a great acquisition to the South Bend Turners, the success of entertainments, fairs, etc., being due to their diligent and earnest work."[83] The club started with 22 charter members in 1904, and by 1911 had grown to 66 members.

There were a number of single women who came to South Bend from Germany on their own, although most were following relatives. In his 1846 letter, Schreyer had made much of the opportunities for young women; "girls especially are eagerly sought after for service, and have ample opportunity to marry as soon as they desire." He noted that girls did not stay and work at home but rather went to the cities "where they earn a dollar a week and that for light work." All the single women, for example, who came over to South Bend on the ship "Ocean" in 1853, listed their profession as servant. Little is known about what happened to these and other young servant women. Some appeared briefly as boarders in one of the German boarding houses in South Bend, and then were not heard from again. They may have left, married, or died early.

But here and there we do get glimpses of the fate of these women. The sisters Esther and Johanna Kropf, for example, emigrated from Arzberg in the 1850s with the help of some funds from relatives. After that they appeared briefly in references and greetings to the "Kropf girls" in letters to Christian Sack to whom they were related through their mother Elizabeth Sack. From 1871 to 1880, the two women lived at 20 Michigan Street. They were not listed in the city directories of 1881 and 1882, but in 1883 they reappeared in a new location at 424 Michigan Avenue. There they remained for the rest of their lives, always listed as dressmakers, and always living together. Johanna seemed to have stayed

single. Esther sometimes was listed as Mrs. Esther Kropf, and once as the widow of Oscar Kropf. In contrast to the sisters and their steady work, Kropf did not appear to have settled down to anything. He was alternately a clerk, a traveling salesman, and, briefly, proprietor of a crockery store at 127 South Michigan Street. Apart from their work, Esther and Johanna Kropf were very active as amateur actresses, appearing repeatedly on the playbills of the German Dramatic Society. Esther died in 1906, and Johanna in 1911.

The daughters of educated professional families could make a career for themselves in South Bend, even if they did not get married. Both Rosa and Thekla Sack became well-known school teachers in South Bend, Rosa teaching music and Thekla German. Since their father had been passionate about learning, his daughters received an excellent education. Thekla studied at Berkeley, at Middleton College in Vermont, and at the University of Chicago. Like her father, she was interested in music, and belonged to the Music Study Club and the Progress Club. It was Thekla who translated the Schreyer letter. The two sisters lived together all their lives and both died in 1943.

Divorce was uncommon among the German immigrants.[84] One such rare case was that of Wolfgang and Emma Bellman. However, they continued to live near each other, and Emma continued to cook meals for her ex-husband, which were brought to him every day by his children. Another divorce was that of Karl Kuespert, who afterwards returned to Germany. Johann Balthasar Muessel and Eva Katharina Riess, who had been married in Arzberg in 1838, were separated at the time of Johann's death in 1876. He died when he fell out of an open window of the boarding house where he was staying. It was a hot night and he had been drinking in the company of John Lederer and others. When he went up to his bed between 1 and 2am, his room was still stifling. So he moved his bed right up to

Katharina Margareta Sack. In 1849, at age 16, Katharina had followed her father to South Bend, one year before the rest of her family. (Courtesy Erwin Scherer.)

Eva Katharina Elbel Kunstman (1799-1879) was loved and respected by her family. (Courtesy John H. Schelleng.)

the window. It was surmised that he fell out when he turned over in his sleep. Their daughter Barbara Muessel was divorced from her husband Edward Buysse, but then later remarried him.

Women, who did not have the vote, and had little part in business and politics, were rendered almost invisible. For example, only immigrant men were naturalized in Indiana in the 19th century.[85] Similarly, the German naturalization document of return immigrants Friedrich and Emma Riess listed only the man as an American citizen, and did not mention Emma. According to Johann Wolfgang Schreyer, women could inherit from their husbands. However, upon the death of a wife, the husband got everything, but at the death of a husband the wife could only receive one third, with two thirds going to the children.

Men said little about the women in their lives, and the women themselves remained silent. Thus Schreyer concluded his letter saying about himself: "I am now, thank God, well and strong, contented and happy, and only regret that I have not come to this country sooner." The only reference to his wife came as an addition: "My wife, I am sorry to say has not been well for a year and a half or two years." This time span, in fact, comprised almost their entire stay in America so far. There was no indication of Mrs. Schreyer's feelings. Her only statement came after her husband's death when she was 70 years old. Her husband's letter had found its way back to America and Mrs. Schreyer dedicated herself to preserving it. At that time, looking back upon her own life, she added her own brief reflections; "I have had much sorrow, suffered long and apparently hopeless periods of illness, but I have also experienced many joyful hours."

Yet Margaretha Schreyer was a strong woman, who actively and creatively helped those around her. When she came to their farm in Indiana and saw that there was no medical help available in the country, she asked her brother, who was a doctor in Arzberg, to send her medical books. With their aid, Mrs. Schreyer took it upon herself to help the sick and

Antonia Wurstner Kamm is pictured in 1896, at the age of 75. She helped to deliver most of the babies in Mishawaka. (Courtesy Beth Kamm Reising.)

deliver babies. Yet nowhere in his long letter did her husband mention that his wife served as "doctor" for their neighbors. Despite Schreyer's silence, however, Margaretha's daughter was very proud of her mother's readiness to help in emergencies, and told her own daughters often about their brave and clever grandmother.

Even though often isolated and silenced, many a pioneer farmer's wife earned the love and respect of their families. Thus Johann Christoph Schelleng described his great grandmother Eva Katharina Kunstman; "Toothless like most of the elderly in that age of undeveloped dentistry, she was bright-eyed and dark-haired, a pleasant looking old lady. Not wearing glasses, she complained that needles were not as good as they used to be. Beneath a generous quilted skirt there was an ample pocket in her petticoat where she carries candy, nuts that she had gathered—hazel, hickory, and walnuts—and apples, and I assume that she gave them to good little girls and boys. She did indeed think a lot of her grandchildren and they of her. On weekdays she wore a black bonnet, but on Sundays changed to one of lace.[86]

Other women acted heroically beyond the confines of their own homes. One such pillar of strength was Elizabeth Miller Ritter, the oldest daughter of the German Baptist minister David Miller. She came to the South Bend area in 1829, bore 13 children, and tirelessly helped others in need. Elizabeth Ritter "was famed far and near for her medical knowledge and skill in nursing all kinds of sickness. Leaving her bed at any time of night, often riding twenty or forty miles on horseback to respond to the call of sickness and distress, to assist at the birth of a child, to care for the dying and prepare the dead for their last resting place."[87]

Antonia Maria Wurstner Kamm, mother of the brewery owner Adolphus Kamm, also did not restrict her activities to her own family but served as midwife for the community, delivering most of the babies in Mishawaka. She, too, got up at any time during the night that

she was needed to help the women around her. When she faced a particularly difficult delivery, she would step outside the house for a moment, lift her arms to heaven, and pray. It is said that in her long career she never lost a mother or a baby. She attributed her success to God's help, but she also relied on her own skills. Antonia Kamm was a strong-willed and forceful personality. Whenever she delivered a baby, she insisted that the husbands stay with their wives through the entire procedure so that they might fully appreciate that "labor" was indeed an accurate description of what women had to endure.

Antonia Kamm loved music and insisted that each of her children and grandchildren learn to play a musical instrument. She herself had a beautiful singing voice. One of her favorite songs was the "Lorelei," a German ballad about a mermaid and an enchanted castle on the Rhine River. It begins with the lines: "I don't know what it means that I am so sad, but I can't get an age-old tale out of my head." The German song, and its melancholy contents no doubt reflected some of Antonia's homesickness. According to family history, she sang that song the night before she died.

Laura, Adolphus Kamm's oldest daughter, started to work in the brewery office when she was 18 years old. When Kamm decided to retire early, Laura took over the management of the office, while one of her brothers oversaw the production. She worked in the company for 45 years and was "one of the highest ranking women ever in local business."[88]

The nuns of the South Bend area were further examples of women providing nursing and teaching services so desperately needed in the new country. The Sisters of the Holy Cross at Notre Dame often took long trips on horseback to minister to the sick. They also created orphanages for the Indian children and worked as teachers in the South Bend academies. The nuns not only provided an excellent education, but they encouraged the young girls in their care to think for themselves and make the best of their lives. The German sisterhood of the Poor Handmaids made it their mission to nurse the sick and especially dedicated their lives to those with dangerous contagious diseases, such as cholera.

Whatever their differences, German immigrant women and men alike agreed on one point—they both were struck by the courtesy American men showed towards women. To the amazement of the immigrants, American men even helped with household chores. In his letter, Schreyer also noted the politeness toward women of American men, who would rise when a woman entered a room and offer her a seat. The women, he found, enjoy the greatest respect. One German woman traveler, even though quite emancipated herself, still found it comical to see a man, dressed formally in a coat and top hat, come from the market carrying baskets of food. She felt that while in Germany woman was the slave of man, in America man was the slave of woman.[89]

The few documents by women point to vastly different perspectives between male and female writers. Unlike the men who felt that "the women folk have it easy,"[90] women immigrants would have sided with such German-American women writers as Therese Robinson, Mathilde Anneke, editor of the feminist *Frauenzeitung* in Milwaukee, and Kathinka Sutro-Schücking, who all agreed "that the New World meant sacrifice and trauma for immigrant women."[91]

VIII.

Politics and Loyalty

German immigrant John B. Stoll, who owned the only Democratic paper in Ligonier and became the publisher of many papers throughout Indiana, was a fervent partisan all his life. As a result of his political engagement, he was courted as well as vilified by the Republicans. Stoll became the target of attacks that ranged from the bizarre to the life-threatening. One of the more unusual ways the Republicans used to try to get Stoll to give up his allegiance to the Democrats was to aim skyrockets in such a way that the shells would fall on his roof and into his yard. Even odder, a naked man in a pushcart was hauled up and down in front of his house. On several occasions, in more serious attacks, men armed with revolvers tried to prevent him from speaking. Once, Stoll had to interrupt a speech at the Goshen courthouse because dynamite was found under the steps where he stood. When he resolutely moved to the steps on the other side of the building, dynamite was discovered there as well, and he finally had to give up completely. After this episode, Stoll started to carry a small leather hand-billy heavily loaded with lead. When his friends heard of this, they began to give him lead canes, and he soon collected an interesting assortment, including one from Dodd City, Texas, that had gold coins melted into the head as a sign of their appreciation.[92]

Stoll was just as vehemently courted by the Republicans as he was attacked by them. While he was in Ligonier, the Republicans went to great lengths to win him over to their side. They created a conference whose secret aim was to convince Stoll to relinquish his Democratic allegiance and join them. At the same time they offered him $2,500—about $40,000 today—as well as a Republican Congressional nomination, which was tantamount to election, and, avid newspaperman that they knew him to be, his choice of a newspaper either in Kendallville or Fort Wayne. Stoll, however, simply returned to Ligonier and continued his work.[93]

Until the 1850s, the majority of German immigrants belonged to the Democratic Party. The Whigs were seen as anti-immigrant and elitist, while the Democrats at that time were the anti-nativist party. The nativists or "Know-Nothings" wanted to keep America free of "foreigners." In 1846, the *Wisconsin Banner* warned its German readers not to trust the Whigs, who had always opposed the rights of the foreign born. In his letter, Johann Wolfgang Schreyer described the presidential election of 1845, in which "the Democrats were the victors by a considerable majority. It was said during the campaign that if the Whigs should gain the victory, no German shall hereafter become a citizen after less than a twenty year's residence. Indeed the views of the Whigs are such as to limit our freedom." The only German newspaper in Northern Indiana, *Der South Bend Courier*, called itself "liberal Democratic."

However, between the election of 1852 and 1856, many Germans switched over to the Republican Party. This was thanks in large part to the efforts of German immigrant Carl Schurz. When Schurz first arrived from Germany in 1852, he joined the Democrats, but with the creation of the Republican Party he became a passionate supporter of Lincoln,

performing "Herculean labors for the Lincoln ticket."[94] Early on, Lincoln recognized the importance of the German vote that in many Midwestern states "represented the balance of power at the polls,"[95] since during the 1850s the German-born population increased by 118 percent.[96] Lincoln even tried to learn the language, struggling with German grammar, and in the 1850s he bought the German newspaper of Springfield, the *Illinois Staatszeitung.*[97] The Germans sided with the Republicans on the issue of slavery. But most importantly for German voters, Lincoln supported a resolution against lengthening the time required to become a naturalized citizen, whereas the nativists demanded up to 20 years for naturalization. This resolution, called the "Dutch Plank," written by Carl Schurz, was adopted at the Republican national convention of 1860, and that same year the national *Turnverein* organization decided to support the new Republican Party. German immigrants now saw the Republican Party as the chief defender against the Know-Nothings, who made their strongest showing in the first half of the 1850s, winning national, state, and city elections all over the country.

As in the rest of the nation, in Indiana in the early 1850s the Know-Nothings became "the most powerful political organization of its day,[98] with councils in practically every town and community in the state."[99] Their chief targets were Catholics and foreigners. The Know-Nothings feared that the United States might come under papal control and that the huge wave of immigrants would change America's moral and economic welfare, making it harder for native-born Americans to earn a living. It must be stressed that nativist sentiments are present in any society, since there is always the temptation to scapegoat the other for one's problems and to fear the unknown. The result is a xenophobic populism, which in 1850s America gained such unusual strength because of the record immigration at that time, coupled with a general political uncertainty as the Whig Party was disintegrating. Many former Whigs moved over to the Know-Nothings.

Although the Know-Nothings targeted Irish Catholics in particular, German immigrants also came under attack with assaults on *Turnverein* parades and other public German gatherings. In Cincinnati in 1855, Know-Nothings tried to stop the Germans and the Irish from voting, which resulted in street fights and several deaths, and election riots in Louisville left over 20 people dead. A *Turnfest* in Columbus that same year turned into a riot with the attackers venting their anger against the "white jackets," as the Turners were dubbed.[100] For the Germans in turn, these attacks had the effect of binding the disparate groups of immigrants together into a united front.

It is not clear how strong the Know-Nothing movement was in South Bend since its main strength was in southern Indiana. A secret society, it kept meetings and members hidden from public view. What is known is that in South Bend Schuyler Colfax, who was to become vice president, promoted Know-Nothing issues in his *St. Joseph Valley Register.* For example, he wrote on June 21, 1855, "we have condemned the efforts of the Papal Church and its dignitaries, to stride onward to commanding political power in the Nation…we have protested against the unjustifiable conduct of foreign authorities in emptying upon our hospitable shores, by the shipload, the inmates of their prisons and their poorhouses."[101]

It is also fairly obvious that Father Sorin of Notre Dame, the head of the biggest Catholic organization in Northern Indiana, with a large number of Irish, French, and German members, saw his institution as a possible target for Know-Nothings in the area. In response, he showed a "keen desire to keep clear of any connection with public politics."[102] Another possible indication of the strength and the violence of the Know-Nothings in the South Bend area was the fact that the Sisters of the Holy Cross were prevented from

starting St. Mary's Academy in Battell Park, Mishawaka, because "fanaticism and bigotry of a violent type drove them away."[103] As late as Christmas 1872, a Know-Nothing burnt down the first Catholic Church in South Bend, St. Joseph's Church located on Hill Street. The cause of the fire remained a mystery until a man, in a deathbed confession, admitted he had set it.[104]

Despite the accusations of the Know-Nothings that the immigrants were unpatriotic, a great number of German immigrants volunteered during the Civil War. The census of 1860 showed that the Germans supplied a proportionately larger share of volunteers for the Union army than either the native-born Americans—many of whom hired substitutes under the bounty system—or the Irish.[105] In the South Bend area as well many German immigrants fought on the Union side, to the extent even that German organizations like the *Turnverein* and the Dramatic Society had for the most part to cease operation during the years of the war.

On August 12, 1862, the *Turnverein* honored the members of their group who had volunteered to join the Union army. They were Wolfgang Elbel, William Gross, Hiram E. Hardman, Charles Hinderer, Elijah Kertell, John Kleindienst, J.F. Meyer, J.M. Meyer, Jacob Riedinger, Daniel Schiller, and B. Siegel. Caspar Rockstroh had helped to collect subscriptions to aid in forming and equipping volunteer companies. The ever-generous George W. Beck spent thousands of dollars to secure substitutes so that drafted men could stay home and support their families. The musicians Lorenz, Johann, and Henry Elbel and their band volunteered their services and were mustered out at Nashville at the end of the war. Andrew and Christian Bellman, originally Poehlman, of the 48th Regiment, Company H of the Indiana Volunteer Infantry, also served and were discharged 12 days after the surrender of the Confederate Army in Vicksburg.

Many German immigrants were part of the 1st German, 32nd Regiment Indiana Volunteer Infantry, which departed from Indianapolis. The *Indianapolis Journal* reported that "It was beyond question the finest regiment that has left our State, and we doubt if any state has sent out a body of volunteers their equal in all respects."[106] In December 1861, the 32nd won the battle at Rowlett Station that "provided a victory for Northern Arms on the fields of Kentucky at a time when the Union suffered embarrassing losses and setbacks on other fronts."[107]

Among the German immigrants to volunteer was Christian Sack's nephew Andreas, who in a letter to his uncle described how on their march to Pittsburg Landing they landed on the Tennessee River "despite the great distance, we could hear the cannons thunder all day, so that the earth shook."[108] He was with the 9th Indiana Regiment, which had a big battle on April 7, 1862. In a letter from Camp Wood, on the Green River, Andreas complained of the constant rain. "Last week it rained every night, and I had nothing but wax cloth; I believe that constantly lying in water, always cold and sleepless, has ruined my health." Andreas longed for beer, wheat bread, and sour salad. "But the hard tack without salt or *schmalz* [a mixture of goose and pork lard] has a sweet disgusting taste." Andreas praised the round tents "in which 16 men can easily have room; the tents are also very high, making a point at the top where there is an opening through which fresh air can come in all the time when it's not raining."[109]

Andreas enjoyed the music in his camp, provided by the German immigrants. "The regular soldiers have excellent music with piccolos and clarinets; they even play heavy overtures and Strauss waltzes…. We have often played the favorite quick step of Mr. Christian Elbel; everyone likes to play it. I love to hear especially the two last parts… I am enclosing a waltz which I composed and arranged for brass. Please ask Mr. Christian or

Erhard Elbel to be so kind as to look through it. I would like to know the mistakes; and if it is worthy to be played, he can copy it out since one can find out the mistakes best when one hears it played."

By May 15, 1862, Andreas noted that every day more deserters came to their camp and that even if there were to be another battle it could not last long.[110] Two years later, *Turnverein* member Daniel Schiller sent similar observations about desertion to Christian Sack. Schiller, stationed at Fort Johnson in Nashville, wrote that deserters came to their camp, who "have no clothes nor shoes, their feet are gangrenous and they don't want to fight any more." As for his own duty, he indicated that he was having an easy time—after only two hours of exercise, he had the rest of each day off.[111]

Christian King, presumably related to Christian Sack's wife whose maiden name was Koenig, also wrote to Sack from the war, giving the perspective of an ordinary soldier living with American soldiers rather than other immigrants. Not only did Christian Anglify his name from Koenig to King, he also wrote his letters in a semi-illiterate Germanified English. In a letter of 1864, from Trinana, Alabama, he said that the daily drills lasted no more than an hour and a half, and that they had good quarters and plenty to eat. He got $15 or $20 worth of cotton for his mattress, and "it makes a very good bed." He also enjoyed a two-day scout during which within two hours he picked enough blackberries for six pies. Nevertheless he was anxious to return home and wrote his uncle asking; "Have you heard anything aboud the Indina Sodiers goin home this fall that is the talk here but I dond believe it yet a while but I hope it is so…If I live throw that and get home I think I will stay home…"[112]

After the war, a period of economic boom began in the United States. Schurz, who had been a somewhat controversial general having gotten the appointment in gratitude for his vigorous campaigning, now tried to construct a liberal Republican platform amidst this growing prosperity. In 1869, Schurz was elected senator in his state of Wisconsin, and he served as secretary of the interior under President Hayes from 1877 to 1881. But, finally, disappointed in his efforts to liberalize the Republican Party, Schurz returned to the Democrats. Nation-wide, many Germans once again followed his lead.

In South Bend, however, the Germans for the most part voted Democratic. Yet it is often difficult to ascertain their political affiliations, since the election records in the city archives begin only in 1890, and the newspapers for the most part did not report city elections. John C. Wagner Jr., owner of Union House on Michigan Avenue, was both city and county chairman of the Democratic Party and a member of the state central committee. John Klingel, who served on the first city council, was a Democrat like the rest of his family. His brothers Adam and Alfred were lifelong Democrats.[113] Emma, the daughter of John's brother Valentine, was married to Charles Goetz, the first mayor of South Bend of German extraction, who also was a Democrat. Goetz was a manufacturer of fine cigars, with special brands Mirella and Goetz No. 1, whose business was at 125 West Washington, next to a Klingel shoe store.

The Germans did not hold local elected offices in any significant numbers until the 1880s. By then they had grown in numbers to a critical mass, especially in the 1st and 4th wards. However, at the same time that they firmly established themselves in their new home, they also became so acclimatized that their ethnic background mattered less and less and did not determine significantly their political affiliation. Many of these politicians were the sons of the original immigrants.

In the 1880s, several German-Americans represented the 1st ward. They were T.E. Knoblock, probably a Republican like the rest of his family, 1883-1886; Henry F. Elbel, a

Democrat, 1888-1891 and again 1900-1902; Adolph S. Ginz, a democrat, and son of Henry Ginz, 1889-92; J.B. Haberle 1892-1894; Isaiah H. Unruh 1894-1897; and John Beyrer 1898-01.

Germans were even more strongly represented in the 4th ward. Andrew Russwurm, a Democrat, and owner of the leading harness-making shop in South Bend, and one of the founders of the *Germania* Club, was the very first councilman of that ward in 1867-68; then followed Dr. Simon Raff from 1874-75; Jonas Lontz 1877-78; J.A. Neuperth 1879-80; Samuel Lontz 1881-82, and again in 1887-88; J.C. Dille 1883-86; John Friedrich Weiss, a Democrat, 1889-91; William Schermann 1898-1899; and Gustav A. Stueckle 1900-02. Frank Vahlert also was prominent in 4th ward politics as a Democrat.

The second ward mainly had native-born representatives, such as T.S. Stanfield, 1865-1869; Clement Studebaker 1870-1872; David Stover 1880-1883; and William H. Longley 1883-1885. Christopher Fassnacht, president of the Indiana Lumber and Manufacturing Company, was the first councilperson in the second ward of German origin, serving from 1889 to 1890. George A. Knoblock, 1898- 1901, was the next.

After John C. Knoblock, who served as town trustee from 1860 to 1862, and on the Board of City Commissioners from 1866 to 1870, the first German city officer was John A. Hartman, who was street commissioner from 1866-67. In 1870 and 1871, George Pfleger was city judge. David Haslanger served as justice of peace in the late 1870s and 1880s. John Wagener was treasurer from 1888-91. In 1894 and 1895, John C. Knoblock's son, Otto, was trustee. Second generation David B.J. Schafer was mayor for a term in 1894, and also second generation Charles L. Goetz served on the Board of Public Works in 1901 and 1902. He became mayor of South Bend for one term in 1910.

In the county, John Zeitler, a Democrat, was Clay Township assessor, and John A. Zaehnle, son of one of the earliest immigrant farmers Arbogast Zaehnle, was trustee and assessor of Harris Township for 10 years. He was a Democrat as well. John N. Lederer, also a Democrat, was County Commissioner in the 2nd District in 1892. William Geltz, a Republican, and son of George Geltz, was assessor of St. Joseph County in 1900. George Rockstroh was county sheriff from 1884 to 1886.

Some wealthy German industrialists like John C. Knoblock, Adolphus Kamm, and Martin V. Beiger, were staunch Republicans. In 1868, a German Republican club was established in South Bend. On August 6 of that year Schuyler Colfax sent the club a letter of thanks, saying that he was pleased "to find at my residence a beautiful pole raised, with the Stars and Stripes floating from it, and a streamer also, with Grant and Colfax upon it in German text."[114] On July 4, a year later, Colfax gave the dedicatory speech at the opening of the new hall of the *Turnverein*. He appeared to have courted the German vote as early as the 1850s. In a letter of 1856, which he wrote from Washington to South Bend resident Charles Heaton Sr., he suggested that South Bend should take an example from La Porte, Indiana, which had "a large share of the Germans and have had a fine German Republican meeting."[115] Yet he did not want it to be known that this was his idea, since he repeatedly asked his friend to keep this letter strictly confidential. The fact that Colfax, who had promoted Know-Nothing sentiments in his newspaper, also could associate himself with the German immigrants may be another indication that the Know-Nothing movement was not particularly strong in South Bend.

Very few German immigrants became involved in politics beyond the local level as did Henry Ginz. Their background in Germany had not accustomed them to political action, and once in America, they were too busy building their lives. Yet some Germans were frustrated by this lack of interest, and the German papers encouraged the immigrants to

become at the very least more politically aware. The *South Bend Courier* showed that in 1900, despite the high percentage of German-Americans in the country, there were only seven members of congress and two senators of German extraction in Washington. Most immigrants resembled the man who, when asked whether he was a Democrat or a Republican, responded that he was a Protestant.[116]

If they had a political orientation, the majority of middle and working class German immigrants in South Bend stayed with the Democratic Party through the 19th century. However, except for lifestyle issues such as Temperance, they had few political interests that united them. The two exceptions were slavery and above all the Know-Nothing movement, which for a time made them cohere into a united front. But over the years, the Germans increasingly chose their political party for economic issues rather than ethnic considerations. Addressing, for example, "all voters of German descent" to support Harrison for President in 1892, a group of German immigrants argued that Harrison worked for the protection of American industry through tariffs and not, like the Democrats, for free trade.[117] But whatever their party affiliation, the Germans always were anxious to stress that they were loyal Americans.

Whatever their political affiliation, however, the German immigrants, into the second and third generation, stressed that they were loyal Americans even if they still felt pride in their German heritage. Second generation Thekla Sack wrote in 1904 that "the German who does not thrill at the memory of this noble, heroic ancestry…is a degenerate whose faithlessness to his mother country permits his loyalty and devotion to his adopted land to be seriously questioned."

The Forty-Eighters

*I*mpatient with the romanticism of his nephew Andreas, Christian Sack wrote him a letter in 1855, in *which he outlined his own philosophy. Andreas had claimed that the "dear God" had created him "not to make money but to cultivate his heart." Sack responded; "Such words are drivel. As long as you cling to this idea you will be the play ball of other people. You will help other people to get rich, but you yourself will remain a poor dunce who will achieve nothing less than the cultivation of your heart; for this you can win only through money, which is the mainspring of everything. To me you need not blather at all about notions such as for what God has created you, if nothing will become of you. Remember that you are descended from your parents and not from God, and that I do not believe in such things without therefore being a bad person.... If you have to have cultivation of the heart, if you have a yearning for science and education, then come to me. Here you can pay tribute to music together with me without needing to make a sad business of it. I can introduce you to both nature and art in chemistry, physics, and natural history. In this way you will achieve cultivation, and your yearning for higher things will be satisfied without taking refuge in mathalistic (?) or any other nonsensical raptures which will only oppress you and keep the light of truth away from you."*[118]

A large group of immigrants came as a result of the failure of the 1848 revolution, which helps to account for the peak immigration in the 1850s. The "Forty-Eighters," as they were called, tended to be educated, liberal, sometimes radical, and politically active. They were set against all forms of dogmatism, and against religion since during the revolution they had seen the church siding with the authoritarian rulers and helping to suppress any ideas of liberation.

Arriving in America in large numbers and with their energies unabated, the Forty-Eighters reinvigorated German-American culture. "No immigrant group before or after them manifested the enthusiasm and the spirit of these erstwhile revolutionaries, and no group left such a deep impression upon German-American culture."[119] They helped to make German-Americans "into one of the most important groups in the American population during one of the most critical periods of American history."[120]

In South Bend, the Arzberger Christian Sack, who had been a revolutionary when he was a student in Germany, was a good example of a Forty-Eighter. Sack was born in Arzberg on December 28, 1820, the 10th of 16 siblings. His father was a respected Arzberg citizen, a master butcher who became a city councilman in 1823. Christian Sack received a good education, first at the gymnasium at Hof, about 30 miles from Arzberg, and then, thanks to a full scholarship, at the University of Erlangen, where he studied theology from 1841 to 1844. He soon realized, however, that he was not cut out to be a minister. During 1848 and 1849, Sack participated in revolutionary activities, and was included on the list of those who were "promoters against the throne and the government." A letter addressed to him on May 16, 1849, in response to his support of the political prisoners of Freiburg, commented; "What you

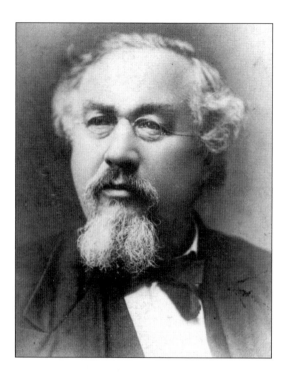

Johann Christian Sack was a Forty-Eighter, South Bend physician, and Turnverein *activist. (Courtesy Erwin Scherer.)*

have the kindness to write me about the active political life of your environment gives me untold pleasure. It is high time that we all stand ready for war and ready to act. For the red monarchies, damned Prussia in the lead, are really acting in too beastly shameless a manner. They will not win if all of us continue to battle bravely. But it still will be a long fight." The letter included a receipt for 14 guilders and 6 pennies that Sack had collected for the prisoners.[121]

A long and emotional letter of November 11, 1848, addressed to Sack, throws further light on the mindset of young men like him and the spirit of the times. They were often impetuous, and not always practical, but driven by a love of freedom and a hatred for the oppressive conditions they encountered everywhere in Germany. The writer, signed Johann, said that he could not open his heart to anyone else but Sack, his "dearest friend." "I know you hate everything that is ignoble and low as much as I do and you detest everything that could hinder the free development and greatness of our homeland." Johann went on to say that only the hope of a unified Germany sustained him when he was so frustrated that he almost wished himself dead. "When during the course of this year I got news of the grand uprising in all parts of Germany, I thanked the Lord that I could witness such a wonderful day and wouldn't have minded to be laid in my tomb at that very moment, knowing the one wish of my life fulfilled. But how deceived was I, and thousands with me! Up until June 27 of this year…nothing could have persuaded me that anything at all could have hindered this great reconstruction.…But already on August 6, the day on which the Central War Ministry was too cowardly to enforce its decree concerning the oath on the flag—from this day on I began to doubt this…force and to despise its thoroughly half-hearted rules.…Oh, if only then a determined step had been taken; those creatures that oppose liberty would lie destroyed at our feet and so much dear German blood could have been saved in the fight against those contemptible forces who want to lead us back to those egotistical court policies that have subjugated Germany for so many years." Johann

said repeatedly that he was no "genuine revolutionary," but wanted to have "a different, more independent position." "I hate violence and lawlessness, whether it comes from above or below and am as little a revolutionary republican as I am an absolutist."[122]

Perhaps the conservative posture of the church during the revolution played a role in Sack's abandoning his chosen profession as minister before he ever took it up. Instead of looking for a position as vicar, he became a preceptor in the castle at Wölsauerhammer, located less than 10 miles from Arzberg. While working as a teacher, he decided that what he really wanted to do was to study medicine. He used the support of friends, earnings from his teaching, and loans to help him finance his studies. As soon as he was finished, he left for South Bend. He arrived in America on July 5, 1855, having gained free passage from Le Havre to New York by working as a ship's doctor.

In South Bend, Dr. Sack established a successful practice as a physician and surgeon and at the same time was one of the most active promoters of the educational and cultural life of the city. Sack was part of the first Choral Society, which he helped to start almost the moment he arrived in South Bend. He also became an active member of the *Turnverein*, believing in its principles of both physical and mental exercise. His university days had made him an expert swordsman and he served as fencing instructor for the *Turnverein*. A lover of literature, he also worked as director of the *Turnverein* Dramatic Society that produced German language plays.

As is evident in the education of his children and the guidance he gave to his grown nephews, Sack remained a freethinker all his life. He believed in freedom through education and a scientific materialism tempered by an appreciation of art and culture. Like Schurz, he combined a love for German language and tradition with a commitment to his new home.

As a doctor, Sack did not limit his professional service to the German community. In 1875, he was instrumental in reorganizing the Saint Joseph County Medical Society, where he served as second vice president. Sack died on April 12, 1889. As an indication that he had gained repute among both the German and the English-speaking communities of South Bend, at his funeral one eulogy was given by Georg Geyer, a prominent member of the *Turnverein*, and another by the Hon. A.L. Brick, a native-born prosecuting attorney of the St. Joseph Circuit Court.

Henry Ginz was another Forty-Eighter in South Bend, but unlike Sack's focus on science and culture, Ginz was mainly interested in business and politics. He was born on February 6, 1830 in Alzey, Rhein-Hessen. After finishing his schooling at age 14, he was apprenticed to learn the cabinet maker's trade. He served as sergeant under the command of Franz Sigel, who between 1843 and 1847 was an officer in the army of the Grand Duchy of Baden. In 1848, Ginz followed Sigel to join the revolutionary forces. Sigel, another Forty-Eighter, emigrated in 1852, and later became a well-known Union general in the Civil War. After the failure of the revolution in Germany, Ginz, like many others, escaped to Switzerland. When a few months later, all non-commissioned officers and privates were granted a pardon for their revolutionary activities, Ginz briefly returned to Germany, but emigrated in 1854. He worked as cabinet maker for 10 years in La Porte and 5 more in Indianapolis, and then came to South Bend in 1869, where he opened his grocery store and bakery. He did well in that business and in 1872 was able to buy an interest in the Knoblock Flour Mill.

Ginz was active in the Democratic Party, and became one of the few Germans who held political office beyond the local level. He was elected to the state legislature in 1878, less than 10 years after arriving in South Bend. Although he ran as a Democrat in a Republican district and his opponent was the prominent and popular Judge Thomas S. Stanfield, he won by a handsome majority.

Henry Ginz was a Forty-Eighter and Democratic Indiana state representative. (From South Bend and the Men who Have Made It, *1901.)*

Sigmund Mayer of Plymouth was another Forty-Eighter who stayed politically active, being a council member twice, the first time in 1873, when Plymouth was incorporated, and then again in 1875-1876. He was married to Hannah Schane (Schoen?) and they had 10 children. Unlike Sack and Ginz, Mayer was a Republican. He must have had national connections because the *Weekly Republican* said that at his funeral in 1912 "the largest number of strangers were assembled who have been in Plymouth for many days."[123] Flowers came from as far away as Chicago, Des Moines, and Seattle.

Men like Sack, Ginz, and Mayer, who had escaped from the repressive and rigid German class system, hoped to create a new free and cultured society in America. They had faith in a community founded on education, a spirit of liberty and equality, hard work, and independence. It was after the arrival of the Forty-Eighters that German clubs and cultural organizations blossomed in South Bend. But, as Sack's letter to his nephew Andreas also showed, the Forty-Eighters tended to be outspoken, to say the least, and sometimes arrogant and intolerant. This attitude brought them into conflict, not only with the Know-Nothings, but with conservative Germans and Americans alike, who saw in their radicalism a threat to religion and to American institutions. Nevertheless, in their political as well as their cultural and intellectual activism, the Forty-Eighters were an invigorating force for the older immigrants. "Like a stone thrown into still water, the Forty-Eighters produced waves in the German-American pool high enough eventually to affect the entire American cultural pattern."[124] They affected not only the German-American community but the larger American one in which they had made their home.

A Center of South Bend's Social History

*T*he night of February 6, 1883, Mardi Gras, was a wild and wintry one in South Bend. A blinding storm had covered everything in a thick layer of snow, making the roads almost impassable. The few gas lamps, lit to point the traveler's way on the main roads, were all but powerless against the blowing and drifting snow. The temperature was zero degrees, but the bitter wind made it feel even colder. Nevertheless a stream of people and carriages made their way to the northern edge of the city, the corner of Marion and Michigan Streets, where the bright lights of Turner Hall greeted the adventurous guests with a promise of entertainment on a scale not otherwise known in South Bend. No one wanted to miss the 22nd annual masquerade put on by the Turnverein.

By eight o'clock on that inhospitable night Turner Hall was crowded, but more and more people kept arriving. At nine o'clock the stirring sounds of Lorenz Elbel's cornet band indicated the moment had come when the carnival procession made its dramatic entry into the hall. Prince Carnival, impersonated by N. Weinberg, was the first to appear, followed by a band of revelers in grotesque costumes. After the prince had welcomed the audience in a ringing address, came a parade by the "kitchen brigade," "a muscular lot of kitchen girls armed with kitchen weapons and commanded by Chief Cook Mose Adler, who flourished a ladle of immense proportions in order to control the movements of his subjects who went through with some evolutions that created a great deal of merriment among the spectators." The "Return of the French Army" was another crowd pleaser as a group of Turners, uniformed in grand style, marched around the hall, led by gymnastic teacher Professor Webber. They went through "a number of military evolutions in good shape, even to the stationing of guards on an improvised ramparts in one corner of the hall."

Professor Dennis' invention of a novel musical instrument, the hogcertina, was a particular success with the crowd. It was indeed the head of a hog onto which stops had been constructed. A big crank was attached at the side which, the professor explained, served to wind up the machine. In good professorial style, he first presented a history of the hogcertina. Then the professor, played by William Sherman, set himself to demonstrate what his instrument could do. As he wound it up with the crank, the delighted crowd heard the rattle of a dozen drums. Unperturbed, the professor beat time with a huge baton and started to play. Now the music floated smoothly and softly from his instrument. With rapt attention the crowd listened to Lorenz Elbel's full orchestra, which, hidden by a curtain on the stage, played everyone's favorite tunes. When the professor cranked up his instrument for a second time, the mellifluent voices of the Turnverein singing section could be heard. When at last the instrument failed to produce any more sounds, the curtain came down as the professor was writhing on the floor in desperation.[125]

Organizers of the event were N. Weinberg, J. Rockstroh, T.E. Knoblock, Felix Livingston, John C. Schreyer, Moses Adler, and J. Lay.

The chief German social and cultural organization in the United States was the *Turnverein*, or the Turners as they were known in this country. "*Turnen*" is the German

Turner Hall, located on the corner of Michigan and Marion Streets, was built in 1869 and served as a center of South Bend's social history. (Courtesy Richard Strebinger.)

word for doing gymnastics. The *Turnverein* combined physical activity, including running, jumping, swimming, fencing, apparatus gymnastics, and free exercises, with social and cultural activities. The Turners' societies thought of themselves as educational institutions, engaging not only in physical, but also in mental gymnastics—*"geistiges turnen."* They held lectures and discussions, mounted theater and opera productions, and maintained their own libraries. One of their basic tenets was that "Indeed, no effect on, and no activity of the mind is possible without an effect on and activity of the body, and vice versa."[126]

In Germany the *Turnerverein* movement dated back to the beginning of the 19th century. Its founding father, Friedrich Ludwig Jahn (1778-1852), believed in the classical ideal of a link between strong bodies and strong minds. His theories of physical and mental health also incorporated the ideals of German patriotism, middle-class virtues, and progress through education.[127] In the United States the *Turnverein* was an urban organization started by liberal, educated German immigrants. The movement flourished in the 19th century, with hundreds of clubs established across the country. At its peak in 1894, there were 317 chapters with approximately 40,000 members.[128] It was the example of the Turners that led gymnastics to become part of the curriculum at the U.S. Naval Academy. In many cities, including Chicago and Indianapolis, the Turners were instrumental in introducing physical education programs into the schools.

Many of the first *Turnvereine* in the United States were founded by the Forty-Eighters, and reflect their political engagement. The Turners' motto was "true freedom, prosperity and education for all classes." Accordingly, their newspaper, *Die Turn-Zeitung*, begun in 1853, pledged support to every "social, political and religious reform," and invited the

A display of Turners' gymnastics exercises. (From Goldenes Jubiläum des South Bend Turnvereins, *1911.)*

friends of progress to "unite against the moneyed aristocracy, political stagnation, and ecclesiastical tyranny."[129] At their convention in 1855, the Turners issued a formal declaration against nativism, prohibition, and slavery. Frederick Douglass is reported to have said that "a German has only to be a German to be utterly opposed to slavery."[130] Because of this political engagement which was specific to their new home, the national *Turnverein* organization soon separated itself from its German roots. The executive committee of 1872 declared; "The Turners of America have nothing in common with the Turners of the old fatherland, except the system of physical training."[131]

Yet despite their rather radical critiques of American society, the Turners also were patriotic Americans. At their 1854 national meeting, for example, the organization made its members obligated to apply for American citizenship as soon as was possible. During the political upheaval of the 1850s, the Turners started to become a political force and many supported the candidacy of Abraham Lincoln. After Lincoln was elected president, on the occasion of his first inauguration, he featured a bodyguard made up predominantly of German Turners. In response, members of *Turnvereine* across the nation volunteered for "Turner regiments" to support the Union cause.

The beginnings of the South Bend *Turnverein* date back to 1860. According to Wolfgang Adam Elbel, who was one of the founders, it was John Muessel who got things started in South Bend after having seen an active Turners' organization in Madison, Wisconsin. Within a few days of his return, a group met twice a week to do gymnastics in the backyard of Caspar Rockstroh's house on North Main Street. When it got too cold, they moved into Rockstroh's barn. Then on June 13, 1861, the group issued its first resolution: "We, the undersigned, have decided to organize a *Turnverein* in South Bend. A meeting will be held

this evening at 8 o'clock at Caspar Rockstroh."[132] The roster of the founding members showed their Arzberg roots since only two of the ten, namely Chockelt and Livingston, were not from Arzberg. The others were Andreas Zeitler, Wolfgang Elbel, Gottfried Poehlmann, George Muessel, John Lederer, John Muessel, Charles Hinderer, and Lorenz Elbel.

Membership fees were 25¢ a month and exercises were scheduled twice a week. The original officers were mainly businessmen, on their way to becoming part of the well-to-do upper middle class of South Bend. John Muessel and John Lederer acted as physical instructors; Dr. Christian Sack was fencing instructor and Gottfried Meyer drill master."[133] The first permanent officers were Charles Hinderer, speaker; William Gross, assistant speaker; William Beck, secretary; Fred Neuperth, assistant secretary; Andreas Zeitler, collector; Gottfried Poehlman, treasurer; J.M. Muessel, leader; J.N. Lederer, assistant leader; Henry Kolb, custodian of apparatus; Carl Liebig, assistant custodian of apparatus. The gymnastics apparatus was made by wagon maker John A. Chockelt and Theodore E. Knoblock. The constitution was formulated by Jacob Riedinger, William Beck, Christian Sack, and Gottfried Meyer.[134]

In 1864, the Turners bought their own site, a quarter-block located at Michigan and Marion Streets, for $800. The new hall was dedicated on July 4, 1869. Surprisingly, former Know-Nothing supporter Schuyler Colfax was the principal speaker at the dedication. Two years later, an addition was dedicated, again on July 4. It had a bar downstairs, a kitchen

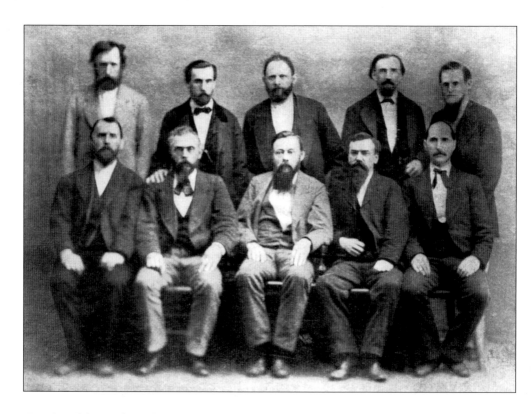

Founders of the South Bend Turnverein. (From Seventy-Five Diamond Jubilee Anniversary 1861–1936.)

and social hall on the second floor, and living quarters on the third. Turner Hall was spacious, with room not only for a gymnasium with the most modern gymnastic equipment, but also a library, a dance hall, and later a bowling alley. As the members of the South Bend *Turnverein* excelled in athletic competitions, ever more victor's wreaths adorned its walls.

Each year during carnival time, the *Turnverein* mounted a masquerade ball. One of the first was in February 1869, which was announced in the paper in the following manner: "Our German citizens are making great preparations for this affair which will be conducted on a grander scale than anything of the kind ever before attempted here. These masquerades are the most mirth provoking of all amusements, and our citizens miss a great treat in not attending them. The following tableaux, scenes from Operettas etc. are in rehearsal and will be presented: "Der Freischuetz," "Die Sieben Schwaben," "The Old Woman's Mill," "The Dudel Sack," and "Die Prezioza." Remember the time Tuesday evening February 9th. Tickets for sale by M. Livingston and Co, J.C. Knoblock, and E. Buysse."[135] The masquerade balls continued to be one of the most successful events for the *Turnverein*. As late as February 1940, in the middle of World War II, 370 people attended that year's masked ball. One hundred forty of these wore masks, with the *Turnverein* singing section turning up in huge masks, each representing a comic strip character.[136]

The "moonlight picnic" was another favorite event, which much of South Bend turned out to enjoy. Sitting at open-air tables with a *Stein* of beer and a bratwurst sandwich were German immigrants and native-born notables. There one could meet John Chockelt, the wagon maker; Godfrey Poehlman of the Meyer and Poehlman hardware store; businessmen Moses and Meyer Livingston; Andrew Russwurm, the harness maker; and many more. But the picnics were also popular with Mayor William George, John M. Studebaker, Schuyler Colfax, Dan Leeper, and other South Bend honoraries. It was another means by which the Turners could promote both their German culture and social interactions with the local society.

The South Bend *Turnverein* combined adherence to the traditions and customs of the members' German origins, such as the carnival masquerades, with a passionate patriotism for their new home. Thus the *Turnverein* organized yearly Fourth of July parades. For the first parade in 1862, the members showed up in white linen trousers and shirts, and paraded through town to the music of the Elbel Brothers brass band.[137] Afterwards, together with their families and friends, they gathered at Bartlett's picnic grounds, by the river at the foot of Lafayette Boulevard. "The festivities included the reading of the Declaration of Independence, exercises on temporary apparatus and singing. The celebration concluded with a dance in the Odd Fellow Hall."[138]

On a visit to South Bend on the Fourth of July in 1865, Samuel Ludvigh, editor of several German language papers, including Philadelphia's liberal *Die Alte und Neue Welt,* found that the Turners were the only people in South Bend celebrating the occasion "with a procession of about forty members and a spirited brass band." There were nothing but German speeches in honor of Independence Day. Ludvigh observed that if the Turner "had not demonstrated their love of liberty and their appreciation of the importance of the day, it would have been as quiet and as desolate in the town as in the streets of Pompeii....the coldest Fourth of July, with the thermometer at 98 degrees Fahrenheit, that I had experienced in 28 years."[139]

A strong patriotism for America, however, did not prevent the Turners from cherishing passionate feelings toward their former homeland as well. Georg Geyer's oration on the occasion of the 50th anniversary of the Arzberg Choral Society demonstrated the fervor

with which the Turners clung to their former homeland, and also helps to illustrate the romantic and patriotic spirit of the time. Geyer, recording secretary for the Turners for more than 25 years, said; "Although many of our old Arzbergers have journeyed across the seas in search of a new home, the love for the old home still remains awake in them. There is no more beautiful piece of earth, there is no more beautiful country, than the one where stood your cradle."[140]

On January 2, 1863, the *Liederkranz*, a Choral Society, was added to the *Turnverein* with, of course, Lorenz Elbel as director. The founding members once again came from the group of major German business owners; John Lederer, John M. Meyer, Godfrey Poehlman, Andrew Russwurm, and Gustav Wenger. The *Liederkranz* wanted to promote German song and poetry and foster brotherhood. The German song *"Brüder reicht die Hand zum Bunde"* (Brothers reach out your hands united) was one of their favorites. But the *Liederkranz* also performed American songs, including My Old Kentucky Home and the Star Spangled Banner, mixed in with its mainly German repertoire. In addition, the group enjoyed frequent social get-togethers, from formal to informal, and many a *"gemütlicher Abend"* (cozy evening) was recorded in its minutes.

Turnverein members also organized into a dramatic society. Their first theater was German immigrant Jacob Boehner's one-story wood structure, located on the corner of Marion and William Streets. It had a hall "designed for the congregating of such men as sought harmless diversion in popular amusements and in conversation and discussion on the topics of the day." From there they moved to the St. Joseph Hotel where in November 1859, they held a celebration in honor of the 100-year anniversary of the birth of the famous German poet and playwright Friedrich Schiller. Schiller's passionate and romantic language appealed to the immigrants and made them proud of their German culture. A year later, they moved to Odd Fellows Hall where they staged their most popular productions.

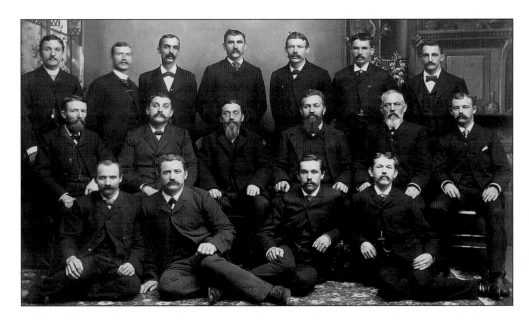

The singing section of the South Bend Turnverein *is seen here in 1887 with Prof. Christian Elbel in the center. (Courtesy Richard Strebinger.)*

A surviving playbill dated December 12, 1860, advertised a performance of Nestroy's *Lumpazi Vagabundus* on December 31, the 18th performance of the society. Many actors had to cover several parts, especially the women. Thekla Sack praised the Klingels' acting ability. Valentine Klingel, who was "known for unusual kindness of heart, became…a villain of the blackest dye." His brother Philip, "a little inclined to obesity, and possessed of far more than ordinary wit, was the comedian par excellence." Andrew Russwurm, owner of a harness-making business in South Bend, was another popular actor in the group. "He frequently moved the audience to tears by the fervor and zeal of the peacemaker, and his impersonation as the good and revered spiritual guide."[141]

Admission was 20¢ and tickets for the dance afterwards were 10¢ and many proceeds were donated to charity. For example, the proceeds of a performance in 1861 went to support the German school, and the November 17, 1862 entertainment was dedicated for the benefit of the families of indigent drafted soldiers. An advertisement for the production said, "Come, fellow citizens; help the troubled and oppressed….Who can look calmly on and see women and children suffer distress while the husband and father is absent, risking life and health in defense of his country."[142]

The theater was closed after 1862 because too many members had enlisted in the Civil War. It reopened on February 26, 1866, with a performance of *Hedwig*. This was followed on April 12 with a comic opera by Leopold Huber entitled *The Devils's Mill on the Mountain of Vienna*, with music performed, needless to say, by the Elbel band. The last performance of the season was *The Robbers of Maria Culm: The Power of Faith*. The winter season of 1866 opened on November 8, with *Preciosa*, an operetta by Carl Maria von Weber, followed on December 27 by a play entitled *Remembrance*.

In 1887, the *Turnverein* added a Benevolent Section, dedicated to support sick members, who lost their pay because they could not work. A committee decided on the distribution of funds. It paid $4 a week for someone who was sick and $50 at death. The Benevolent Section was dissolved in 1925.

One of the best-known and loved gymnastic instructors in South Bend was a member of the *Turnverein*. Edward Koenig was born in Waldorf, Saxony, on September 30, 1863. Shortly after his graduation in 1877, he came to America. He eventually attended the American Gymnastic Normal in Milwaukee, from which he graduated in 1886. After a brief stint in Indianapolis, Koenig came to South Bend. In 1898, he was appointed director of physical instruction of the schools. From 1886 on he also served as physical education instructor for the *Turnverein*, and his students won competitions across the nation. Edward Koenig was very popular and when a new athletic field was about to be dedicated, Koenig received nearly as many votes as all other candidates combined and the field was named after him. At his death on February 12, 1927, the schools throughout the city were closed in honor of his long and successful service.

For most of a century the *Turnverein* was a major institution in South Bend. "Much of the social history of the city centers around Turner Hall."[143] It served the German immigrants as a home in a foreign country, where new arrivals could meet older more established immigrants and build networks, where they could celebrate German holidays, and sit together drinking beer as they had done back in Germany. Members came from the middle class of business men as well as from that of skilled workmen employed in South Bend's major and growing industries. In 1921, one member was quoted as saying that "Men of all classes mixed together. The business man as well as the most common laboring man enjoyed one another's company at the hall."[144] From member lists and meeting records it appears indeed that middle-class and working-class people belonged to the

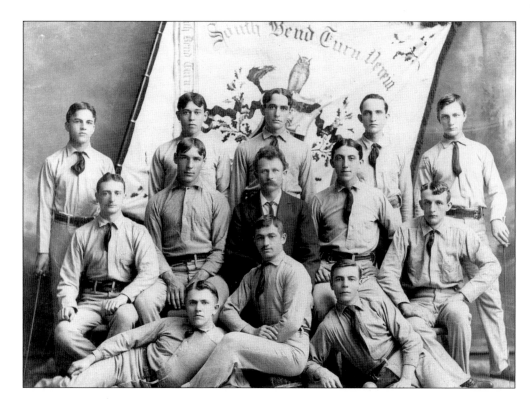

The hugely popular instructor Edward Koenig is pictured here with young gymnasts. (Courtesy Richard Strebinger.)

Turnverein. Given their strict class divisions in Germany, however, it is not clear to what extent these groups interacted on a more than perfunctory level. The officers, for example, tended to come from the business class.

But at the same time the *Turnverein* helped the immigrants to become integrated into the life of their community. The activities of the club, especially its musical performances and events like the masquerades, brought the *Turnverein* to the attention of the city and furthered the interaction between Germans and the native-born. Moreover, *Turnverein* members received guidance from the national organization and its publications which helped them to understand American customs and the political system. The national *Turnverein* also encouraged all members to integrate themselves into their local communities as soon as possible. Active participation in the *Turnverein* served as an introduction to the civic life of South Bend and helped the immigrants get elected to public offices.

Over the years, the *Turnverein*, like the *Maennerchor*, lost its exclusively German character. Most members no longer knew German, only the officers of the club were required to be able to speak and write it. Minutes continued to be kept in German. Somewhere in the 1930s, even this requirement was dropped.[145] The singing section, however, maintained German minutes into the 1940s.

After the German connection was almost completely lost, the Turners continued to serve as an exercise and social club for the general public. By 1999, however, the club could no longer support itself, sold its remaining properties, and closed.[146]

Agent of Assimilation

THE CATHOLIC CHURCH AND GERMAN IMMIGRANTS

*C*harles Rother from Rüdesheim, a Brother of the Holy Cross, came to Indiana in 1841. Brother Joseph, as was his name in the order, was born on July 11, 1808, and arrived in Vincennes on October 2, 1841. In 1842, he joined Father Sorin at Notre Dame, who gave him a task that well suited Brother Joseph's enterprising temperament. He was assigned to travel all over the state to check on the Catholic population and look for land bargains, for Father Sorin was eager to buy cheap land and set up Catholic parishes and schools throughout the state. Brother Joseph threw himself into his task with great enthusiasm, and reported back to his superior in a stream of letters describing the people, the land, the condition of the roads, and the weather. He wrote to Father Sorin mostly in English but occasionally also in French, as he was equally fluent and literate, if not dramatic, in both languages.

As Brother Joseph filed his reports from across Indiana, he kept assuring Father Sorin that he was making wise purchases, that he was "looked upon as smartly keen" and would not be overreached in his dealings.[147] Nonetheless, Father Sorin doubted the Brother's business sense, and the two were in continual conflict with each other, in part, perhaps, because they had rather similar tempers and entrepreneurial energies. On March 31, 1847, Brother Joseph wrote to Sorin in response to what must have been a scathing letter: "I read it over and over in order to sooth <sic> my grief, but in vain, the more I read it, the worse I made the matter; in truth, I immediately lost the appetite of taste of all food and I was for several hours nearly out of senses, not with anger or rage, but grief bordering on despair."[148]

Four months later, he seemed to have recovered his equilibrium, for he wrote Father Sorin with another business proposition. This time he suggested that Notre Dame buy a vineyard. "The grape vine grows most luxuriantly in this country…one acre of ground can easily receive 2,500 stocks, each stock bearing at the lowest calculation 50 cents per annum." Trying to convince his superior, Brother Joseph said that he was familiar with wine culture since he came from a winegrowing area in Germany. And most importantly, he added, that by cultivating grapes we will "render service to the country and it is in this manner we must work ourselves into favor and gain the heart of…It is by an unblemished life and habits of industry the Jesuits have in many places done more good than by teaching and preaching." He concluded with the fact that " I have 100 stocks growing beautifully."[149]

The two men, however, could not resolve their differences and Brother Joseph left Notre Dame on February 5, 1850. He went back to Vincennes, where he was in charge of an orphanage. Although officially no longer a Brother of the Holy Cross, he was called Brother Joseph until his death on January 5, 1890. He was buried in Vincennes.

A large number of Catholics of all classes came from Germany, especially in the second wave of immigration beginning in 1872 with the *Kulturkampf*, the battle between the Catholic Church and the new German state led by Bismarck. Eventually parochial schools were closed, members of religious communities were prohibited from teaching in state

schools, and entire religious communities were dissolved.[150] But even before the onset of this battle, many German immigrants from Catholic areas had come to America.

The Rt. Rev. H.J. Alerding's account of the diocese of Fort Wayne, which includes South Bend, lists a great number of German priests.[151] At a time when there were hardly any German bishops in the United States, the first four bishops of the Fort Wayne diocese were German or of German extraction.

Catholic German immigrants wanted little to do with Protestant German immigrants, and even less with the club-oriented Forty-Eighters, whom they saw as "infidels." Thus in 1869, Father Ernest Anthony Reiter, S.J., of Boston, admonished German Catholic immigrants not to "accept employment from German Protestants or fallen-away Catholics," and not to join any secret society or even the *Turnverein*, which must be regarded an anti-religious body.[152] At the same time he stressed the importance of commanding children to speak only German at home, and militated for exclusively German churches and schools.[153]

One local example of the hostility between Catholics and Protestants was the conflict between Notre Dame and the German Beiger family, which erupted because of the Beigers' hospitality to two Protestant ministers. Jacob Beiger, who was born in Breitenhausen, Prussia, on July 14, 1814, and his wife Anna Maria Beiter left Germany in 1844, and settled on a farm two miles south of Mishawaka. Since they were Catholics, they worshipped at Notre Dame. In 1847, two protestant missionaries, the Reverends Seifert and Platz, arrived at their farm on horseback. According to an account in the *Mishawaka Enterprise*, "Their simple faith and upright lives charmed the honest souls of the couple…They became interested and their cottage was thrown open for services. For this they were refused permission to worship at Notre Dame, and they accordingly joined the German Evangelical Association; and many others of the neighborhood subsequently identified themselves with the movement. This "apostasy," the Mishawaka paper concluded, "was the immediate cause of the large Evangelical element in the district south of town."[154]

The Beigers deeded land from their farm for a church to be built on the corner of what is now State Road 331 and Jackson Road.[155] The church was named the Coalbush Evangelical Church. Coalbush was a term used for this area because the charcoal ("coal") for the iron smelters in Mishawaka was prepared from the local trees ("bush").[156]

The Beigers farmed for 24 years before Jacob purchased Palmer and Worden's Woolen Mill in 1868, which eventually became the Ball Band Company and later Uniroyal. Their son, Martin V., became a major industrialist in Northern Indiana and continued his parents' support of the Protestant church. An intensely religious man, he was saddened by declining church attendance at the turn of the century. To revitalize interest in the church, he suggested that a Rally Day service be held on September 27, 1903. The service did take place, but it turned into a funeral service for Martin V. Beiger, who had died the day before.

Priests were desperately needed in Indiana for the growing Catholic congregations. The Rev. Joseph Kundek, who founded Catholic parishes and even whole towns in southern Indiana, was making every effort to get German priests to serve his German parishioners who were longing for services in their language. He himself would make frequent trips on horseback to visit as many of them as possible. On these missionary excursions he encountered parishioners who had lived together for years and raised families, waiting for a priest to bless their union and baptize their children. On one such trip in 1841, Kundek covered 700 miles, preached 30 sermons in five weeks, and heard over 800 confessions.[157]

The South Bend area was in a similar predicament. In the 1840s, there was a thriving settlement in Bertrand on the St. Joseph River. When a German missionary held a German service there, "Germans from every denomination came from their distant settlements to

The Catholic church in Bertrand, Michigan, in the 1840s was one of the earliest Catholic churches in the area, served by the Brothers and Sisters of the Holy Cross. (Courtesy Northern Indiana Historical Society.)

listen once again (for some the first time in 20 years) to the Word of God in their native language."[158]

With its foundation in 1842, Notre Dame became the predominant Catholic presence in the South Bend area. Catholic laypeople of all ethnic backgrounds worshipped at Notre Dame in the Sacred Heart parish church, and the Cedar Grove Cemetery on Notre Dame Avenue served as the community burial grounds. The 1879 census of Sacred Heart parish listed 14 German Catholic families, and Harris Township subsequently had many more German Catholic families who worshipped at Sacred Heart.

Notre Dame was staffed by Brothers of the Holy Cross, an order founded by the Very Reverend Basil Anthony Moreau in Le Mans, France. Although most of the monks were French or Irish, there also was a noticeable German presence, especially in the 1850s. Thus when Father Moreau visited Notre Dame in 1857, he asked for the Rules of the Congregation of the Holy Cross to be translated from French into both English and German. It appears, however, that the German translation never did happen. It may not have been necessary since, like Brother Joseph, the German Brothers soon became assimilated into the international Catholic brotherhood that prevailed at Notre Dame.

Sixty-seven Brothers of the Holy Cross came from Germany to Notre Dame between 1842 and 1880, 30 of them in the 1850s. Out of the 67 German novices, 42 either left or were dismissed in the first years of their novitiate. This was not unusual since many joined as young men and soon found that the religious life did not suit them. A few left, and returned, and left again. Francis Fernstein, for example, arrived in 1862 at age 19, and left in 1865. That same year he reentered Notre Dame and then left again in 1866. In 1878, he

came back for a third time, but finally quit the order in 1879. Seven of the German Brothers were dismissed in that period, or *renvoyé*, as the General Matricule said. This was the register of all activities of the order, which because of the French origins of the Brothers of the Holy Cross, was kept in French. Some German Brothers moved to other seminaries. One went to New Orleans where he died of yellow fever, and others moved to two of the main German settlement areas, Milwaukee and Cincinnati. The remaining 21 of these early German Brothers were buried at Notre Dame.

The Brothers came from many parts of Germany, including the Rhine country, Hessia, and Prussia. But Baden, Württemberg, and Bavaria were the most represented. One example of chain migration were the Lauth brothers, Peter, John, Jacob, and Michael, from Bous, Luxemburg, who all became Brothers of the Holy Cross in the 1870s. Peter, born on May 24, 1834, was the first to emigrate to Notre Dame in 1854. He was ordained as a priest in 1869. Jacob and John followed soon thereafter and both were ordained on the same day, November 11, 1870. Peter served as pastor of St. Joseph's church in South Bend from 1873 to 1874, when he moved to St. Patrick's where he served from 1876 to 1880. By 1902, he had returned to St. Joseph's. John served briefly at St. Joseph's after which he joined his brother Jacob who was pastor at St. Vincent's in Allen County. Michael, the youngest, was the problem child of the family. He was ordained on November 30, 1881, but withdrew from the order in 1898 because he had become an alcoholic. Michael died in Milwaukee on May 2, 1908.

A German Brother of the Holy Cross who climbed the Catholic hierarchy was Peter J. Hurth. He was born on March 30, 1857, in the Rhine Province, and came to America in 1874. From 1894 to 1909, he served as Bishop of Dacca, Bangladesh, and then as Archbishop of Manila in the Philippine Islands until his death in 1935. Another German to attain high rank was Frederick Linneborn from Hüsten in Westphalia, born May 27, 1864, who became bishop in 1909.

Soon after the first Brothers of the Holy Cross, the Sisters of that order began to arrive in South Bend, first from France and Ireland, but later also from Germany. Between 1846 and 1878, 36 Sisters of the Holy Cross came from Germany to St. Mary's and Notre Dame. Of these, 15 arrived in the 1850s, 9 in the 1860s, and 11 in the 1870s.[159] The 1850s peak corresponds to the general peak in German immigration and the larger numbers in the 1870s reflect Father Sorin's recruitment in Germany. Sorin founded a separate novitiate in 1872, dedicated to domestic help. There already were plenty of Sisters at Notre Dame to do the teaching and nursing, but he still needed Sisters to do the laundry and bedding, and also bake the altar breads.

In 1875, Mother Angela of St. Mary's also went recruiting to Germany, but she was looking for teachers at the academy. She brought back 8 young women. They were in their late 20s, which was a few years older than the average postulant and of a "high degree of persistency." Mother Angela insisted that they get the best possible education, including language, music, and art so that they would be familiar with all the newest educational theories and at least as well equipped as any lay teacher.

Not much is known about most of these early Sisters since many of the early interrogatories are no longer available, and the Sisters altogether were instructed to be unassuming. Yet there were strong and assertive women among them. Some worked as administrators and were able to navigate the dangerous currents between the motherhouse in France, Father Sorin at Notre Dame, and the interior conflicts between Sisters who were American, French, Irish, and German. Others served as missionaries or looked after orphanages and helped the Indians. It was the Sisters who, in 1882, started St. Joseph's, the first hospital in South Bend.

Sister Alfred Moes from Luxemburg came to St. Mary's in 1856, then moved to the German convent St. John's, Indiana, and finally founded a community in Rochester, Minnesota. There she started the hospital, which became the Mayo Clinic. Another, Sister Rose Bernard, went into missionary work and founded a sisterhood in Toomiliah, near Calcutta in India. Eighty-five of the then-200 Sisters, some of whom had German backgrounds, served as nurses in the Civil War. Veronica Scholl was one of the earliest, leaving for Cairo, Illinois, in 1861, to help take charge of a hospital in Mound City, Illinois, where Sister Ferdinand Bruggerman, originally from Hanover, Germany, soon joined her.

Above all, the Sisters served as teachers. Sisters of the Holy Cross taught at parochial schools attached to St. Patrick's, St. Mary's, and St. Hedwig's churches, and at the St. Joseph's Academy. The latter had the reputation as the best grade school in South Bend at the time. In 1867, 155 girls attended the academy. Since some of the Sisters were from Germany, the school also offered instruction in German.

Another group of German immigrant Sisters belonged to the order of the Poor Handmaids. Dedicated to nursing the sick, the order was founded in Dernbach, Germany, in 1850, and the first Sisters arrived in the U.S. in 1868. In Indiana, they began their work at Fort Wayne, but soon established themselves all across the state. On October 25, 1878, the Sisters set up St. Agnes Convent, on Fourth and Spring Streets in Mishawaka. They worked as nurses and also taught at the parochial school of St. Joseph's parish in Mishawaka.

In 1846, only four years after the founding of Notre Dame, Mishawaka already had its own Catholic church, Holy Angels Catholic Church, located at 815 South Elm Street. The small frame structure is still there today. A roster of church members on October 28, 1849, showed 22 Germans out of 32 names, including six Kleins, three Bechers, and one each Bauerlein, Biersbach, and Schmitt.[160] Rev. B. Mager was the first resident German pastor in 1857, followed in 1859 by Rev. Henry Koenig, who was born on October 7, 1835 in Heiligenstadt, Westphalia. He was ordained as a priest in Ireland in 1859, and came to Mishawaka the same year.

The larger St. Joseph's Church of Mishawaka was built in 1861, by two Germans, August Kelner and John Saenger. This was the parish of the popular and well-known Rev. August Bernard Oechtering, who, from 1867 to his death on December 27, 1898, was pastor at the church. He was born near Münster in Westphalia on September 8, 1837, emigrated after finishing college in 1858, and was ordained by Bishop Luers in 1861. Reverend Oechtering was committed to educating the young in his congregation, and in 1871, almost immediately upon taking office he initiated the construction of a parochial school. It was only a simple frame structure, located on Fourth Street, but in 1882, he built a much bigger school on Mill Street in Mishawaka.

As his congregation grew and prospered, the old St. Joseph's Church became too small and too plain. In the 1880s, Father Oechtering established a building committee for a new church, which included many Germans such as Adolphus Kamm. The new church was completed in 1893, five years before his death. Curiously, Father Oechtering, who had spent his life building permanent memorials to the Catholic faith, requested that at his death no sermon be preached and no monument put over his grave. Oechtering was followed by another German pastor, Rev. Louis Aloysius Moench, originally from Freudenberg in Baden.

South Bend did not have a Catholic church outside Notre Dame until 1853, when Father Sorin established St. Joseph Parish Church at Water and Hill Streets in Lowell. In 1859, priests from St. Joseph's organized St. Patrick's parish on Western Avenue, and Germans

The charter members of St. John's Society, organized in 1879, included: Jacob Jahn, John Heil, and John J. Fritzer. They were instrumental in establishing a German Catholic parish in South Bend in 1882. (From Diamond Jubilee of St. Mary's Church 1958. *Courtesy Indiana Province Archives, University of Notre Dame.)*

helped to build the church. Some German services were held at St. Patrick's, although the priests were almost all Irish. When St. Patrick moved to South Taylor Street in 1869, German services were discontinued. For about 12 years the Germans did not have services in their language and there was increasing resentment about this in the German community. In 1882, it was reported that "many of the Germans left South Bend or joined the Turner Society, an infidel organization, and thus far few have returned to the true fold."[161]

This resentment was part of a national feeling, for the most divisive issue for Catholics in the 1880s was the argument over national parishes, especially the demand for German parishes and German bishops. This was true in particular in the so-called "German triangle of the West," made up of Milwaukee, Cincinnati, and St. Louis. Under the slogan "Language Saves Faith," German Catholics fought for their own parishes. In 1886, Father Peter M. Abbelen of Milwaukee wrote, "All direct and violent efforts to deprive the Germans of their language and customs, to 'americanize' them in a quiet way, are nothing but fatal means of leading them away from the Church. Let us leave this 'americanization' to its natural course, to a gradual amalgamation."[162]

Although as early as January 1845, Notre Dame was aware of the need "to make more convenient opportunity for preaching to the German population and hearing confessions,"[163] the Germans did not get their own church until 1882. In 1879, German Catholics in South Bend had organized the *"Johannes Unterstützungs Verein."* Charter members were Jacob Jahn, John Heil, and John Fritzer. They appealed to Bishop Dwenger of Fort Wayne for a German-speaking priest, and in response to their request, Rev. Paul Kollop from Alsace was sent a year later to St. Patrick's to take care of German Catholics in South Bend.

In 1882, the Germans finally were given their own parish, St. Mary's, and Rev. Peter

*St. Mary's Church (*Maria Himmelfahrt
Kirche*), the first German Catholic church
in South Bend, was erected 1883.(From*
Diamond Jubilee of St. Mary's Church
1958 *Courtesy Indiana Province Archives,
University of Notre Dame.)*

Johannes, CSC, became its first permanent pastor. He was born in Eichen, Luxemburg, on
September 29, 1855, and had arrived at Notre Dame on May 12, 1874. In 1882, he was sent
to St. Mary's, where he remained until his death; he was much beloved by his congregation."

After the arrival of Father Johannes, a German Catholic church was built on South Taylor
Street. It cost $4,500, which compares to about $75,000 today, and was called *Maria
Himmelfahrt.* The first mass in the new church was held on Christmas 1883. At first, the
parish priests lived at St. Patrick's or at Notre Dame. It was only in 1895 that Father
Johannes obtained permission to purchase a house next to the church since, as he said,
"we find it difficult to live with the Irish."[164]

At the end of the 19th century, the German parish grew by leaps and bounds. In 1882,
only 50 families were registered, but by 1903, the number had risen to 190.[165] Between the
first baptism, that of Elizabeth Bertha Fritzer in 1882, and his early death, Father Johannes
performed 1,027 baptisms. This was a record never to be reached again in the history of
St. Mary's. Membership peaked in the 1890s, and slowly declined until the 1950s when the
Federal Housing Commission directed the church to relocate because the area was to be
designated for a low cost housing project.

As soon as he had his church, Father Johannes saw to it that a Catholic school was added
to it. The *Marienschule* was opened in January 1884. At first there was only room for it in
the sacristy of the church. By November 1884, the congregation had a one-story frame
school house right next to the church, to which another story was later added. Sisters of
the Holy Cross functioned as teachers with Sister M. Albina as superior. By 1893, the school

The Rev. Peter Johannes, CSC and the children of St. Mary's School are seen here c. 1885. (From Diamond Jubilee of St. Mary's Church 1958. *Courtesy Indiana Province Archives, University of Notre Dame.)*

had a record number of 243 pupils.[166] Over the years, 10 of its male students became Brothers of the Holy Cross. Among the women, 18 joined holy orders, 8 becoming Sisters of the Holy Cross, and 7 joining the Poor Handmaids. St. Mary's school closed in 1950.

German was spoken less and less at St. Mary's, although the first pastor who knew no German at all was Rev. William Lennartz, CSC, who served from 1939 to 1942. He was followed by Rev. Frank C. Brown, CSC, who again spoke German. As late as 1950, there still was Father Louis Putz, CSC, who could take confessions in German. But on the whole Father Abbelen's prediction for German Catholics proved to be true—Americanization came by itself with the passage of time. With it the furor over national parishes died down. After all, German Catholics had started out in a universal Catholic church in America, worshipping together with the native-born as well as with immigrants from other countries. This was made easier since a good part of the mass was in Latin anyway. The drive toward national parishes, though strenuously fought, was only a passing phase.

The Catholic experience differed considerably from that of the Lutheran Protestants. Their church not only originated in Germany, but saw its religious culture closely allied to the German language. But as second generation German Catholics became Americanized, they were content to have English services. Brothers and Sisters of the Holy Cross were assimilated even more quickly than the general population. Their pride in being part of an international congregation superseded any sense of ethnic belonging. In fact, the Catholic Church can be seen as an agent of assimilation. "It was within the fold of the Catholic Church and there, perhaps, more than in any other sphere that a significant number of immigrants from Europe learned to live together as Americans."[167]

The 'German Jews' in South Bend

*A*braham Kohn, from Mönchsroth in Bavaria, saw no future in Germany for a penniless young Jewish man. Although he hated to leave his family, especially his mother to whom he was devoted, he decided to emigrate to America in 1842, when he was 23 years old. He had to walk from Bavaria to Bremen where he embarked for New York. However, it was not too long after he arrived in New York that he realized life in the new world could be just as hard as it had been in the old. Like many other young Jewish men without means, he started out as peddler. He invested the little money he had in whatever he could afford—shoelaces, thimbles, suspenders, cooking pots—which he carried in a heavy pack on his back. He barely managed to survive, and many a weary night he regretted that he had ever left his home.

Kohn kept a diary in which he recorded the trials of his first year. He used it also to speak to his mother and remember longingly what she would do and say. Both his daily writing and his faith helped him through the darkest hours. "It is hard, very hard indeed, to make a living this way. Sweat runs down my body in great drops and my back seems to be breaking, but I cannot stop; I must go on and on, however far my way lies."[168] He often asked himself: "Is this fate worth the losses you have suffered, the dangers you have met on land and sea? Is this an equal exchange for the parents and kinsmen you have given up? Is this the celebrated freedom of America's soil? Is it liberty of thought and action when, in order to do business in a single state, one has to buy a license for a hundred dollars?"

The onset of winter brought even more hardships. "We were forced to stop on Wednesday because of the heavy snow. We sought to spend the night with a cooper, a Mr. Spaulding, but his wife did not wish to take us in. She was afraid of strangers, she might not sleep well; we should go our way. And outside there raged the worst blizzard I have ever seen."

In the midst of all this suffering, he wrote an imaginary address to young men like him back home. "O youth of Bavaria, if you long for freedom, if you dream of life here, beware, for you shall rue the hour you embarked for a country and a life far different from what you dream of. This land—and particularly this calling—offers harsh, cold air, great masses of snow, and people who are credulous, filled with silly pride, cold toward foreigners and toward all who do not speak the language perfectly."

Abraham Kohn's hard times, however, were over very soon. Less than two years after his arrival in New York, he owned his own store in Chicago. In 1847, Kohn was one of the founders of Chicago's first Jewish congregation, the Kehilath Anshe Ma'ariv. In 1860, he was elected city clerk of Chicago. Kohn was an ardent Republican and supporter of Abraham Lincoln. When Lincoln became president, Kohn sent him a gift that brought him some national attention. It was an American flag with verses from Joshua 1 inscribed on its red stripes, including the words: "I will not fail thee nor forsake thee. Be strong and of good courage."

Kohn died in 1871, when he was 52 years old.

The percentage of German Jews who emigrated was higher even than that of the Christian population. No doubt this was because in addition to all the other reasons that

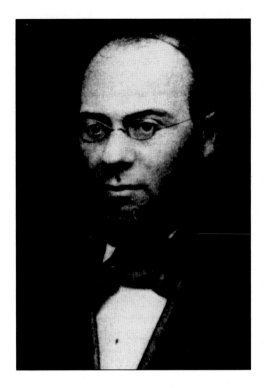

Abraham Kohn came to America in 1842 and started out as peddler. By 1847, he owned his own store and was one of the founders of Chicago's first Jewish congregation. (Rita Studio, Inc., Chicago. From Central European Jews in America 1840-1880 *[Routledge 1998].)*

propelled Christian Germans out of the country, the German Jews suffered terrible discrimination as a poorly treated minority. "In the patchwork of German principalities, the Jews were treated as non persons, not persecuted as Catholics and Protestants persecuted each other, but penned up in ghettos and deprived of what few civil liberties were granted the Gentiles by the petty tyrants who ruled them."[169] As a result of this persecution, in many German small towns and villages, the Jews disappeared almost entirely. For example, after 1870 no Jewish families at all were left in the Bavarian village of Niedernberg. They had either emigrated or died.[170] About half of all Jews who emigrated from Germany came from Bavaria. A good number also were from central Europe, especially Bohemia and Posen, the easternmost province of Prussia that had been Polish until the end of the 18th century. Between 1820 and 1860, Jews in the United States increased from about 6,000 to 150,000.[171]

The Jewish Germans arrived at about the same time as the Christian Germans, and between the 1830s and the 1870s followed a similar emigration curve. But their social and demographic profile was different. German Gentiles tended to come as middle class families, ready to settle. German Jews at that time were mainly single and poor young men, who, once they arrived, were more willing to move from place to place in search of opportunities.

Like Abraham Kohn, many of the German-Jewish immigrants who came to the United States between 1830 and 1870, began as peddlers. If they had no money at all to get started, they looked to a relative or some German-Jewish acquaintance already settled in business for a loan. Peddlers had to walk for miles and miles, in all weather conditions and along terrible roads, carrying their wares on their backs, in packs which often weighed as much as 150 pounds. Going from farm to farm, they were strangers everywhere. Yet the isolated farm-steaders they visited also appreciated them as a link to civilization.

From such difficult beginnings, many Jewish immigrants eventually settled in towns where they prospered and owned stores of their own. One of the most famous Jewish-German peddlers to reach fame and fortune in America was Levi Strauss, creator of Levis jeans. He was born in Bavaria in 1829, came to the U.S. as a pauper in 1843, and by his ingenuity and shrewd business sense reached almost unheard of prosperity. More than half of the German-Jewish immigrants to America went into the clothing business. By 1872 in Columbus, for example, every clothing and dry goods store was owned by German Jews,[172] and in Indianapolis 70 percent of the clothing establishments in the 1860s were Jewish-owned.[173] Other developing towns, including South Bend, had a similar preponderance of German-Jewish clothing and dry goods stores. Across the nation, three quarters of all clothing businesses and an even higher proportion of department stores were controlled by 'German Jews.'[174]

As they prospered, the German Jews brought over other members of their families and helped them to set up in business as well. Most went into partnerships within the family, usually adding "Brothers" to the title of the firm. In South Bend, for example, there was Adler Brothers Clothing, and Lantz Brothers, and in Plymouth there was Lauer Brothers Clothing. The industry and success of the German-Jewish immigrants not only helped them and their families, but it was a major driving force in the creation of the cities and towns to which they came. "It was the subsequent development of the itinerant peddler into a resident shopkeeper that laid the foundation of local trade and helped to change primitive settlements into towns and cities."[175]

In South Bend, a number of German-Jewish immigrants rose "from peddlers to merchants,"[176] to become prominent in the civic life of the city. What was said of clothing store owner Liebman Lippman from Waldorf in Hessen-Darmstadt, could apply to many of the German-Jewish immigrants: "By industry, ability and frugality Mr. Lippman had become

Moses Livingston was a businessman and one of the founders of the Hebrew Society of Brotherly Love *as well as the South Bend* Turnverein. *(From* Goldenes Jubiläum des South Bend Turnvereins, *1911.)*

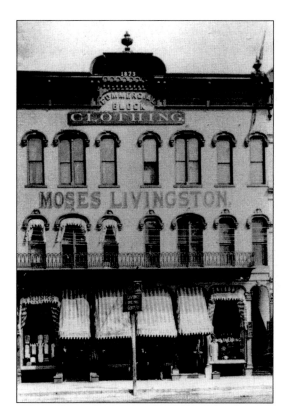

Moses Livingston Clothing Store was a popular meeting place for business and social gatherings. (Courtesy Northern Indiana Historical Society.)

a man of large property holdings although he began with practically nothing."[177] The cousins Meyer and Moses Livingston, who both came to South Bend in 1856, were two other hard-working and enterprising young men. In 1860, they opened their first small dry goods store. In 1876, their partnership dissolved and Moses became sole owner of the business. By 1880, it had grown into one of South Bend's leading dry goods and clothing establishments, with an elegant store located in the business center at 58 Washington Street. Through the years, Moses Livingston branched out into other business ventures. By 1874, he owned an office specializing in sea passages and exchanges, and after 1876, he went into partnership with his brothers-in-law Moses and Samuel Adler in the Adler Brothers clothing store.

Livingston was very active both in Christian-German clubs and in the organizations of the Jewish community, in particular the Hebrew Society of Brotherly Love. From early on, his store was a popular meeting place for social as well business gatherings. In November 1861, the first official meeting of the South Bend *Turnverein* was held in a room above his store, and Livingston was one of the 10 founding members of the *Turnverein*, serving as its vice president in 1871. He and his cousin Meyer also belonged to the *Germania* Lodge, as well as to the *Maennerchor*, where Moses was a candidate for vice president in 1876. Moses died in 1892. His cousin Meyer lived until 1914.

Abraham Hanauer came to South Bend from Felheim, Bavaria, in 1859, when he was 43 years old. In 1870, his clothing and dry goods business, which was located at 82 and 84 Michigan Street, was valued at $35,000, which corresponds to about $560,000 today. It was at his store that the first German choral society in South Bend met in the 1850s. In 1867, he was secretary of the *Germania* Lodge. Hanauer and his wife, two sons, and two

Adler's Hat Store was adjacent to Adler's Clothing Store, located at 107, 108, and 109 Michigan Street. (Courtesy Northern Indiana Historical Society.)

daughters lived on the corner of Marion and Michigan Streets in Little Arzberg. Like Moses Livingston, Hanauer was also a leader in the local Jewish community. He died on November 17, 1909 at the age of 93.

Samuel Adler, his brother Moses, and his sister Carrie, arrived in South Bend in 1857. The two young men started work as clerks. By the 1870s, the Adler brothers owned a clothing and boot store as well as the Adler and Company Hatters. Carrie had married Moses Livingston. Moses Adler was prominent in German organizations such as the *Turnverein* and the *Maennerchor*.

Another establishment, located on the southwest corner of Michigan and Washington Streets, called itself the New York Clothing Store, and was owned by the brothers William C. and Simon P. Lantz. It carried a wide variety of goods, as indicated by its advertisements in South Bend city directories—"Gentleman's Furnishing Goods, including collars, cuffs, gloves, hosieries, handkerchiefs, shirts and a fine stock of cloths, cassimeres and vestings." Isaac Kahn, another German-Jewish immigrant to South Bend, owned a store at 57 Washington Street that specialized in hats and furs.

Henry Barth also started in the clothing business but ended up in partnerships with the native-born elite. Born in Baden on March 8, 1818, he began in Philadelphia as a young peddler without means. In 1847, Barth came to South Bend where he started a lumber business which by 1850 was worth $2,500. Barth then became part owner of the successful Phoenix Mill. His partner was John H. Harper who, like Barth, also first had owned a dry goods store. After Harper sold out, an Eastern capitalist by the name of Sheffield was interested in a partnership with Barth. Together they bought a mill in Toledo and Barth moved to Ohio for

several years. When that business failed, just before the Civil War, Barth returned to South Bend. He started a lumber business with Judge Stanfield and the Hon. Andrew Anderson, a lawyer. The firm Stanfield, Anderson, and Barth continued successfully for many years.

During his lifetime, Barth acquired more than $50,000 worth of real estate and personal property. It was from Henry Barth and his wife Lisette that the land for the building for the South Bend *Turnverein* was purchased. He also sold the Muessels 136 acres on Portage Road for their brewery. Barth died on April 14, 1895, and the South Bend paper wrote that "he took an active interest in politics, but though affiliating with the Democratic Party was conservative in his views. He was broad minded on all subjects of a public character and ready to aid any enterprise that was calculated to improve South Bend."[178]

Theodore J. Seixas was "one of the brightest financiers in the history of the county" whose "business ability, kindliness and strict integrity" were credited with the success he achieved in all his ventures.[179] Seixas was instrumental in founding the St. Joseph County Savings Bank in 1869. He worked together with the most prominent South Bend citizens, including both native-born and German immigrants, such as Almond Bugbee, John C. Birdsell, Louis Humphreys, John C. Knoblock, and David Greenawalt. Seixas received much of the credit for the extraordinary success of the bank.

Typically, the first Jewish organization to be created in a town, even before a synagogue, was a burial society. After a burial society, many communities established a B'nai B'rith Lodge, followed by Jewish charitable organizations, mostly led by women. The secret order of B'nai B'rith was founded in 1843, as a reaction to Gentile discrimination. When a dozen young men applied for membership in the New York Odd Fellows Lodge and were refused, they organized the Independent Order of B'nai B'rith. Its purpose was to unite the Jewish

community and to promote humanitarian causes. B'nai B'rith became an international Jewish humanitarian society, dedicated to helping Jews living in the countries of the diaspora to become a unified homogenous community. In South Bend, the B'nai B'rith lodge was not established until the 1920s.

The burial society, founded on May 22, 1859, was called the Hebrew Society of Brotherly Love. Its mission was to "procure and provide suitable grounds for the burial of deceased Israelites;" to maintain these grounds, and "to suitably and at the expense of the association inter according to the rites and usages of our faith, Stranger (*sic*) and indigent Israelites who may decease in our midst."[180] Founding members were Henry Barth, Jacob E. Gutman, Meyer Livingston, Theodore J. Seixas, Henry Goodman, and Abraham Hanauer.

Annual dues for the Society were set at $2, though over the years they were raised to $20. The minimum age required for membership was 21. The first action taken by the society was to buy land for the burial ground. For $80, members purchased a half acre on Emerick Street, now Niles Avenue, in what was then the town of Lowell. Twenty-two people, more than half of whom were infants, were buried on the site. The first interment in the children's row was the stillborn son of Meyer and Esther Livingston, and the first adult burial was David, the older brother of Theodore Seixas. From 1880 on, part of the grounds were leased to the Singer Company, which had their cabinet factory nearby. When the more spacious Rosehill Cemetery was founded in 1884, the 22 graves were moved there from this original site.

The founding president of the society was Abraham Hanauer. Henry Barth, Meyer Livingston, Ephraim Gerstle, Jacob Gutman, and M. Israel made up the first board of trustees, responsible for the government of the association. Theodore Seixas served as secretary. On January 1, 1860, Henry Barth took over as president. From then on, the same small group was elected to the offices of the society. Meyer Livingston was president from 1864 to 1880, and Moses Livingston served as treasurer during the same time. In 1881, the two reversed roles, with Moses as president and Meyer as treasurer. Theodore Seixas was secretary until 1882, when Florian Seixas took over. By 1895, not much had changed. Moses was still president; Meyer Livingston was treasurer; and Felix Livingston secretary. There also was a new position, vice president, which Meyer Stern occupied.

Unlike most other societies and clubs of that time, the Hebrew Society of Brotherly Love was open for membership to both men and women. It appears however, that not only were all of the original founders male, but until 1942, so too were all of its subsequent officers and trustees. It may be symptomatic of a change in climate that in the last entry in the books of the society, dated July 23, 1942, a woman, Mrs. Charles Feig, signed as secretary. But then up to that date her husband had served in that role.

The first wave of German-Jewish immigrants may have started out orthodox, but by the 1850s they became predominantly "Reformed." In their synagogues, the sexes were not separated, and many did not even require men to cover their heads. The aim of the Jewish Germans was to integrate the Jewish community into the American mainstream and to avoid anything that separated the Jews from the rest of society. "The Jew must be Americanized" declared Isaac Mayer Wise, the religious leader of the Jewish community in the 1870s. He had come to the United States in 1846, from Radnitz in Bohemia, and after 25 years of working toward his goal of a national religious organization of American Jews, he succeeded in establishing the Union of American Hebrew Congregations. Mayer's argument was that "the Jew must become an American in order to gain the proud self-consciousness of the free-born man."[181]

Initially the Reformed congregation in South Bend was served by Henry Englander, the Rabbi of Ligonier. However, since the Rabbi was working in Ligonier on Fridays and

Saturdays, services in South Bend had to be held on Sundays. In 1905, Rabbi Englander assisted a group of largely German Reformed Jews to found the Temple Beth-El. Charter members of the Temple were Simon Greenebaum, Moses Livingston, J. Livingston, Samuel Adler, Samuel Spiro, Moses J. Frankel, Martin Batt, and S. Grossman.

While the Jewish community was a notable presence in South Bend, the smaller town of Ligonier became a major Jewish center. Ligonier was developed by two related German-Jewish families. Frederick Straus and Solomon Mier from Prussia both arrived in Ligonier in 1854, starting as peddlers outfitted by Joseph Stiefel, a relative in Fort Wayne. They were attracted to Ligonier because of the promise of a railroad. And indeed after the arrival of the Lake Shore and Michigan Southern Railroad, the town grew rapidly, and both Straus and Mier became wealthy entrepreneurs. Both first opened clothing and dry goods stores, and ended founding banks and huge real estate conglomerates. They imported manufactured goods from New York and sent farm products from the Ligonier area to Chicago.

In 1868, the Straus Brothers started the first bank, Citizen's Bank, in Ligonier. In 1870, Solomon Mier also opened a bank, which eventually became the first state bank in Ligonier. By 1915, the Straus Brothers Company called itself "the largest real estate dealer in the United States, if not the world."[182]

The Mier and Straus mansions are still standing and are the most splendid in a great number of beautiful homes in Ligonier. The two cousins brought so many of their relatives from Prussia to Ligonier that 10 years after their arrival, there were more than 40 related families in town. They worked in the growing enterprises of their relatives or started businesses of their own. Over the years, Mier and Straus were engaged in a rivalry that turned into a family feud. It continued through the generations, involving ever more of their families.

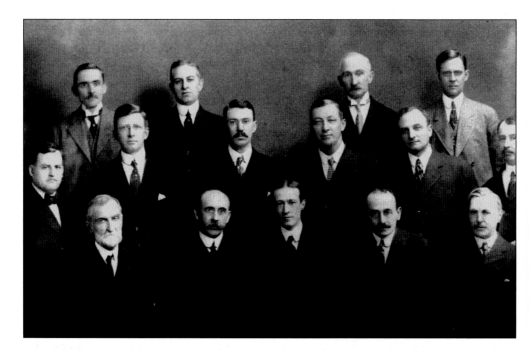

Founders of Temple Beth-El, 1905. (Courtesy Sarah Coffman, Temple Beth-El.)

The Jacob Straus Residence was located at 210 South Main Street, Ligonier, Indiana. The Straus Brothers established the first bank in Ligonier and by 1915 could say that they were "the largest real estate dealer in the United States, if not the world."

In 1880, the Jewish population of Ligonier numbered 200, about 15 percent of the population, but it was responsible for 90 percent of all business conducted in Ligonier. By the turn of the century, Ligonier had grown into a thriving town, a "Little Jerusalem ... the richest small town in America."[183] Straus and Mier were merely the wealthiest families in a wealthy Jewish community, where many had chauffeurs, servants, and ball rooms at the top of their mansions. They led a dazzling social life where, for example, Mrs. Straus would have 100 ladies for tea, who came dressed in the latest New York fashion. Today, the town still is an impressive example of 19th century architecture. Italianate, Queen Anne, Victorian Gothic, and Georgian-, Greek-, and Neoclassical Revival houses and buildings can all be found side by side on its wide tree-lined streets.

The German Jews of Ligonier had a major influence on the town also in their public buildings and institutions. Frederick Straus, in collaboration with John B. Stoll, established the first school in Ligonier. Solomon Mier was instrumental in laying the first sewer system and established the water works. The Jewish population also helped to get a Carnegie library set up in Ligonier. The first synagogue in Ligonier was established in 1868, with Rabbi Baum, a Straus relative, as first Rabbi. The larger Ahavas Sholem Reform Temple, now a museum, was built in 1888. Its opening was celebrated by a three-day round of balls and receptions. In the 1870s, a part of the Ligonier cemetery was consecrated for Jewish burials. Altogether 180 people were buried there, many in elaborate mausoleums. The Ligonier B'nai B'rith Lodge was organized in 1876, and it admitted not only Jews, but select

Ahavas Sholem Reform Temple in Ligonier, built 1888, is now a museum.

members of the local Gentile community.

The business interests and the lifestyle of the Ligonier German Jews eventually outgrew the confines of a small Midwestern country town. The wealthier families began to conduct more and more of their business in Chicago and New York, and had their children educated away from home. One by one the Jewish families left, and their departure began the decline of the town. The last Jew in Ligonier, Durbin Mier, died in 1982.

Plymouth also had a large Jewish population in the 19th century, though not on as grand a scale as Ligonier. The brothers Levi and Meyer Lauer arrived in 1858, choosing Plymouth because other families of the Jewish faith lived there. Levi Lauer was born on December 18, 1827, in Gehus, Saxe-Weimar, and Meyer was born there on January 18, 1831. Meyer came to New York in 1852, working as a cabinet maker. He then moved to Cincinnati, a center for Germans as well as for cabinet making. His brother Levi joined him there. Together they left Cincinnati and worked their way north to Plymouth, selling merchandise from their backpacks. Just three years later, in 1861, the two were able to open the Lauer Brothers Clothing store at 118 North Michigan Street. In 1872, the brothers purchased a larger building across the street at 111 North Michigan Street, where the store remained until 1910. In 1881, Meyer had bought out Levi's interest in the store and brought his son Moses into the business, whose wife was the daughter of the well-known Sigmund Mayer. From that time on the store used the slogan "M. Lauer and Son—Of Course." Until recently it was the oldest business in Plymouth and, perhaps, the oldest Jewish-owned business in Indiana.[184] After separating from Meyer, Levi Lauer started another clothing store in

Plymouth, in partnership with Simon Becker, which was known as Becker and Lauer.

When Meyer Lauer was buried in 1904, a corner of the Plymouth Oak Hill Cemetery was consecrated for Jewish burials. At that time there were about 25 families of the Jewish faith living in Plymouth. All were of German origin, except one Russian family. Other Jewish families, including generations of Lauers, were buried in the consecrated area of the Oak Hill Cemetery, but it was never formally designated as a Jewish burial site. Even today the area is not marked or separated from the rest of the cemetery.

There are indications that in the United States the German Jews at first tended to settle in German neighborhoods. In 1832, a S. Meylert, who had been in the United States for a while, wrote to his nephew August Mailert, newly arrived from Germany; "I believe that you will do better where there are Germans."[185] Similarly, Henry Stern chose to start his dry goods business in Milwaukee "principally because the German immigration was directed there at that time."[186] Leopold Mayer, writing about 1850s Chicago, said, "The Germans, Jews and non-Jews were one, and the prejudices from the fatherland, if not dead, were at least hidden."[187] In Indianapolis many prominent German Jews were members of *"Das Deutsche Haus,"* and one of the biggest German parades, held on July 4, 1866, included a float of the Abraham Lodge No. 58.[188]

The German Jews of South Bend also were in close contact with their Christian compatriots. Moses and Meyer Livingston, Abraham Hanauer, Mose Adler, and others who were very active in the Hebrew Society of Brotherly Love, also were engaged in one or more of the Christian German organizations. Moses Livingston was one of the founders of the South Bend *Turnverein*. Henry Barth was elected as one of the officers in the *Germania* Lodge in 1879. Daniel Schiller also was a member of both the *Turnverein* and the Hebrew Society of Brotherly Love. In a letter to Sack, written in German, from Fort Johnson, where Schiller was stationed during the Civil War, he asked repeatedly to be remembered to the members of the *Turnverein*, expressing how much he missed the *Turnverein* and wanted to have its news.[189]

The frequent social contacts between the two groups generated friendships. Meyer Livingston, for example, was a good friend of John Klingel and served as one of the pall-bearers at Klingel's funeral in 1900. The list of wedding guests at the Emma Muessel and George Rockstroh wedding included, among many Christian Germans, also Mr. and Mrs. Sol Fox, Mr. Levi, and Miss Lou Hanauer. At the turn of the century, many Gentile German-owned businesses provided funds for the building of Temple Beth- El. Although the largest contributions came from the charter members themselves, the Muessel and the Kamm and Schellinger brewing companies also supported the Temple fund, along with other major businesses such as Studebaker's, Oliver's, and George Wyman's clothing store.

The language and national heritage the German Christians and Jews shared united them in the foreign land to which they had come. One historian argues that the German Jews were "vociferous defenders of the German immigrants' popular culture," and that German Jews and Gentiles "were bound together in an organic unity which lasted for generations and which must be taken into account for either community to be properly understood."[190] By contrast, Arthur Hertzberg found that "this involvement in German culture was essentially a brief phase," which ended in the late 1860s."[191] In South Bend, however, members of the Jewish-German community remained in contact with the Christian Germans far beyond the 1860s. Simon Greenebaum, one of the founders of the temple, was president of the Turners in 1911 when they celebrated their Golden Jubilee. In 1913, he helped the society pay off a debt of $5,000. This continuing activity in German organizations may be one reason why there was no B'nai B'rith lodge in South Bend until the 1920s.

While it is true that the German Jews associated quite closely with the German Christians, it was above all the common language and common culture that bound them together. In other respects, the German Jews felt allied both to the Americans and to their fellow Jews. Rabbi Bernhard Felsenthal explained these multiple loyalties in 1901; "Racially I am a Jew...Politically I am an American...Spiritually I am a German."[192]

The German Jews mandated integration not separation from American society. As a result, English became the language of universal communication, which brought the Jewish community closer to the English-speaking world of their new home. If they did not start out using English in all their organizations, Jewish immigrants soon switched from German to English. While the German Jewish immigrants enjoyed participation in German clubs and organizations, this was merely one small part of their lives. The greater part was spent either within the Jewish community or in the general public life of the city.

The Jewish community helped each other to such an extent that there were very few indigent Jews in any community. As early as 1840, Mordecai Manuel Noah, a Jewish leader in New York, urged his fellow Jews "to defend less fortunate Jews, and to help with money and public support."[193] Christian Germans also observed that the German-Jewish immigrants held together and supported each other far more than did the Christian Germans. If one of them ran for office, for example, German-Jewish immigrants as a group supported him, even if they did not share his outlook. Christian Germans on the other hand tended to fight among each other and envy someone who appeared to be rising above the rest. It was said that if a German-Christian immigrant got elected, it was often despite, and not because of, his compatriots.[194]

Although German immigrants of the Jewish religion made up a minority of 1-2 percent of all immigrants, they enjoyed a prominence far beyond their numbers. Generally, they were more involved in the public and political life of their communities than the German Christians. Thus the first German immigrant elected to congress, Meyer Strouse of Pennsylvania, was a Jew. Unlike the Christian Germans who were not united in a common interest, the Jewish Germans in America "had adopted the misery of other Jews as their cause. This caring was their principle of unity."[195] This common cause held them together, even when other factors, such as religious differences, might otherwise have torn them apart. It gave them an agenda, both nationally and internationally, that sustained them as a community. The threefold loyalties mentioned by Rabbi Felsenthal contributed to the private and public success achieved by the German immigrants of the Jewish faith. It made them more flexible and adept at negotiating different cultures. They could honor their German cultural background, and at the same time maintain a powerful allegiance to the Jewish community as well as adjust quickly to America.

The extent and success of this Jewish community of the 19th century had far reaching consequences. The immigrants were "the pioneers of a migration overseas that knows no parallel in Jewish history...and was materially to transform the Jewry not only of Germany but of the whole world."[196]

Hunger for Land and Land Hunger

In his later years, John C. Schreyer, son of immigrant farmer Johann Wolfgang Schreyer, liked to settle himself in his rocking chair, take his grandchildren on his lap, and tell them his favorite story from his childhood. "We had a farm just south of South Bend, and our home was a log cabin. It was a small place, and I had to share a room with my two sisters. One day my father had to take a wagon load of wheat to the mill in Plymouth to be ground. He left in the morning, but had to be gone overnight because the 8-mile trip from his home to Plymouth was a long one with a horse and wagon. This meant that my mother and us three children were alone that night. We went to bed as usual, and just as we were falling asleep, we suddenly heard a noise. To our astonishment the cabin door opened and in came an Indian. He said nothing, but merely went to the fire and lay down in front of it. Of course, if he had spoken, we would not have understood him anyway. At first we were terrified, and did not know what to do. Then we went back to our beds, but none of us could go to sleep for a long time. Toward morning we must have dozed off, because when we awoke, the Indian was gone.

As soon as my father came home, we excitedly told him about the visit from the Indian. He only laughed. The man was a friend of my father's who had seen him leave for Plymouth with his load of wheat. Since he knew that there were some unfriendly Indians on the warpath in that vicinity, the Indian had stayed in our home that night to protect us."[197]

The Indian belonged to the Potawatomi tribe, which was known to be friendly to "the White Man," even though they had taken his land, and in 1838, engineered the horror of the enforced deportation of the Trail of Death.

The promise of cheap land drove many Germans to the United States in search of a farm of their own. Hungry for land, they went wherever property was available at the best price and worked hard to transform the virgin woods into farms. But the vast stretches of empty land also brought others who were driven by land hunger to engage in land speculation and land scams, often at the cost of those eager to farm land of their own.

After Ohio was largely settled, the Germans moved west to Indiana and German farming communities sprang up all around South Bend. To the north, on Douglas and Grape Roads, so many Germans bought land that the area was known as Dutch (*Deutsch*) Island. On the west side, they settled in what later was called German Township. Likewise south of South Bend and Mishawaka there were a great number of German farms. The town of Bremen in Marshall County was platted and laid out by German George Beiler in 1851.[198] All around that area, little cemeteries filled with German graves, many with German inscriptions, still dot the countryside.

Johann Wolfgang Schreyer, who had first tried the butchery business in Ohio, believed that farming, particularly in Indiana, offered the best opportunities for German immigrants. In his letter home, he had tried to give an accurate picture of what farming in

The first cabin of the Schreyer family, 1840s. (Courtesy Northern Indiana Historical Society.)

Indiana was like in the 1840s, and noted the many Germans who already were farmers there. "Here in our settlement, which is eight years old," wrote Schreyer, "there are several hundred inhabitants and the number is increased each year by from ten to fifteen new ones, for the most part Germans."

By the 1840s, land was cheaper in Indiana than in Ohio, which had been settled earlier. In 1843, Schreyer's 40 acres, near Plymouth, only cost him 25¢ an acre. In Ohio, at about the same time, land cost five times as much.[199] The price Schreyer indicated, however, was lower than the going rate of $1.25 an acre for public land in Indiana.[200] In 1831, Peter Rupel purchased 80 acres of public land south of South Bend for $1.25 an acre, and in 1840, Frederick Ritschie bought 40 acres in the Bremen area for the same price. Land prices depended on location, and on whether any of it had been cleared of trees or had any buildings on it. In 1853, John and Catherine Bellman purchased 60 acres near Bremen for $16 an acre, and in 1860, John Walz paid $9 an acre for his 80 acres of uncleared land on Pierce Road near Lakeville.

Schreyer informed family and friends back home that public land was becoming scarce even in Indiana. But "if anyone should desire to come to this part of the country, he could still find land to buy… there is still land to be had for three dollars an acre." He added that more developed property also was available. "Not far from me, there was sold during the winter, a piece of forty acres with a house, granary, barn, and twelve acres of cleared land, fenced, for two hundred twenty-five dollars." Johann Friedrich Diederich, who settled near Milwaukee, wrote an account similar to Schreyer's, in which he advised, "He who settles on wild land should have about $500; but for $2,000 [about $35,000 today] one can at any time buy the finest farms, with all livestock and with provisions for one year."[201]

Public land was free from taxes for five years after purchase. After that, the tax was 1¢ per acre. Schreyer explained that people could pay this tax by working on the public roads. He added, "If the taxes are not paid within the period allowed by law, there is no collector sent until after two years, and if the taxes are not paid then, the land is advertised for sale without the knowledge of the owner and sold at any price."

One could always tell a German-owned farm by the large size of its barns and outbuildings, since the Germans preferred to keep their animals more confined than was the practice with native-born farmers who let them roam outside even in winter. The size and orderliness of German vegetable gardens, and the general neatness of the farm's appearance were other indications of a German farm.

In contrast to the "One-Crop Yankee," the German settlers continued the diversified farming and crop rotation they had used back home. According to Schreyer, a farm of 100 acres usually was arranged with 60 acres for wheat, 15 acres for corn, 10 acres for oats, 8 acres for rye, 5 acres for buckwheat, and 2 acres for potatoes.

A typical practice Schreyer observed during harvest time might have seemed strange to German farmers. "A wagon loaded with whiskey and water is constantly taken about the field to supply the harvesters with something to drink." Schreyer liked the way the pioneers helped each other, especially in the barn raisings, where neighbor helped neighbor, and they then celebrated their achievement together.

Although Schreyer admitted in passing that he had experienced hard times at first, he did not dwell on the difficulties farmers had to face. Instead of the hardship, he stressed the rewards. "All who are diligent will find that they need never suffer want in this country." After three years of farming, Schreyer had eight acres under cultivation, more than enough to live on. He also owned "two large oxen, two cows, and a number of smaller animals about and a whole herd of hogs."

However, preparing the heavily wooded land for planting required backbreaking labor. John Walz spent an entire year clearing away trees so that he could begin to farm between the stumps. When possible, the timber was burned right away. Otherwise the green wood was stacked by the side of the road to dry. At night, the glowing embers from the day's log and brush fires could be seen across the horizon, as inch by inch the land was cleared for farming. Initially the enormous quantities of hardwood seemed nothing but a terrible obstacle to cultivation. Only later was its potential value recognized. "In after years the walnut timber that grew upon the land was found to be more valuable than the land itself."[202]

Once the land was cleared, it needed to be fenced. Schreyer said that it "costs about ten dollars to clear an acre and fence the land," adding that all fields must be fenced in by rails from 10 to 11 feet long. "The fences must, according to law, have a height of from seven to

The Walz farm at 18318 Pierce Road, Lakeville, Indiana was built in 1861.

111

eight rails arranged in zigzag fashion so that two lengths shall equal a rod, or sixteen and one half feet." As Daniel McDonald observed, "to fence a forty-acre lot was a long tedious job, and many a man ruined his health by long continuance at this kind of labor."[203]

Johann Diedrich described the labor a farmer had to endure day to day in his first year. We "cut down trees for logs, carried them on our shoulders through the snow…and continued this work from Monday until Saturday, all week long. If you, my dear ones, could have seen me—how I arose in the morning from my bed of cornstalks with a block of wood for a pillow, partook of half baked or half burnt, sour, dry bread and black coffee without sugar, for breakfast; at noon dry bread and black coffee again, with turnip soup, and the same in the evening…[204]

Most early settlers purchased the land for their own use and in the process created the fertile farms of the Midwest. Even so, land speculation in America was rampant, making even the new territories not as free and open as people had dreamed. *Turner's Gazeteer of the St. Joseph Valley* of 1867 described the frenzy; "lawyers, not in pairs but in packs, came poking their angular faces into the most promising settlements of this incipient Eden. Speculators swarmed in land offices, made paper towns, 'played out,' and left wiser and poorer if not better than they came."[205] As a result of land speculation, by 1855, no more public land was available in Indiana. And yet, because so much of it was held by speculators, vast stretches of the state remained totally unimproved.[206]

It will be remembered that in the 1860s and 1870s, some of the more prosperous and enterprising urban immigrants participated in this land speculation in other states. If people took advantage of the hunger for land of small farmers and workmen, the speculator's land hunger also could have fatal consequences.

One of the victims was August Betcher of South Bend. He was born in Germany in 1832, where he married Libbie Kamiska in 1860. When the couple came to South Bend with their three children, Betcher found employment with the Studebaker Company. The Betchers had two more children in South Bend. In 1878, the family read an announcement in the local newspaper: "TEXAS HO! Best Climate in the United States, Cheap Lands, Good Homes, etc."[207] The ad was placed by the Eagle Colonizing Association which was founded by a group of Germans in 1876, in Dayton, Ohio. Karl H. Kaltwasser (who called himself Coldwater), Emil C. Lehman, Samuel Lehman, Charles R. Dietz, and William Schlotz had bought "asylum lands,"[208] in Texas, for a 10 percent down payment. They planned to resettle up to 350 people, and recruited German immigrants from factories such as Studebaker's.

Lured by promises of rich land and an easier life, the Betchers, along with over 300 other German immigrants, signed up for the Eagle Colony venture. They each paid $250 for the trip, which was made in brand new Studebaker wagons. However, it was not an easy journey. They had to pass through rocky ravines, quicksand, and bogs. When at last they arrived at Eagle City, their troubles were far from over. They had to live in tents and to pile rocks all around their tents to keep out the rattlesnakes.

The arrival of such a large group of Germans in Texas in 1878 was duly noted by the *Fort Worth Daily Democrat;* "A colony of four hundred German families have just arrived in Baylor County from Indianapolis and vicinity. They bought an even 100,000 acres of land, and paid cash down at the rate of $1.50 per acre, or $150,000. They have ample capital and material to at once begin farming operations, and will make a fair crop this year."[209]

Once in Texas, Coldwater bought mules as transportation for the immigrants. But neither the Betchers nor anyone else in their group was used to handling the obstinate animals. Moreover, the mules responded only to Spanish commands since they had been driven by Mexicans. According to Tommie Clack, an Abilene school teacher, "The Germans' first mistake

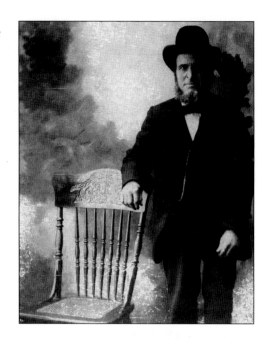

Henry Ritschie is seen here at about the time of the Tennessee disaster. (Courtesy John Gardner.)

was that they addressed the obstinate beasts in the language most often used in the colony—forceful German. The mules, in turn, objected vigorously." August Betcher's 14 year-old son Albert was greatly amused by the scene. "I know it was a funny sight to see those fellows wrestlin' Spanish mules and cussin' them in German."[210]

The first summer went well. The weather cooperated and the crops were rich. With the onset of winter, however, the trouble began. After Coldwater had taken all the money he could from the settlers, he disappeared. Even the Studebaker wagons, which the Germans had thought were theirs, were confiscated by the sheriff of Buffalo Gap, because they had never been paid for. The settlers had neither food, nor fuel other than buffalo chips. They would have starved had not the cattlemen of the area taken pity on the hapless group and occasionally donated a side of beef. Anyone who still had money went back to Indiana, but most had to stay and tough it out.

As they struggled to survive, the Betchers began bitterly to regret their move. August worked odd jobs on the ranches in the area, but Libbie, trained as a teacher, could find no work at all. She was forced to leave the younger children under the care of the older ones, and, in the company of only Albert, she walked to Dudley, about 10 miles away. Once Libbie found employment as a maid on the ranch of Mr. and Mrs. John Trent, the Betchers moved to Dudley, living in a dugout near the Trent place. Eventually August got a job in Abilene in his trade as blacksmith. He stayed in Abilene during the week and walked the almost 20 miles home each weekend, laden with provisions. As soon as the family had saved enough money, they sent their oldest daughter, Mary, back to Indiana to sell the house they still owned there. She made the trip successfully, hiding the money from the sale sewn into her clothes as she returned.

With that money, the Betchers' fortunes improved. In the 1880s, they bought a farm, and in 1900, they built their own home. It had a stone chimney of which they were particularly proud. The sturdy house still stands today. There they lived, contented at last, until their deaths. August died on August 29, 1919, at the age of 87, and his wife Libbie lived until August

Henry Ritschie is pictured as an old man in South Bend with daughters and granddaughters. (Courtesy John Gardner.)

26, 1926, when she also was 87.[211]

A fate with a less happy ending befell the farmer Henry Ritschie. He was born in Waldfischbeck in Baden in 1834, and came to Bremen, Indiana, in 1839, with his parents Frederick and Anna Margaretha. On March 27, 1840, they bought land from Adam Hensel,[212] and continued to add 40 acre plots adjacent to their property. Suddenly in 1870, Henry and his wife Barbara, whom he had married the year before, sold all their land for $2,100, which was close to double what they had paid for it during the 1860s. Almost all their property was bought by Frederick Knoblock, whose farmland bordered on theirs. Then the Ritschies left in a covered wagon for Tennessee.

But instead of rich farmland and the easier life they had expected, they found a barren countryside, rich only in stones. Henry's wife soon died, leaving him alone with seven small children, ranging from less than one year to 11 years old. Destitute and disillusioned, Henry, with his children, started the long trek back to South Bend. But he always remembered one good incident from that otherwise sad journey. After a dusty, hot, and tiring day on the road, he stopped one evening at a house to ask whether he could park his wagon in the yard so that the family could rest. The black woman who answered the door not only invited them into the house, but fed them, and gave them a place to sleep. The next morning, she fixed a basket of food for their journey. Henry never forgot the kindness of that woman.

Back in South Bend, Henry worked as a laborer for the rest of his life, never again owning his own land. However, a picture of him as an old man standing in the yard of a nice frame home, suggests that in the end he managed to escape the poverty he had suffered for so long and make a better life for himself after all.

There was no quick and easy road to success for farming pioneers. Schreyer may have written that country people were "happy and carefree," but those who succeeded did so by endurance and incessant labor. Perhaps an indication of the hardness of the work was that many of the sons of these early farmers, like Schreyer's own son, left the country to seek employment in South Bend. Nevertheless, German immigrants, hungry for land they could never hope to own in Germany, came anyway in large numbers. By their labor they helped to change the wilderness into flourishing farms. However, the land hunger of the speculators achieved the opposite. It enriched a few, ruined many, and made the land too expensive for those who wanted to develop it productively.

114

XIV.

The Problematic Hyphen

*O*n *a beautiful autumn evening in the year 1852, a group of German immigrants gathered on the pros-
perous farm, on the Edwardsburg Road, which belonged to Johann Melchior Meyer and his wife
Elizabeth. The immigrants had come to support the Democratic presidential candidate Franklin Pierce. On
the lawn beneath the trees, long tables stood, laden with the sausages, potato salads, dumplings, and roasted
chickens so popular with the immigrants. After everyone had enjoyed the feast, and as the stars began to
appear above, the ceremonies began. In the name of the young German girls of the community, Elizabeth's
daughter Katharina presented an American flag to the Democratic Club. Then Anthony Schmidtmeyer
addressed the group in a speech that "lingers still in the memory of all who heard it."*

*Schmidtmeyer spoke about the problem of loyalty to two countries, an issue that was important to the German
immigrants gathered around him. Under the attacks of the Know-Nothings, they had again and again felt
driven to defend their twofold patriotism for Germany as well as America. "We have learned to love this land,"
Schmidtmeyer told them, "and shall always seek to be loyal citizens and prove worthy of the blessings that we
here enjoy. Yet none of us will ever forget the land of our birth where the happy years of our childhood were
spent, for we cherish it as we cherish the kind and loving mother whose memory shall ever be sacred. America
stands in our affections as the bride of our youth to whom we owe faithfulness and chivalrous devotion. We can
be true to both; indeed, we cannot be otherwise, for the man who forgets the mother to whom he owes his life,
who fails to honor and respect her always, cannot and will not be true to his chosen wife."[213]*

*Several decades later, Schmidtmeyer's eloquent metaphor, which had moved the immigrants on the quiet
farm in St. Joseph County, was quoted by Carl Schurz in Berlin when he was the guest of honor at a dinner
given by the German Emperor.*

From their arrival to at least the end of the 19th century, many Germans in the United
States referred to themselves as German-Americans, the hyphen symbolizing both of their
attachments. Carl Ruemelin, first president of the *Pionier Verein* of Cincinnati, said in
1869, "We did not wish to establish here a mere New Germany, nor, on the other hand did
we wish simply to disappear into America... we have succeeded in remaining honorably
German without at the same time being untrue to our new Fatherland."[214]

As they were becoming Americanized, German immigrants also were encouraged to keep
alive in their children and grandchildren the love of the German language and of German
literature, poetry, songs, and culture. Through clubs, social organizations, their press,
churches, and schools the immigrants continued many of their German customs and tradi-
tions, which fostered their sense of cultural distinctiveness. In fact, culture became the
defining element of the Germans' ethnicity rather than any common political interests.[215]

However, the German immigrants did not only, or even mainly, look back to their past, they
also looked forward to becoming valuable members of their new nation. They adapted their

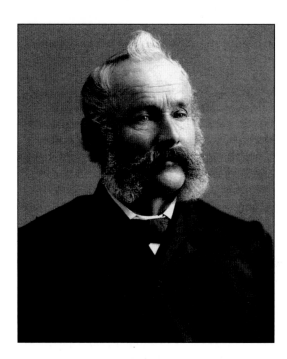

George W. Beck was said to have a striking resemblance to German Emperor Friedrich Wilhelm. (Courtesy Tom Lang.)

behavior quickly to their new environment. Most German immigrants immediately anglicized at least part of their names. The Germans were determined to integrate themselves into their new environment, enjoying its liberties, and they were proud to be Americans. The German immigrants to South Bend were helped in this effort through their daily contact with the English-speaking population. Their businesses and their residences were next to those of the native-born, and a good number entered into business affiliations with them.

The very organizations that promoted the cultural identity of the immigrants also helped to integrate them into the mainstream of society. The national *Turnverein* organization, for example, urged its members to become naturalized citizens and to take an active part in American democracy. The *Turnverein* hoped that by doing this, German immigrants would add a unique ingredient to the American melting pot, and help to instill German values and German culture into their new homeland. German-Americans like Heinrich Armin Rattermann had faith that it was just this mixture of nations that would help to create the particular character of "the most cosmopolitan country of the present," and that it was the mission of the German element to impart its culture to the new world.[216] Similarly in 1867, the famous German-American Carl Schurz wrote in a letter to his wife, "The mission of Germanism in America…can consist in nothing other than a modification of the American spirit, through the German, while the nationalities melt into one."[217] In South Bend, Chauncey N. Fasset, editor of the *Sunday News*, came to a similar conclusion, "The Teutonic was one of the elements of nationalistic quality that contributed to the formation of communistic [*sic*] character in South Bend. It gave not a little to the sturdiness of this community. Its influence is likely to continue for many years to come, if not permanently.[218]

The members of the South Bend *Turnverein* became active in the social and political life of the larger community. They were elected to local offices, celebrated national American holidays, and volunteered in the Civil War. Membership in the *Turnverein* was a key to success for South Bend's German-Americans. Six out of the 15 community leaders who

arrived before 1860 were German, and between 1850 and 1880, German immigrants furnished 11 out of 18 leaders.[219] Thus while the *Turnverein* proudly upheld German traditions, it did not isolate itself into a German ghetto but helped to prepare its members for leadership in the English speaking society and its political life.

A similar argument can be made for the German press. German language papers promoted the preservation of German traditions and the German language, but at the same time they familiarized their readers with American society and the American political system. Like all other German papers in America, *Der South Bend Courier* carried news from the German states, which incidentally was designated as foreign news, but on the front page it covered American politics and public affairs.

In the first generation in particular, this created a biculturalism, a complex mixture of both cultures. "During the transitional period, the relatively high status of German culture may have permitted a kind of biculturalism, as essentially assimilated persons moved back and forth between German and non-ethnic cultures, adopting at will the behavior of either."[220]

The biculturalism of this early period was symbolized in a banner, which became the main emblem of the South Bend *Turnverein*. It was designed by Christian Sack in 1867, and showed the Stars and Stripes on one side and the *Turnverein* emblem on the reverse, depicting a discus thrower and the words "Sound Mind" and "Sound Body." The banner visually demonstrated the club's dual commitments. Another interesting fact about the *Turnverein* banner was that it was embroidered on silk by the Sisters of the Holy Cross, although usually Catholics considered the *Turnverein* an infidel organization.

This full biculturalism did not last for more than a generation. The second generation of German immigrants became absorbed in American society. In fact, some social historians argue that "No other nationality group of equal numerical strength and living in one country has ever been so well nigh completely assimilated."[221] Nevertheless, the second generation continued many of the traditions of their parents, celebrating German holidays, participating in German social organizations, and marrying other second-generation German immigrants.

The central challenge for the immigrants was to find a balance between "the need to preserve and the impulse to assimilate."[222] Carl Ruemelin had formulated the problem succinctly—how to avoid total absorption and "disappear," and how to achieve the balance of remaining "honorably German" while at the same time becoming a part of the new home country. This is a perennial problem for all immigrants to the present day, whether to strive for assimilation or preserve ethnic identity, or what balance to achieve between the two. Carl Schurz' answer for the Germans is still relevant to present-day immigrants from whatever country; "I have always been in favor of a reasonable Americanization, but that never means an abandonment of all that is German. It means that we should adopt the best traits of the American character and join them to the best traits of the German character. In this way we shall make the most valuable contribution to the American nation and to American civilization."[223]

The German language, and with it German songs, poetry, and prayers, became an important tool in preserving their ethnic identity. In South Bend, the *Turnverein*, the *Germania* Club, and the *Maennerchor* conducted all their affairs in German even beyond the end of the 19th century. Because of this commitment to German by the immigrants, "German in its heyday almost attained the position of an unofficial second language for the United States."[224]

However, over the years, as the second generation grew up, the Germans gradually switched to English. By 1895, Anna Beiger could not have the German burial service she

had wanted in the Coalbush Church of Mishawaka. The solution was to have two funeral services—one in German, at her home, and the other at the church, in English. St. Peter's Church of South Bend continued German services until World War I, and Zion Church maintained some German services until 1921. The only local German language newspaper, *Der South Bend Courier,* already had ceased publication in 1901.

The *Turnverein* and the *Maennerchor* held on to German longer than the other institutions. Although gradually the language of communication among its members became English, the officers of the Turners had to know German and the minutes were recorded in German. In the mid-1930s, however, the Constitution of the society was translated into English and soon thereafter German was dropped altogether. In the *Maennerchor* it was not until April 7, 1942, that members introduced a resolution to hold all meetings in English. Although by that time, many members were hardly able to speak German any more, they still felt that this was a big step, which needed careful consideration. Over a period of three weeks, the resolution was read three times at separate meetings. In addition, every member was informed about the proposed change in writing and given a chance to respond. The minutes of May 5, 1942 said that the resolution was read a third time. And this was where, perhaps fittingly, the record ended.

The *Monatsblatt*, the monthly newsletter of the German Protestant Zion Church in South Bend, reflected the struggle, as well as the ultimate futility, of trying to preserve the German language over the generations.[224] Pastor Goffeney praised the German Protestant church in America for doing a good job in preserving the German language and German traditions. He cited their teacher training seminars, their synods, and their press, which all were conducted in German. Writing in 1904, he noted that the German Protestant church was "a stronghold of the German language and the German spirit." Had it not been for the church, hundreds of thousands of Germans and hundreds of thousands of their children would simply have lost their "Germanness."[225]

In 1904, Goffeney published a three-part series in the *Monatsblatt* on "The German Language in America." In the first installment he talked about the intimate connection between language and culture, and urged his readers to preserve the German language in their homes. He himself, he explained, had married the daughter of German immigrants who, however, could not speak German. But she had soon learnt it, and at home everyone in his family, including his children, spoke only German. "Although I am open to the good things in our country and busy learning English, I have yet maintained in my heart a fervent love for my old home and my German language, as well as German customs and traditions."[226]

In another installment Goffeney inveighed against the Know-Nothings, who argued that if immigrant parents taught their children their mother tongue, they condemned them always to remain "foreigners," and never to become proper Americans. Like so many before him, Goffeney stressed that people could be both good Americans and yet preserve their love for their ancestral home. He also added that there were thousands of English-speaking Americans who had learnt German. "That doesn't make them less patriotic: it makes them more clever and more educated."[227]

Despite Pastor Goffeney's fervent commitment to keep German alive within his congregation, the use of the language declined markedly, even within his own publication. Although he continued to write all his articles in German, the business advertisements at the back of each issue used more and more English. In 1897, 31 businesses advertised, all of them in German except for a few English terms such as "ice cream." Two businesses specifically indicated that they were German—Christian Rockstoh's German bakery, and Otto Bastian's German drugstore, and another stressed that "in this store we speak

Advertisements in the Monatsblatt *of Zion Church in 1897 and 1906 showed the development toward more English and fewer ads. (Courtesy Harry Koehler, archivist, Zion Church.)*

German." By 1906, five of the ads were entirely in English, and the others carried far more English in their text than in 1897. George Sommerer described his business, in English, as "Wholesale and Retail Grocer," and F.E. Mueller called himself "Dealer in fine Groceries." Moreover by 1906, the number of ads had been drastically reduced from 31 to 20. Presumably businesses were less interested in an all-German newspaper because its readership was disappearing together with its language.

Even without the language, however, the descendants of the immigrants continued to identify themselves as German-American into the 20th century. Writing in 1940, John Arkas Hawgood saw this identification as "tragic." He believed that it postponed assimilation by several generations, and kept immigrants out of touch with both worlds, unable to negotiate the social and political realities of either country. To define themselves as German-American may have been a satisfactory solution for the original immigrants, but it was "disastrous" for their children and grandchildren. According to Hawgood, this was especially the case during World War I, during which German-Americans found themselves in a most difficult and painful position. They wanted to support their American home, but could not see themselves killing their German brothers. "It is alleged that cases of suicide in the draft camps were not uncommon among the sons of German homes, for whom this conflict and this break had proved unbearable."[228]

Prior to the entrance of the United States into World War I, German language newspapers

in America supported the German side. And a number of organizations in America raised funds for Germany. From 1914 to 1917, the National German-American Alliance for war relief sent a total of $886,481 to Germany.[229] The German Aid Fund, headquartered in Milwaukee, Wisconsin, collected funds from German-Americans "to help the surviving families of our German brothers who died in the war." By November 27, 1915, $19,784.02 had been received from people all over the country, including $2 from the German-American boy Fred Brinkman from South Bend. Up until 1917, the South Bend *Turnverein* also collected $1,626 for the "sufferers of Germany," which was turned over to the Red Cross.

After the United States entered the war, however, such support stopped. Nonetheless, German-Americans were attacked as unpatriotic and un-American. Derogatorily called the "Kaiser's helpful hyphens," they were accused of everything from starting fires to putting glass in food."[230] The teaching of German was outlawed in public, private, and parochial schools across the nation.[231] In Indiana, this reversed a law that had been passed in 1869 that "authorized instruction in the German language in the common schools wherever the parents of twenty-five students petitioned for it."[232]

German-Americans now tried to be as inconspicuous as possible. They erased any public references to their German roots. Many, who still had German last names, changed them into English ones. All over the country, German street and town names were anglicized. *Das Deutsche Haus* of Indianapolis rubbed its German name out of the portal, and renamed itself Athenaeum, by which it is still known today. During the war, most German language papers, which already had been struggling to survive, ceased publication.

German-Americans in Northern Indiana also were deeply affected by the anti-German mood of the country. Charles Beutter, the grandson of German immigrants to South Bend-Mishawaka, still vividly remembers how difficult it was to be German during World War I. "When I was growing up and in school, they weren't allowed to teach German...It was terrible, you couldn't say you were German." He also recalls a front page article in a South Bend paper which said that Hugo Weichelt, Pastor at St. Peter's, was "PRO-GERMAN." As a result, the church discontinued their German language services.[233] Thekla Sack, who taught high school German in South Bend, was not only professionally affected by the removal of German from the curriculum, but profoundly disturbed by the hatred of Germany, whose culture and traditions she had been taught to hold dear since childhood.[234] In 1917, the *South Bend Tribune* asked the president of the Turners what stand the society was taking on the declaration of war between the United States and Germany. The answer simply was that the society admitted Americans only to membership.[235] The President could have added that 31 Turners fought in the war on the American side.[236]

Hawgood claims that as soon as America entered the First World War, German-Americanism ceased to exist. The war "split their Germanism from their Americanism, for they could no longer retain both, and it dissolved the hyphen which had for so long served to unite them."[237] However, this seems to suggest too abrupt and simple a break from the past. German-Americans were loyal Americans, many of them serving in the United States Army, but this did not mean that they could so quickly and completely sever themselves from their past. People do not walk away from their identity overnight. Although the war no doubt created tremendous inner conflicts for German-Americans and made any outward show of their German heritage impossible, it did not dissolve all the connections people of German origin felt toward their roots.

At least a partial and private identification as German-American remained with the descendants of German immigrants, not only after World War I, but even after World War II. Even though people of German descent no longer spoke German, and had lost touch with most

Gabrielle Robinson presents the key of the city of South Bend to Arzberg Mayor Winifred Geppert and County Executive Peter Seisser (seated) in June 2002.

of their German culture, they still retained some feelings of ethnic belonging. When John Christopher Schelleng, grandson of Johann Christoph and Anna Barbara Keisler, had a meeting in London after the Second World War, he made it a point to travel to Arzberg to visit his relatives. He reported that the trip was "marked by conflicting feelings upon entering the homeland of my grandparents and the domain of the Nazis."[238] When Henry Frederick Schricker, governor of Indiana and grandson of German immigrants, was offered the position of governor general of Germany after World War II, he turned it down because he felt that with his German background people would say he was being partial.[239]

At the beginning of the 21st century, descendants of German immigrants have happily rediscovered their German roots. Americans in the South Bend area whose families came from Arzberg in Bavaria, are enthusiastically trying to reestablish contacts with Germany. Several are making trips back to Germany in search of their roots. And the citizens of Arzberg in turn are holding out their hands to welcome the descendants of those who left in the 19th century. At the Arzberg city fest in June 2002 they held a reception for the visitors—or "relatives" as they were called—in city hall.

The 2002 visit was further celebrated with an exhibition on South Bend, and the mayor unveiled a permanent memorial in front of city hall in commemoration of the South Bend–Arzberg connection. The text on the three-sided memorial reads:

There were citizens from Arzberg who, in the middle of the 19th century, left their home in search of a new existence. In South Bend in Indiana they found a new home, which enabled them to live a life in peace and freedom.

There were citizens of South Bend, who in the year 2002 came to Arzberg from Indiana in search of their historic roots. In Arzberg they found citizens who welcomed them in friendship, and thereby expressed their thanks to the American people.

The citizens of Arzberg and the citizens of South Bend established here a symbol of friendship and solidarity between the German and the American people.

The recent flowering of German-Americanism is, of course, of a different nature than that of the 19th century when the German immigrants first came to America. Then it was motivated by homesickness and the common experience of being foreigners in a strange land. At the dawn of the 21st century, it is the impact of the postmodern world that helps to create the climate for a rediscovery of ethnic origins. The new interest in German-American history can be linked to a search for identity that is becoming more insistent as the world is getting more similar and impersonal. Instead of homesickness, it is driven by nostalgia for a past, where, it is assumed, people had a clearer sense of who they were.

Paradoxically, this rediscovery of the past is not only a reaction to the anonymity and sameness of life in the postmodern world, but also one of its symptoms. The postmodern mentality cherishes and celebrates the small and the local, and finds history less in world changing events, than in ordinary individual cases. This goes beyond the often uneasy balance of hyphenation, making the local international, and the international local. Like the roots of the cowslip, the flower that was imported by homesick German immigrants in the 19th century, everyone's roots are an intricate and delicate though sometimes almost invisible mesh that needs to be nurtured and explored in order to be understood.

The Weiss wedding feast, 1899. (Courtesy Erwin Scherer.)

Endnotes

1. "Letter Written by Mr. Johann Wolfgang Schreyer." Donald F. Carmony, ed. *Indiana Magazine of History* xl, no. 3 (Sept. 1944), 283-306.

2. Charles C. Chapman. *History of St. Joseph County, Indiana*. Chicago: Charles C. Chapman and Co, 1880, 929.

3. Dean R. Esslinger. *Immigrants and the City. Ethnicity and Mobility in a Nineteenth Century Midwestern Community*. Port Washington, N.Y.: Kennikat Press, 1975, 54.

4. Timothy Edward Howard. *A History of St. Joseph County Indiana*. Chicago: The Lewis Publishing Co. 1907, 562.

5. *One Hundred Anniversary. American Turners—South Bend 1961*.

6. *South Bend Tribune*, July 26, 1971.

7. Chauncey N. Fassett. "Sweet Singers of Thirty Years Ago Called to Mind." *South Bend News Times*, June 18, 1917.

8. Esslinger, 108.

9. *South Bend Daily Times*, April 7, 1904.

10. "Schmier" was either tarock or *Schafskopf*, played with old German cards, both of which have a move the Germans call "schmieren."

11. Carl Wittke. *Refugees of Revolution. The German Forty-Eighters in America*. University of Pennsylvania Press, 1952, 139.

12. The first place is the home, the second work, and the third place is a place of informal socializing where everybody is a guest and no one has the responsibilities of either home or work. Ray Oldenburg. *The Great Good Place*. New York: Marlowe and Co, 1997.

13. Esslinger, 107.

14. *South Bend Daily Tribune*, April 23, 1900.

15. Richard O'Connor. *The German-Americans. An Informal History*. Boston: Little. Brown and Co, 1968, 6-7.

16. See Kathleen Neils Conzen. *Immigrant Milwaukee 1836-1860*. Harvard University Press, 1976.

17. Esslinger, 84.

18. Conzen, *Immigrant Milwaukee*, 228.

19. Great-grandson Karl Soellner's account based on family stories.

20. Bruce Levine. *The Spirit of 1848. German Immigrants, Labor Conflict, and the Coming of the Civil War*. University of Illinois Press, 1992, 22.

21. Meyer in Carmody, ed. "Letter Written by Mr. Johann Wolfgang Schreyer," 305.

22. Otto Knoblock. "When South Bend Was Young." *South Bend News Times*, June 23, 1935.

23. Wolfgang Helbich. "The Letters They Sent Home: The Subjective Perspective of German Immigrants in the Nineteenth Century." *Yearbook of German-American Studies*, vol. 22 (1987)," 4.

24. Meyer in Carmody, ed. Schreyer Letter, 305.

25. Friedrich Wilhelm Singer, *Die Amerika-Auswanderer der Evang.-Luth. Kirche in Arzberg*. Arzberg: Evang.-Luth. Kirchengemeinde, *1995*, 76-77.

26. Singer, *Amerika-Auswanderer*, 68.

27. Jacob Rader Marcus. *Memoirs of American Jews 1775-1865*, 2 vols. Philadelphia: The Jewish Publication Society of America, 1955, vol. II, 103.

28. See Tyler Anbinder's vivid description in *Five Points*. New York: Plume (Penguin Group), 2001.

29. Bruce Levine. *The Spirit of 1848. German Immigrants, Labor Conflict, and the Coming of the Civil War*. University of Illinois Press, 1992, 82.

30. Elbel seems not to have been entirely correct, for there was a cholera outbreak at Notre Dame in 1854, but it was kept as secret as possible. Johann Friedrich Elbel, to Dr. Christian Sack, April 8, 1855. NICH 87.28/1.

31. Timothy Edward Howard, *A History of St. Joseph County Indiana*, Chicago: The Lewis Publishing Co, 1907, 374.

[32] *South Bend News Times*, October 17, 1920.

[33] *St. Joseph Valley Register*, Oct. 15, 1874.

[34] Helen Walz Maxwell. *Sketches of My Kith and Kin*, 1966 n.p. Her book gives wonderful personal details about growing up on a farm at the turn of the century.

[35] Quoted in Agnes Bertille Hindelang. "The Social Development of South Bend, Indiana, as Shown by Its Ordinances." Master Thesis, University of Notre Dame, 1933.

[36] John J. McCusker. "How Much is That in Real Money?" *Proceedings of the American Antiquarian Society*, vol. 101, part 2 (1991), 297-373. All further conversions are based on this study.

[37] The *Maennerchor* records have survived from its inception until 1942. The extensive books, covering 2,000 pages, handwritten in the old German script, are available at the Northern Indiana Center for History.

[38] Anderson and Cooley. *South Bend and the Men Who Have Made It*. South Bend: The Tribune Printing Co, 1901, 111.

[39] Otto Knoblock. "When South Bend Was Young." *South Bend News Times*, June 23, 1935.

[40] *South Bend News Times*, February 15, 1907.

[41] Lorraine Soellner, granddaughter of Andreas Soellner. Typescript, 1965.

[42] Esslinger, 68.

[43] *South Bend News Times*, August 18, 1917.

[44] Esslinger, 95.

[45] *South Bend News-Times*, Sept. 9, 1935.

[46] *South Bend Daily Tribune*, November 16, 1912.

[47] Esslinger, 85.

[48] *Indianapolis News*, April 8, 1926.

[49] *South Bend Weekly Tribune*, August 10, 1876.

[50] *South Bend Weekly Tribune*, April 7, 1906.

[51] Christian Sack to Andreas and Georg Sack, Jan. 6, 1855. NICH 87.28/3.

[52] Chailer F. Grob to Christian Sack, Nov. 13, 1855. NICH 87.28/21.

[53] Andreas Sack to Christian Sack, Jan. 1, 1863. Not yet catalogued.

[54] Andreas Sack to Christian Sack, Jan. 18, 1872. NICH 87.28/10.

[55] *South Bend Daily Tribune*, September 30, 1916.

[56] John C. Schreyer to Katie Meyer, June 8, 1875. *Ancestors Charts*, vol. 3. Local History, St. Joseph County Public Library.

[57] *South Bend Daily Tribune*, Dec. 5, 1907.

[58] *South Bend Daily Tribune*, May 18, 1878.

[59] Carmony ed., Schreyer letter, 286.

[60] *South Bend Tribune*, February 19, 1921.

[61] *South Bend Daily Tribune*, July 5, 1899.

[62] *South Bend Weekly Tribune*, December 26, 1885.

[63] Johann Friedrich Elbel to Christian Sack, April 8, 1855. NICH 87.28/1.

[64] The figures of how many Arzbergers left are taken from Singer's *Amerika-Auswanderer*, 5-9.

[65] The industrialist Max Ebenauer recorded in his diary that he set up the first steam powered machine in his cotton weaving industry in 1851. The diary is available in the Arzberg *Stadtarchiv*.

[66] Friedrich Wilhelm Singer, *Hochzeit im Sechämterland*. Arzberg, 1988, 66-67.

[67] Anton Bauer to Christian Sack, June 25, 1856. NICH 87.28/17.

[68] D. Mathias Simon. *Arzberger Heimatbuch*. 2nd ed. Verlag der Stadt Arzberg, 1954, 261.

[69] The large red brick structure still stands on Elwood Road, just off Portage Avenue, although the faded name on its walls reads not Muessel but Drewery, the last owner of the brewery before it closed down altogether.

[70] The last living Elbel in South Bend is Frederick C. Elbel, who once again was conductor of a military band. His father, whose portrait hangs in the Northern Indiana Center for History, was President of that organization from 1936-1966.

[71] Otto Knoblock. "When South Bend Was Young." *South Bend News Times*, June 23, 1935.

[72] Thekla Sack's diary "What Happens Every Day," November 1872-December 1873. NICH.

[73] Singer, *Amerika-Auswanderer*, 85.

[74] *South Bend Weekly Tribune*, March 30, 1895.

[75] Dorothea Diver Stuecher. *Twice Removed. The Experience of German-American Women Writers in the 19th Century*. New York: Peter Lang, 1990, 50.

[76] *South Bend Tribune*, July 26, 1929.

[77] Norbert Krapf, ed. *Finding the Grain. Pioneer German Journals and Letters from Dubois County, Indiana*. Indiana University Printing Services, 1996, 184.

78 Schelleng, "The Keislers." Typescript.

79 Siegmar Muehl. "Shock of the New: Advising Mid-Nineteenth Century German Immigrants to Missouri." *Yearbook of German-American Studies* 33 (1998), 95.

80 Wolfgang Helbich, *Amerika ist ein freies Land. Auswanderer Schreiben nach Deutschland.* Darmstadt: Luchterhand Verlag, 1985, 113.

81 *South Bend Weekly Tribune* of January 24, 1880.

82 Schelleng, "The Keislers." Typescript.

83 *Goldenes Jubiläum 1861-1911*, South Bend Turn Verein.

84 According to the *St. Joseph Valley Register* of January 28, 1869, about 400 divorces were granted in Indiana in 1868.

85 Only men are listed in *An Index to Naturalization Records in Pre-1907 Order Books of Indiana County Courts.* Indianapolis: Indiana Historical Society, 2001.

86 Schelleng. "The Keislers." Typescript.

87 *St. Joseph County Scrapbook No. 2 1900-1922*, p. 38.

88 *South Bend Tribune*, Nov. 2, 1960.

89 Linda Kraus Worley. "Through Others' Eyes: Narratives of German Women Traveling in Nineteenth Century America." *Yearbook of German-American Studies* 21 (1986), 47.

90 Philipp Lautenschläger to his father, 1830, in Helbich, *Amerika ist ein freies Land,* 129.

91 Stuecher, 110.

92 *South Bend Tribune*, April 4, 1926.

93 *South Bend News Times*, Sept. 5, 1926.

94 Wittke, 216.

95 O'Connor, 133.

96 Wittke, 43.

97 Wittke, 214.

98 Carl Fremont Brand. "The History of the Know Nothing Party in Indiana." *Indiana Magazine of History*, vol. xviii (1922), 81.

99 Brand, 75.

100 Henry Metzner. *History of the American Turners.* Louisville: National Council of the American Turners, 1989, 10.

101 Quoted in Willard H. Smith. *Schuyler Colfax: The Changing Fortunes of a Political Idol.* Indianapolis: Indiana Historical Bureau, 1952, 59.

102 Marvin R. O'Connell. *Edward Sorin.* Notre Dame University Press, 2001, 425.

103 Rt. Rev. H.J. Alerding. *The Diocese of Ft. Wayne 1857-Sept. 22, 1907.* Ft. Wayne: Archer Printing, 1907, 231. Alerding does not spell out the perpetrators of this violence, but it is most likely that they were motivated by Know-Nothing ideology.

104 Esslinger, 24.

105 O'Connor, 130.

106 *Indianapolis Journal*, September 30, 1861.

107 Michael A. Peake. *Indiana's German Sons. 32nd Volunteer Infantry.* Indianapolis: Deutsches Haus Athenaeum, 1999, back cover.

108 Andreas Sack to Christian Sack, April 14, 1862. NICH 87.28/5.

109 Andreas Sack to Christian Sack, January 30, 1862. NICH 87.28/9.

110 Andreas Sack to Christian Sack, May 15, 1862. NICH, not yet catalogued.

111 Daniel Schiller to Christian Sack, January 26, 1864. NICH, not yet catalogued.

112 Christian King to Christian Sack, July 21, 1864. NICH, not yet catalogued.

113 *South Bend Daily Tribune*, July 7, 1906. Alfred Klingel was one of the stockholders of the Democratic *South Bend Times*.

114 Quoted in Smith, 302.

115 Schuyler Colfax to Charles Heaton, Sr., August 7, 1856. NICH, box 1, folder 9.

116 *South Bend Courier*, March 16, 1900.

117 "Germans Speak. *South Bend Daily Tribune*, Oct. 27, 1892.

118 Christian Sack to Andreas Sack, October 23, 1855. NICH 87.28.2.

119 Wittke, 60-61.

120 Wittke, 371.

121 Blumroeder to Christian Sack, May 16, 1849. NICH 87.28/11.

122 Johann to Christian Sack, November 11, 1848. NICH, not yet catalogued.

123 *The Weekly Republican*, January 16, 1912.

124 Wittke, 281.

125 *South Bend Daily Tribune*, Wednesday, Feb. 7, 1883.

[126] *Jahrbücher der deutsch-amerikanischen Turnerei*. Band I, Heft 1, 1892, p. 19.

[127] Giles R. Hoyt. "Germans." *Peopling Indiana: The Ethnic Experience*. Robert M. Taylor and Connie A. McBirney, eds. Indianapolis: Indiana Historical Society, 1996, 160.

[128] Annette R. Hofman. "One Hundred Fifty Years of Loyalty: The Turner Movement in the United States." *Yearbook of German-American Studies*, vol. 34 (1999), 64.

[129] Wittke, 110.

[130] Bruce Levine, 9.

[131] Metzner, 25.

[132] *South Bend Tribune* October 15, 1931.

[133] *South Bend Tribune*, May 31, 1936.

[134] *Seventy-Fifth Diamond Jubilee Anniversary 1861-1936*.

[135] *St. Joseph Valley Register*, January 28, 1869.

[136] Minutes of the Singing Section of the *Turnverein*, February 23, 1940.

[137] *South Bend Tribune*, May 31, 1936.

[138] *South Bend Tribune*, October 15, 1931.

[139] *South Bend Times*, April 7, 1904.

[140] Singer, *Amerika-Auswanderer*, 95.

[141] *South Bend Times*, April 7, 1904.

[142] *South Bend Times*, April 7, 1904.

[143] Kathleen Smallried. *South Bend News Times,* March 5, 1933.

[144] *South Bend Tribune*, July 23, 1921.

[145] There is a gap of about 20 years between 1919 and 1939, when all Turners' records appear to have been lost. It was during this period that the society changed to English.

[146] *Turnverein* members still meet in South Bend and even put out an occasional newsletter. Don Miller, who in 1998 was the last President, and his wife Velma are the leaders in this. Typically though for the South Bend Turners at this time, only Velma, who comes from five generations of Turners, is of German extraction.

[147] Brother Joseph to Father Sorin, January 11, 1847. Indiana Province Archives, University of Notre Dame.

[148] Brother Joseph to Father Sorin, March 31, 1847. Indiana Province Archives, University of Notre Dame.

[149] Brother Joseph to Father Sorin, July 13, 1847. Indiana province Archives, University of Notre Dame.

[150] Linda Pickle Schelbitzki. "German and Swiss Nuns in Nineteenth-Century Missouri and Southern Illinois." *Yearbook of German-American Studies* 20 (1985), 62.

[151] Alerding's book is an excellent resource for identifying immigrant Catholic priests of German extraction.

[152] *Social Justice Review* 52, 166.

[153] *Social Justice Review* 52, 132.

[154] Obituary of Anna Beiger, *Mishawaka Enterprise*, October 4, 1895.

[155] *St. Joseph County Deed Book V*, 493.

[156] I am grateful to Merle Blue, local historian, for this explanation.

[157] Norbert Krapf, ed. *Finding the Grain. Pioneer German Journals and Letters from Dubois County, Indiana*. Indiana University Printing Services, 1996, 41.

[158] *South Bend Tribune*, December 23, 2001.

[159] Information provided by Sister Campion Kuhn, CSC, archivist at St. Mary's College.

[160] *A Century of Catholic Faith in Mishawaka*, 15.

[161] "Chronicles 1882," quoted in *Diamond Jubilee, St. Mary's Church 1820-1958*. South Bend: Ideal Press, 1958.

[162] Coleman J. Barry. *The Catholic Church and German Americans*. Milwaukee: Bruce Publishing Company, 1953, 63.

[163] Record of Missions Attended from Notre Dame 1842-1854, handwritten in Latin. Indiana Province Archives, University of Notre Dame.

[164] "Chronicles 1882," quoted in *Diamond Jubilee, St, Mary's Church, 1958*.

[165] "*St. Mary of the Assumption Parish: 100 Years of History*."

[166] *The Big Book of Accounts 1846-*, Sisters of the Holy Cross, 97.

[167] Barry, 277.

[168] Abram V. Goodman. "A Jewish Peddler's Diary 1842-1843." Jeffrey S. Gurock, ed. *Central European Jews in America, 1840-1880: Migration and Advancement*. New York: Routledge, 1998, 55-85.

[169] O'Connor, 241.

[170] Information provided by Robert Wagner, archivist of Nierdernberg.

[171] Arthur Hertzberg. *The Jews in America. Four Centuries of an Uneasy Encounter: A History*. New York: Simon and Schuster, 1989, 103-106.

[172] Marc Lee Raphael. "The Early Jews of Columbus, Ohio: A Study in Economic Mobility, 1850-1880." *Central European Jews in America*, 1840-1880, 228.

[173] Judith Endelman. *The Jewish Community of Indianapolis 1849 to the Present*. Indiana University Press, 1984, 25.

[174] Hertzberg, 137.

[175] Glanz in Carolyn Eastwood. *Chicago's Jewish Street Peddlers*. Chicago Jewish Historical Society, 1991, 10.

[176] Joseph Levine. *From Peddlers to Merchants*. Indiana Jewish Historical Society, 1979.

[177] *South Bend Weekly Tribune*, April 7, 1906.

[178] *South Bend Weekly Tribune* of April 20, 1895.

[179] Howard, 411.

[180] Founding Document of Hebrew Society of Brotherly Love, 1859.

[181] Jacob Rader Marcus. *Memoirs of American Jews 1775-1865*, 2vols. Philadelphia: The Jewish Publication Society, 1955, II, 133.

[182] Advertisement in Ligonier paper of November 5, 1915.

[183] *New York Times*, November 11, 1984.

[184] Joseph Levine, 1.

[185] Joseph L. Blau and Salo W. Baron, eds. *The Jews of the United States 1790-1840. A Documentary History*, 3 vols. Columbia University Press, 1963, III, 802.

[186] Marcus II, 158.

[187] Marcus II, 284.

[188] Endelman, 56.

[189] Daniel Schiller to Christian Sack, January 26, 1864, NICH, not yet catalogued.

[190] Stanley Nadel. "Jewish Race and German Soul in Nineteenth Century America." Jeffrey S. Gurock, ed. *Central European Jews in America, 1840-1880*, 307 and 310.

[191] Hertzberg, 118.

[192] Nadel, 306.

[193] Hertzberg, 110.

[194] "Eine parteifreie politische Epistel an die Deutschen in den Vereinigten Staaten." *Der deutsche Pionier*. 11. Jahrgang, Heft 1, 1879, 140-145.

[195] Hertzberg, 111.

[196] Letschinsky in Barkai, 41.

[197] Catherine M. Rascher, granddaughter of John C. Schreyer. Letter to Northern Indiana Historical Society, Sept. 12, 1972.

[198] Daniel Lamont McDonald. *History of Marshall County, Indiana: 1836-1880*. Chicago: Kingman Brothers, 1881, 24.

[199] In 1846, a German immigrant paid $500 for 100 acres in Ohio. Singer, *Amerika-Auswanderer*, 70.

[200] Wolfgang Adam Elbel called Schreyer's land a "dangerous fever-laden spot," which may account for its relative cheapness. Handwritten memoir of 1895.

[201] Richard H. Zeitlin. *Germans in Wisconsin*. Madison: State Historical Society of Wisconsin, 2000, 67.

[202] Mc Donald, 56.

[203] McDonald, 156.

[204] Zeitlin, 62.

[205] *Turner's Gazeteer of the St. Joseph Valley 1867*, 49.

[206] Paul W. Gates in Roland Berthoff. "A Country Open for Neighborhood." *Indiana Magazine of History*, vol. lxxxiv, no. 1 (March 1988), 40.

[207] *South Bend Daily Tribune*, February 12, 1878.

[208] Under its Constitution of 1866, the Texas Legislature could sell "asylum lands," which were lands granted for public schools.

[209] *Fort Worth Daily Democrat*, March 5, 1878.

[210] Susan Doughtery Navarro. *Eagle City. An 1878 Colony on Lytle Creek in Taylor County, Texas*. Copyright, 1981. Arlene Christian University Library, Abilene, Texas, 11.

[211] Hicks A. Turner, ed. *I Remember Callahan. History of Callahan County Texas*. The Callahan County Historical Commission. Dallas: Taylor Publication Co., 1986, 307-308.

[212] Interestingly, Anna Margaretha's maiden name was also Hensel.

[213] Thekla Sack. "An Illustration of Local Patriotism." *South Bend Daily Times*, April 7, 1904. Report of a speech Miss Sack gave at the Northern Indiana Historical Society on April 6, 1904.

[214] John Arkas Hawgood. *The Tragedy of German-America. The Germans in the United States of America during the 19th Century—and After*. New York: G.P. Putnams, 1940, 274.

[215] Kathleen Neils Conzen. "The Paradox of German-American Assimilation." *Yearbook of German-American Studies* 16 (1981), 156.

[216] *Der deutsche Pionier*, ixii, 6 (September 1880), 235-38.

[217] Wittke, 224.

[218] *South Bend Tribune*, December 23, 1916.

[219] Esslinger, 110-111.

[220] Conzen. "The Paradox of German-American Assimilation," 156.

[221] Heinz Kloss in *The German Language in America*, ed. Glenn G. Gilbert. University of Texas Press, 1971, 249.

[222] John S. Kulas, *Der Wanderer of St. Paul. The First Decade, 1867-1877. A Mirror of German-Catholic Immigrant Experience in Minnesota.* New York: Peter Lang, 1996, 199.

[223] *Monatsblatt*, September 1, 1904.

[224] The *Monatsblatt* was published in conjunction with the Protestant St. John Parish in Niles, Michigan, between 1897 and 1906, by Martin Goffeney, the first pastor of Zion Church.

[225] *Monatsblatt*, October 1, 1904.

[226] *Monatsblatt,* August 1, 1904.

[227] *Monatsblatt*, September 1, 1904.

[228] Hawgood, 295.

[229] George Theodore Probst. *The Germans in Indianapolis 1840-1918.* Revised and Illustrated by Eberhard Reichmann. Indianapolis: German-American Center and Indiana German Heritage Society, 1989, 49.

[230] Paul J. Ramsey. "The War against German-American Culture: The Removal of German-Language Instruction from the Indianapolis Schools, 1917-1919." *Indiana Magazine of History*, vol. xcviii, no. 4 (Dec. 2002), 297.

[231] Probst. 153.

[232] Probst, 69.

[233] Interview with Charles Beutter, November 27, 2001.

[234] *Old Courthouse News*, vol. vi, no 3, September 1972.

[235] *South Bend Tribune*, July 23, 1921.

[236] *Seventy-Fifth Diamond Jubilee Anniversary*, 1861-1936, 2.

[237] Hawgood, 295.

[238] John Christopher Schelleng, "The Keislers." Typescript.

[239] Schricker. Typescript. June 13, 1988.

Himmelschlüsselchen *(cowslip)*.